D0810672

National Identity in
Global Cinema

National Identity in Global Cinema

How Movies Explain the World

Carlo Celli

First published in 2011 by PALGRAVE MACMILLAN® in the United
States—a division of St. Martin's Press LLC, 175 Fifth Avenue, New York,
NY 10010

Where this book is distributed in the UK, Europe and the rest of the
world, this is by Palgrave Macmillan, a division of Macmillan Publishers
Limited, registered in England, company number 785998, of Houndmills,
Basingstoke, Hampshire RG21 6XS.

Palgrave Macmillan is the global academic imprint of the above companies
and has companies and representatives throughout the world.

Palgrave® and Macmillan® are registered trademarks in the United States,
the United Kingdom, Europe and other countries.

ISBN: 978-0-230-10882-0

Library of Congress Cataloging-in-Publication Data

Celli, Carlo, 1963–
 National identity in global cinema : how movies explain the world / Carlo
Celli.
 p. cm.
 Includes bibliographical references.
 ISBN 978-0-230-10882-0 (alk. paper)
 1. National characteristics in motion pictures. 2. Culture in motion
pictures. I. Title.

PN1995.9.N33.C45 2011
791.43'639581–dc22 2010025761

Design by Scribe Inc.

First edition: February 2011

10 9 8 7 6 5 4 3 2 1

Transferred to Digital Printing in 2011

What has been will be again, what has been done will be done again; there is nothing new under the sun.

<div align="right">—Ecclesiastes 1: 9–14</div>

Contents

Illustrations

Introduction

This book presents nine national cinemas (China, Finland, France, India, Iran, Italy, Mexico, Ukraine, and the United States of America). These countries were chosen as a representative mixture of world cinemas and are examined alphabetically with an eye to four criteria: (1) cultural heritage, (2) centralization, (3) common language, and (4) convention— points that should provide an astute observer with the tools to determine the basic characteristics of any national cinema on the planet. This approach derives from the ancient Greek philosopher Aristotle (384–322 BC) who wrote about mimesis (imitation), how art can imitate reality and represent nature. When elements that define a nation's historical and cultural identity appear in popular films, it is possible to see such imitation in action. Despite its reputation as a new art form, cinema can be atavistic, an expression of past traits in the present. Studying specific national cinemas with attention to how stories and motifs repeat reveals the deep cultural and sociological essence of a nation so movies truly can *explain the world* one country at a time.[1]

Some nations in this book (Italy, Finland) with consistent master plots and themes are examined chronologically around film production centered in a "mini-Hollywood" in that nation's capital.[2] Others (France) have cinemas that reveal how cultural elites sponsor films with themes opposite to what is popular at the box office. Nations with ancient cultures (India, Iran, Mexico), subject to colonial rule into the nineteenth and twentieth centuries, show how millennial identity can manifest in popular cinema. Some nations (Ukraine) long subject to foreign imperial dominance have national themes in the work of individual directors. The world's most economically successful cinema industry, Hollywood, is actually more of an international than simply American phenomenon. Hollywood producers, ever pragmatic, understand that audiences in the United States and around the world like to leave the theater in a good mood. But as we will see, the few films about indigenous American stories that rank high in the all-time domestic box office do not completely follow Hollywood's stereotypical happy-ending model.

Each chapter derives from the basic idea that culture is a superstructure formed from an underlying structure of fixed elements like geography, demography, or deep-seated cultural influences derivative of sacred texts and religious traditions. The narratives that national audiences favor, usually evident in the box office champions of the early sound period, are a product of these fixed inputs that form the basic structure around which the superstructure of culture is formed. By this interpretation readings based on individual and personal physical characteristics such as race, gender, or class are a further superstructure that actually obfuscate understanding of the cultural heritages, which influence the national narratives in popular cinema. It is the hope of the author that the method inscribed herein may be applied to any nation and that the choice of nations for this study, which vary greatly in terms of geography, history, and tradition, may offer models for future examinations of other national cinemas.

Centralization

The physical lay of the land in terms of fluvial plains, vast prairies, or impervious mountain ranges has long determined national economic and cultural development. The change from agricultural to industrial production brought demographic and migratory transformations that led to the expansion of urban centers. In the late nineteenth century and early twentieth century, many nation-states underwent cultural, political, and economic centralization. The cinema is, by its very industrial essence, the art form that has reflected the latest of these transformations, especially in the periods of the early sound cinema when production was dependent on centralized studio organizations. By the 1930s, even in countries that had not experienced complete industrialization, cinematic production often became concentrated in a country's political, economic center or in cinematic hubs, which became focal points of talent, production, and distribution. The result was the development of national cinematic cultures.

This process whereby underlying economic reality influenced and even determined cultural production is further evidenced in the global political reliance on protectionism in trade during the early sound period (and the global economic depression) of the 1930s. If protectionist and autarkic policies had a negative effect on world trade in the 1930s, then for the cinema it meant a boon for the development of indigenous cinematic cultures. Countries developed national industries that no longer had to compete against the market dominance gained by the Hollywood cinema industry after World War I. The same national governments that limited free trade through protectionist policies also established censorship codes

resulting in increased government power to influence and even determine cinematic content. Some governments even awarded subsidies to producers who made films that seemed to promote governmental policy.[3] The resulting networks of centralized film production working under the threat of government oversight and censorship created film industries around the world that promoted themes transmitted through the popular cinema to a national audience. Thus economic and political centralization had the effect of favoring thematic production of cultural elements tied to the dominant, hegemonic structures within a given nation. The power of the cinema was in the expression of cultural commonplaces in a manner that undoubtedly pleased not only authoritarian regimes but also the status quo of countries that respected republican constitutions. A sense of identity and belonging according to what was presented and reinforced in a national cinema became an important tool for the creation of national cultural consensuses. Nationalist political cultures may have been established in the nineteenth century as part of a desire for self-determination and expression of indigenous cultures, but this process did not have a medium at its disposal with the visual communicative power of the cinema. Thus the films of the early sound period in particular truly did promote conventions, common languages, and cultural heritage in a climate of political centralization that has influenced the way in which national identities are perceived to the present day.

Convention

Centralization allowed for the creation of national cultural consensus through the propagation of models of behavior displayed in the cinema. These commonplaces were encoded into the cinema through narrative conventions. When certain narrative conventions gained popularity, as evidenced by box office success, they became blueprints for future production. Mimetic impulse is ingrained into artistic production and has an economic component, for when a story line is popular and achieves the benediction of popular acceptance, it may become an established convention. Successful narrative models spawn imitation. Because the making of a film is potentially such an expensive undertaking, once a successful formula is established, screenwriters copy it, eager to attract producers. The happy-ending pattern affirmed in Hollywood's classical studio period was the result of market calculation and industrial standardization: the application of industrial production techniques to film. Silent film producer Thomas Ince recognized that a script is not just a story but a production blueprint, an organizational plan whose final objective is a positive return

on investment.[4] Following the industrial culture created by pioneers such as Ince, in the late 1940s Radio-Keith-Orpheum (RKO) executive George Stevens reported how studio executives and screenwriters closely examined the structure of past box office hits in the hopes of discovering formulas for success.[5] For example, the Hollywood formula of a three-act happy ending drama inspired imitation by filmmakers and producers within the Hollywood industry and abroad. The Hollywood cinema and many of the mini-Hollywoods that formed throughout the world have worked in this mimetic tradition whereby narrative patterns indicative of historical and cultural identity were repeated either in response to audience demand or as a result of the desires of elites to express their sense of culture. However one must look beyond the Hollywood three-act model in order to discern the narrative conventions that truly reflect national cultures. The mini-Hollywoods around the world communicated cultural and historical identity through narrative conventions by referring to deep currents within the history and culture of their nations. One could argue that this was a conscious process whereby producers eager to establish an autochthonous voice and culture for the cinema found commonplaces indicative of national identity, which were then rewarded by domestic audiences. The key to understanding cinematic conventions is that an audience conditioned to established narrative patterns reacts with immediacy to the presentation of an established plot line. This immediacy reinforces the cultural connection between the centralized film industry working under the coercive eye of government censors and sponsors and public spectators. Even in cases where a controlling elite consciously promotes or sponsors films contrary to public taste, the power relationship is a two-way street. The centralized power in charge of production and censorship may promote certain narrative conventions favorable to their political world view. However, if the public reacts negatively and refuses to reward the film at the box office, then the sanctioned narrative convention may be threatened and with it the political legitimacy of the ruling hegemony. Thus the plots sanctioned in national film distribution are a possibly explosive matter with huge political potential. Paradoxically, even in cases where a film industry is fettered and controlled by censorship, the cinema has a truly democratic aspect as the public may simply refuse to attend screenings or even ridicule the message of a film. Thus the cinema lives a precarious equilibrium between the tastes of a mass audience and the desires of controlling elites eager to promote their political and social views. Through its connection with the mass of public opinion, a medium like the cinema can forge the direction of future production and thereby influence the course of a national culture.

Common Language

An important aspect of the political centralization mentioned above is the desire of a centralized government and its cultural outlets to promote a uniform national language. Studies of national culture often cite the concept of the nation as an "imagined community" with origins in the educational policies and print media of the eighteenth and nineteenth centuries.[6] Yet national languages were not standardized in Europe until well into the nineteenth century. In the case of some countries, national language was an academic construct with roots in the works of great authors of centuries past rather than a living, vibrant mode of communication among the populace. Thus national languages in many cases are the artificial creations of government hegemony. And the question of the adoption of a national tongue was by no means a given. In many cases the imposition of a national tongue came either through violence, educational reform, or by the sheer force of propagation through mass media, which has at its essence the aim of replacing local dialects. It must be recalled that under the imperial reality before World War I many of the national identities in Europe were not able to establish their own nation-states. Therefore the process of linguistic assimilation on which the cinema rode into prominence in the early sound period conveys much larger issues about national identity and origin. The prodding of nationalistic polices from governments especially in the early sound period in effect helped to solidify a national language's diffusion.

Of course, with silent film the question of spoken language had little relevance. Silent film had universal cultural appeal, almost a return to the iconography of earlier ages where the spectators experienced an anti-iconoclastic universality. No Western film stars have ever relived the fame enjoyed by silent film actors like Charlie Chaplin or Mary Pickford, because silent film existed above the cultural differences emphasized by language barriers. Silent film actors spoke all languages and none, with their delivery dependent on pantomime and intertexts. The arrival of sound, first via radio and later in the cinema and television, was an epochal event in the cultural histories of many nations. Sound divided films according to politically sanctioned, standardized tongues that communicated specific cultural identities. If film could be universal before sound, after sound it could reinforce national culture on a scale previously impossible. Sound also allowed national film industries struggling from competition with Hollywood a chance to find a niche in national markets.[7] After World War I the Hollywood film industry had been able to enter world markets, particularly in Western countries, which were short of the sort of capital needed to produce films. In the contemporary marketplace the less linguistically or culturally specific a film is, the better its chance to appeal across cultural

boundaries. This was not the case in the early sound period of the 1930s when national cinemas sought to gain domestic market share by offering a product in their own tongues.

Perhaps since film is such an obviously visual medium, its linguistic component has yet to receive adequate treatment. In both film study and cultural studies, instead of attention to the inclusive power of language within a national and cultural context, there has been a focus on diversity, multiculturalism, subaltern otherness, and the manner in which cultural identity is "de-centered."[8] The shortcoming of this approach has been that it has focused attention on the legacy of colonialism, slavery, and immigration under the false assumption that power and wealth ratios are static. However in the historical record permanence in economic and power relationships has never been the case. If it were, then Rome would still control the Western world. Countries presently with increasing rates of economic growth such as Brazil, India, or China would be permanently poorer than the countries that ruled over them as colonial overlords. Even within individual nations, economic relationships are dynamic by nature, and cultural influence is an undeniable offshoot of economic power. The influence of Hollywood cinema coincided with American economic strength in the twentieth century, but as stated, such status is not permanent, and the cultural influences of countries with positive economic growth rates are bound to increase. By approaching countries according to their indigenous cultural heritage and the manner in which cultural identity is expressed through a national cinema, it is possible to recognize cultural entities beyond a world view bound by economic rankings of the nineteenth and twentieth centuries. As countries such as India or China enjoy an increasing sway over world cinematic culture, an understanding of their basic cultural heritage and how it is reflected in the cinema will be a useful tool for aesthetic appreciation.

Even when countries with small populations such as Finland or countries with censorship barriers such as Iran developed a national cinematic culture, it was done for domestic audiences that reacted positively at the box office to a product in their own tongue, even if that tongue was a promoted construct of a central government. Cultural studies, especially those concentrating on film, have missed the importance of sound for the promotion of linguistic and cultural assimilation, a process that truly began with radio and received a more continued diffusion through cinema and television. A more complete exposition of multiculturalism would recognize and promote the relevance of the study of cultural differences among countries whose colonial history ended in the nineteenth century such as Italy or Mexico, or of countries whose colonial subjugation ended in the twentieth century such as Finland or Iran. Thus a recognition of the

manner in which a standardized national tongue gained diffusion through the cinema offers an opportunity for a true understanding of the cultural wealth, not only between peoples of different physiognomies, but also between peoples of different cultures.

Cultural Heritage vs. Cultural Theory

Cultural heritage is inherited from previous generations and may include aesthetic practices, religious traditions, and social customs as well as shared experience. The commonplaces of national cultural heritage and national character may also be understood if approached in terms of what has resonated over the centuries among national audiences as well as what has been promoted and enforced by a ruling elite. The cinema has the advantage of having specific economic results through the box office that reflect popular mood and taste. Films and styles of films that gained popularity and convey a certain type of national essence can safely be determined to be a direct expression of a cultural heritage and national identity. The cinema offers a manner for the revelation of themes and motifs due to their popularity and repetition. This study will attempt to discern those identifying characteristics evident in the narrative commonplaces of popular cinema that reveal the essence of national cultural heritage. The cinema can provide an intersection between popular tastes as revealed through box office receipts under ruling political elites and commercial interests.

Of course studying the cinema with an eye to expose the grand themes within national cultures is a departure from trends that have dominated cinema study in the twentieth century. Attempts to analyze cultural heritage in film have been hamstrung by trends in cultural theory that emphasize diversity and particularity rather than communality and universality. This tendency to avoid broader cultural and sociological issues in film study has a long history and may perhaps have an origin in the tendency for film study to be dominated by theories such as auteurism or psychoanalysis that describe art in individual terms. The auteurist model allowed film scholars to write in the Romantic tradition of art historians more suited to describe a single Renaissance painter than an industrial process like the cinema. The auteurist approach is reminiscent of the writing of Renaissance art history Giorgio Vasari (1511–74) whose writings focused on the character traits of great artists that were then conflated into a reading of their paintings. An auteurist approach tends to apply the same method to the pantheon of great directors of art cinema: Federico Fellini, Ingmar Bergman, and the like. This concentration on the individual has the effect of reducing attention paid to the culture that spawned the directors in question. A director

like Fellini undoubtedly made films that are a result of his personality; but he also produced films within the working world of postwar Italy and requirements in terms of censorship and production demands in anticipation of box office reception. Furthermore despite the scholarly attention paid to renowned directors, or *auteurs*, the films of famous directors who had the power to determine the content of their films in the way that a painter can control a canvas actually constitute only a small percentage of film production. Some acclaimed directors may have had enough prestige or the financial means to impose their artistic visions on films. But unlike other art forms, such as painting or literature, film is rarely the product of a single mind. It is the result of a collective, an entire industrial and cultural apparatus that requires scores of participants: writers, actors, and technicians.

Psychoanalytical approaches in film study, like the auteurist approach, also focus on personal issues in recognition and promotion of themes on an individual emotional scale. Such themes may be conflated to larger societal relevance. The application of Freudian or Lacanian themes gained popularity in cultural studies. However, the focus on interpersonal relationships, even if extended to a societal scale, reduced the relevance of cultural origin, and the study of film has been poorer as a result. Parental and sexual relationships may be universal, but not everyone has an Italian mother or a Chinese father or has been in love in France. Cultural milieus have an enormous influence on the sort of gender or generational relationships that are emphasized in psychoanalytical studies. This book will demonstrate how cultural environments have determined the cinematic essence in specific countries and will provide a manner for discerning the cinematic culture of national identities that have produced a cinema.

Critics and scholars have also tended to categorize art in terms of stylistic periods rather than cultural heritage. The invention of terms like "Italian neorealism" or "French poetic realism" allowed critics to ponder films according to stylistic and political criteria, paying more attention to a cinematic school or style than to the culture that spawned it. Instead of a consistent adherence to national cultural heritage, such categories promote a fixation with a specific historical and political moment. Italian neorealism is inexorably linked to the postwar political and cultural moment that sought to exalt the indigenous Italian Resistance against Nazism and Fascism. Just as Italian neorealism is tied to the mythology surrounding the Italian Resistance, French poetic realism is tied to the mythology created around the brief reign of the Popular Front in the years immediately preceding World War II. The marriage of political and artistic moments such as neorealism or poetic realism is quite important in cinematic history, but the cultural heritages of France and Italy run deeper than reactions to the

events of World War II, and the breadth of such legacies should be reexamined for their relevance to popular cinema.

Film historians have also emphasized genre—the types of narrative formats produced by film industries. Rather than products of a specific cultural heritage, films were studied in terms of narrative types: westerns, romantic comedies, road movies, thrillers, and so on. The Hollywood western of the United States, the spaghetti western of Italy, and the curry western of India may all belong to the same genre, but the cultures of these countries profoundly influenced the type of western they produced. The impetus for promoting genre studies within cinematic traditions is perhaps explicable by the desire to find elements that can be universally applied to film as with any art form. But film remains the result of an industrial process in a specific cultural milieu.

As has occurred in literary criticism, film and cultural studies have turned to terminology from the social, political, and behavioral sciences. Approaches derivative of structuralism, Marxism, feminism, postcolonial studies, or textual analysis can be useful for the study of films and genres in terms of social and political phenomena, particularly when concentrating on a particular ethnic, social, or sexual group. However, such approaches tend to separate artistic works from their cultural origins by emphasizing themes of class, gender, ethnicity, or textual detail rather than cultural heritage. A point this study hopes to impart is that considerations of class, gender, ethnicity, and the like are personal physical characteristics that remain inexorably dependent on cultural heritage. To study such physical characteristics without taking into account the larger context of the more nebulous concept of cultural identity with roots in geography or religious traditions is counterproductive for the simple reason that the resulting conclusions will be poorer for their lack of breadth. With the present interconnections between previously separated nations, the idea of an equation between racial physiognomy and national identity is increasingly anachronistic. Attempting to study gender issues in countries like India, Iran, or Finland would be untenable without an understanding of larger cultural history. In Islamist countries women have the same level of legal rights as minors. In contrast Finland was among the first nations to grant women's suffrage. Finnish and Iranian films are thus obviously driven by different assumptions and cultural traditions regarding the role and rights of women. Similarly approaches based on themes of class consciousness presume static power relationships within the societies of capitalist countries and between competing nations when in fact the rule of societies and the universe is constant dynamism.

Some more recent theoretical approaches have opted for a more pragmatic and eclectic approach to film study not by being confined to any

one theory but by combining and shifting between them.[9] Some scholars have attempted to propose more macroscopic readings of influences on film: by identifying possible allegorical designs, models and iconographies;[10] by writing of national identity in cinema in terms of the transmission of the essence of a national culture in an inclusive manner;[11] and by identifying the essence of national cinema as a dynamic, ever-evolving process that grows to fit the changing nature of a national culture.[12] However, attempts to connect cinema with cultural specificity still fall prey to theoretical distractions. The very idea of cultural identity has received comparatively little attention from theorists trained to discern the particularities of "postmodern" divisions or deconstructed signs rather than the deeper common ground of geographical, historical, sociological, and cultural essence.[13] The irony is that the theoretical groundings valued by film scholars are ultimately reflective of the political and cultural moments that spawned them, which are unquestionably shallower than the cultural heritage of any country. Despite efforts to champion a particular theoretical paradigm, whether in Marxist cultural theory, psychology, gender-based or semiotic explanations, scholars inevitably flirt with questions of cultural specificity—what makes an Italian film Italian, a Hollywood film American, and so on. This study aims to reveal how elements of centralization, common languages, and convention can be expressions of cultural heritage within national cinemas and bring critical theory back into equilibrium with artistic expression.

I

China's Confucian, Misogynistic Nationalism

Following free market reforms China has begun to reassert the economic might it had held in the global economy until the definitive rise of the industrialized nations of Western Europe in the eighteenth and nineteenth centuries. The liberalization of the Chinese economy has a corollary in the Chinese cinema, which despite persistent domestic censorship has also made strides in the world cinema market. Given the challenges to film production in the politically and economically troubled years preceding World War II and the intense oppression from the communist government after 1949, three recent films will suffice for an understanding of the manner in which Chinese film reflects larger themes of Chinese culture and history. *Hero* (2002) by Yimou Zhang, one of the all-time Chinese box office champions, is a nationalist epic about the formation of imperial China in ancient times. *Springtime in a Small Town* (2002) by Zhuangzhuang Tian, a remake of the 1948 film by Mu Fei, features a deflated China after the ravages of World War II and before the definitive communist takeover. *Kung Fu Hustle* (2004) by Stephen Chow is another box office hit with influences from world cinema as several political entities with film industries can claim Chinese cultural and ethnic heritage: mainland China, Taiwan, and Hong Kong. These three films (*Hero, Springtime in a Small Town, Kung Fu Hustle*) have themes of gender rivalry bordering on misogyny, authoritarianism versus individualism, and a yearning for the supremacy of the physical over the technological that lies at the heart of Chinese cultural identity as displayed in popular Chinese cinema.

Centralized, authoritarian governments and their accompanying philosophies, both political and ethical, have a millennial history in China. The Chinese fluvial plains were among the first in the world to provide the sort of agricultural surplus needed for the creation of civilization. However with economic development came political centralization and abuse

of power. In fact the suffering of the Chinese citizenry at government hands over the centuries is staggering. To cite only one recent example, the communist regime under Mao Tse-tung (1893–1976) enacted the Cultural Revolution of 1966–76, leading to deaths through famine estimated as high as 30 million people or more. Mainland China also envelops numerous regional and ethnic entities and has a long history of rebellions against imperial authority. Again, to cite only one recent example, China's 1950 invasion and subsequent colonization of Tibet has hindered Tibetans' ability to express a national identity separate from the nationalist dictates of China's communist government.

Economic development in ancient China occurred under political centralization with uniquely Chinese cultural and philosophical currents that continue to define national identity to the present. As early as the Zhou Dynasty (1046–256 BC), there was an equivalence between moral precepts and power with the "right of a dynasty to rule based on ethical judgment."[1] These codes are entrenched in Chinese culture and society, especially following the diffusion of the teachings of Confucius (551–479 BC), whose ideas about reciprocity of behavior, male ancestor worship, filial piety, and music formed the center of an educational methodology and life philosophy. With its teaching of "golden rule," self-control responsibility, and ancestor worship, Confucianism has constituted a philosophical line in Chinese civilization that has fostered power and authority at a familial and governmental level. The conclusion to be reached from a cursory look at Chinese history is that the weight of centralizing influences are evident not only in economic history but also in the most essential Chinese philosophies and behavior. The role of hierarchy and acceptance of authority, whether familial or governmental, is an essential aspect of Chinese society.

At a more basic level, there are Chinese conceptions of the world in terms of the influences of two opposing forces: the yin negative force of a female, yielding principle versus the yang positive force of a male, active principle. These two forces promote harmony when in balance and irrationality and chaos when out of sorts.[2] These ideals were expounded in the foundational texts of classical Chinese culture that became important for entrance examinations into the bureaucratic service class of Chinese imperial administrations over the centuries.[3] In China, the feudal system was tempered by Confucian ethics with appointments through promotion by examination rather than completely on nepotism.[4] The goal of the Confucian system was the propagation of standards of behavior of enlightened benevolence, thus reducing the necessity for recourse to legal sanction or violent coercion, a modus operandi that favored centralized authority by reducing potential avenues for reform or rebellion.

Another recurring aspect of ancient Chinese culture has been the persistence of military culture as espoused in the writings of authors like Sun Tzu around the fifth century BC whereby military power and the martial arts are a means to harness the chaos according to the order and harmony precept of the Dao philosophy. In contrast to the harmonizing tendencies of economic philosophical practices, there is an undercurrent within Chinese martial culture that emphasizes individual ability. The expertise of a single martial artist may always be subject to the greater harmonizing rules of Chinese culture and society, but by their very existence they provide an outlet for more unpredictable impulses. The inability of the ancient Chinese military culture to completely adapt technological advances that could threaten the individual abilities of martial artists could be interpreted in sociological terms as an attempt to maintain this outlet within the hierarchy of Chinese society. In Japan, for instance, the hostility to firearms was also quite pronounced recalling the attitudes of European knights in the early sixteenth century who would hang musketeers on sight in recognition of the threat they posed to the edifice of chivalric society. In Chinese cinema the abilities of individual martial artists to threaten or to correct a societal imbalance has become a mainstay in narratives where a centralized authority, whether governmental or extralegal, attempts to thwart an individual effort to return society to harmony.

The almost legendary era of Chinese centralized government according to Chinese historiography was the Zhou era, a golden age under the reigns of Kings Wu and Wen. These leaders were able to end the bloodshed resulting from regional strife and enforce their will for the creation of an imperial pax. The Qin dynasty (221–207 BC) set in place an imperial system with reliance on the collective spirit in Confucian ethical codes with codes of filial duty stressing family relations and benevolence and harmony limiting confrontation and criticism. Further dynasties include the third-century Han period often compared in scope to the Roman Empire and the Mongol period and the ensuing *Pax Mongolica* of the thirteenth and fourteenth centuries. Despite the changing of ruling elites and even capitals, the narrative of Chinese cultural history does not really change significantly. Chinese imperial administrations incorporated Confucian elements for the creation of a society based on the attainment of peace and harmony through acquiescence to imperial authority. The moral precepts of a Confucian system are based on a paternalistic structure, where social obligations and rule by example are extremely important according to what may be described as a "golden rule" of doing unto others as one would have others do to oneself. The result of such a system is that the assumptions of behavior and duty leave little room for individuality or challenge to paternalistic hierarchy. The Confucian system also had correlations in social and

technological stasis whereby the established order and harmony of the ruling system was not to be threatened. It is precisely in these areas where the themes that resonate within popular Chinese cinema have made their marks in films about individualism facing authoritarian power. The Chinese cinema will receive less attention than others presented in this study for the manner in which it became a popular industry. This is due in large part to the constrictions on natural evolution placed on mainland Chinese cinema by the repression of the communist regime. Second, in cultural terms and also in terms of the development of a cinema industry, Chinese cinematic culture has three main points of production: mainland China, Taiwan, and Hong Kong. Each of these countries established film industries of varying scope and content. The most successful, the Hong Kong film industry, became an exporter of films and genres, the martial arts film in particular, at a time when mainland China was still struggling under the brutally restrictive government policies of the Maoist regime. These three cinemas would seem to pose an obstacle for the understanding of Chinese cinema as a source for the standardization of culture and language. In many aspects even though China represents arguably one of the most ancient cultures on the planet, many of the processes of modernization, chief among which is the complete standardization of language, have not occurred. In the cinema the most obvious separation culturally is between the historically more libertarian Hong Kong, Cantonese identity that contrasts to the impulses of a centralist, Mandarin identity in the mainland. Such a division does not take into account the numerous regional identities, whether linguistic, ethnic, or even religious, which exist within present-day China. The goal in this study of Chinese cinema will therefore be to reveal the larger themes that could be seen as unifying and essential in all three traditions.

One of the most popular films of all time in the Chinese domestic box office is *Hero* (2002) by Yimou Zhang, the renowned director who was also in charge of organizing the nationalist displays at the opening ceremonies of the 2008 Beijing Olympics. *Hero* is set during the eventually successful campaign of King Qin Shi Huang (259–210 BC) to unify China despite the assassination plot of a trio of martial art experts: Sky, Broken Sword, and Flying Snow. One day a regional official, Nameless, appears at court to claim a reward for eliminating these three dangerous assassins. Nameless recounts his victory over the assassins and initially seems to gain the king's trust. The narrative conventions that reoccur in Chinese film are immediately evident: centralized authority is threatened by individuals possessing advantages in the martial arts. One of the prizes that Nameless has come to claim is the honor of an audience within ten steps of the person of the king. This distance is sufficient for a martial arts expert willing to renounce his

own survival to kill anyone. However the king realizes that Nameless is in cahoots with the other assassins and has come not to claim a reward but to assassinate him. The king retells the story of Nameless's elimination of the assassins Sky, Broken Sword, and Flying Snow as a conspiracy whereby the three willfully accepted death at Nameless's hand in order to allow Nameless an opportunity to assassinate the king.

The film, which had been the subject of several adaptations, attracted audiences with its vivid cinematography and dizzying choreography of martial arts combat sequences. The basic theme and narrative of the film recall the master plot of socialist realism whereby an antigovernment hero (Nameless) comes to understand his historical role in benefit of the collectivity, in this case the imperial designs of the king.[5] In *Hero* the class consciousness of socialist realism is replaced with nationalist consciousness. The king is able to convince Nameless to accept self-sacrifice for the benefit of the nation. The king's Machiavellian argument is that unification under his rule would lead to greater prosperity for the collectivity. In the final scene the single figure (Nameless) faces death from a shower of arrows from the masked hordes of the imperial guard confirming submission of the individual to centralized authority, a theme politically appealing to Chinese governments from ancient times to the present day. The synchronized movements of the masses of the king's faceless palace guard and courtiers acting as a single entity in accordance with the king's orders indicate the cult of the concentration of power within Chinese authoritarianism. The film ends with a funeral procession for Nameless with full honors. Ironically once Nameless entered the palace compound, his death was inevitable. Had he assassinated the king, he would have been a champion of regionalism. With his self-sacrifice for the king and elimination of the three assassins, he is a "hero" to the cause of Chinese nationalism and imperialism.

Hero also communicates a message of Confucian harmony regarding male-female hierarchy through the female characters (Snow and Moon) who oppose Nameless's plan because of their love for Broken Sword. Their disagreements degenerate into violent combats that echo themes of yin-yang imbalance. The appropriation by female characters of macho attributes in combat reveals themes of gender rivalry to the point of misogyny, with strongly willed females as a threat to the paternalistic authoritarian system under Confucian harmony. In Chinese cinema masculinity and the national order are dependent on Confucian legal codes that favor masculinity in governing nation and family.[6] There is a long history of female protagonists and antagonists in Chinese film, particularly in the martial arts genre. In one of the earliest surviving martial arts films, *Heroine in Red* (1929), a woman becomes a martial arts expert and defeats a local

tyrant. Such plot formulas have become a staple of Chinese production. These plot mechanisms have been adopted recently by Chinese filmmakers such as John Woo in contemporarily set Hong Kong buddy films in which honor codes are threatened among both criminals and police and in which women actresses "embody the contestation of Confucianism."[7] Narrative conventions about gender rivalry, misogyny, authoritarianism, and a fantastic desire for the supremacy of the physical over the technological in a silent-era fantasy like *Heroine in Red* and in the more recent *Crouching Tiger, Hidden Dragon* (2003) or *Hero* have a deep resonance in Chinese history. The figure of female as a disruptive influence in dynastic cycles is an established topos in Chinese (and Confucian) historiography that tends to emphasize negative consequences of females in power. For example, upon Emperor Gaozu's death in the second century BC, real power went into the hands of an empress who killed off rivals and manipulated succession.[8] During later periods there was also an increase in castrated bureaucrats (eunuchs) in imperial administration who even gained the right to confer noble titles and adopt heirs.[9] The dowager empress Wu (625–705) vilified by historians started as a concubine and still suffers a reputation for being selfish and irrational.[10] In the Ming dynasty many emperors came to the throne as minors with power yielded by eunuch ministers and dowager empresses. According to the yin-yang harmony of Confucian ideals, such occurrences were indicative of a world out of balance. Negative characterizations of female figures in Chinese history have continued to contemporary times. The dowager empress Cixi was a key figure in Chinese political decline from the late nineteenth century until her death in 1908. The twentieth century had both the peevish Madame Soong May-ling, wife of nationalist General Chiang Kai-shek, and Mao Tse-tung's ambitious wife Jiang Qing, later tried in the Gang of Four show trials in the aftermath of the state-sponsored terror and mass starvation program of the Cultural Revolution (1966–76). This antifemale historiographical bias is also reflected in the demographics of this highly populated country where female births are not always welcomed as evident in the practice of female infanticide in times of natural calamities or shortage. Such practices became recent government policy with the one child policy of the current Chinese regime.[11]

In accordance with the alleged anti-Confucian campaign of the Maoist regime, there were films that questioned the practices of patriarchal China such as Yimou Zhang's antipolygamy film *Raise the Red Lantern* (1991). But this current also preceded the communist takeover as is particularly evident in the film *Springtime in a Small Town* first made in 1948 by Mu Fei, faithfully readapted in (2002) by Zhuangzhuang Tian. *Springtime in a Small Town* is a film about contrasts: male-female, Chinese-Western,

traditional-modern, rural-urban, ill-healthy, and impotent-vital. The original film was made before the definitive Communist takeover in 1949, and its remake retains relevance despite the changes in turn-of-the-millennium China. The resonance of the film is perhaps due to the manner in which it expresses the duality of yin-yang, harmony-imbalance themes in Chinese society. In *Springtime in a Small Town*, a sickly husband and dissatisfied wife live in a small town with the husband's younger sister and their servants. The man's illness seems to be psychosomatic, almost a reflection of the trauma and destruction suffered by the nation during the Japanese occupation of World War II. The plot evolves around the visit of the husband's childhood friend, a city doctor, whose attraction to his friend's wife upsets the previously shaky equilibrium between petulant wife and infirm husband. The Confucian harmony of the man's house was already in imbalance since he cannot, or will not, act as a virile agent for his wife and community. The city doctor, trained in Western medicine, arrives as a vibrant influence potentially able to redress the imbalance by introducing activity and vitality into a passive, sickly situation. *Springtime in a Small Town* climaxes with the husband's unsuccessful suicide attempt. The dissatisfied wife and Westernized doctor reveal the weakness of traditional Chinese cultural heritage faced with the competition of Western achievement in science and technology. The ultimate gesture of failed suicide by the husband is an attempt to restore the Confucian order of the household. The story recalls the carnival tradition in the West, where destruction spurs vitality, and an outcome of chaos is revitalization. The film may be set in the early post–World War II period, but the themes of contrast and conflict between tradition and modernity of mainly Western derivation have been a constant debate within China since the early nineteenth century. Such sentiments have periodically boiled over into revolt with the contemporary legacy of anti-Western impulses as expressed in the May 30th Movement of 1925 in which popular uprisings blamed China's ills on Western cultural, scientific or political, and military influence.[12] In *Springtime in a Small Town*, the challenge to authority is reversed from *Hero*. No longer is traditional Chinese society in charge, rather it is under assault from Western influences. However the reaction against this new hegemonic force does not come from the expected source of individual martial arts expertise. The sickly Chinese husband, whose nation had been subjugated to Japan during the war and now in peacetime is a subject to Western influences has no way, in terms of traditional narrative conventions, to counter the story line of a challenge to the ruling order from his dissatisfied wife. A film like *Springtime in a Small Town* may not have martial arts sequences and certainly does not succumb to the fantasy of the martial arts film. However even in *Springtime in a Small Town*, the nonverbal communication

between characters—husband and wife, the drunken dance between wife and visiting doctor—points to a level of physical communication that recalls the status duels in martial arts films. The husband, unable to dance with his wife, loses the umpteenth status contest to his friend, the Western-ized doctor whose ability with Western boogie woogie dance steps charms the wife.

Kung Fu Hustle (2005) by Stephen Chow is one of the highest grossing films in Chinese film history.[13] The film is party to the Hong Kong mar-tial arts genre, yet it retains the basic narrative signatures of Chinese film with themes of individual threat to patriarchal order and yin-yang imbal-ance due to female usurpation. The opening sequences depict an idealized Shanghai of the 1940s where the patriarchal order is not in the hands of an imperial state but rather under the control of criminal gangs who have the run of the local police station. Although much could be made of the political and ideological differences between mainland China and Hong Kong, at least in narrative terms the conflict between individual will and organized and sanctioned power seems to be a continuing thread in Chi-nese cinema.

In the film the leader of the Crocodile Gang tears a police station to pieces to rescue his girlfriend. The subjugation of the police to the gangster functions as a clear indication of the power enjoyed by the gang. When the rival Ax Gang appears, not only do they kill the Crocodile Gang leader, but they also brutally murder the gang leader's moll after she agrees to come with them. She is eliminated due to the inconsistency of her allegiance. Whether she had been in cahoots with the police in apparent betrayal of the Crocodile Gang leader or whether she had worked with the Ax Gang previously is not vitally important. The very fact that she worked as a potential threat to the dominant order, whether police or rival gangs, is enough of an affront to warrant her elimination as the narrative strikes a misogynistic chord early in the film.

After the elimination of the Crocodile Gang leader, the Ax Gang seems to rule Shanghai without rival. Then they cross a pair of middle-aged land-lords, former Kung Fu masters, who come out of retirement once the gang upsets the renters in their apartment block. The husband makes a yin-yang tracing in the courtyard of their renters' abodes. The wife, as seen in Fig-ure 1.1, emits an apocalyptic yell, upsetting the entire city. The grotesque characterization of the lady landlord is consistent with the misogynistic, even gynophobic characterization of strong women in Chinese film. The entire apartment complex had lived in fear of her wrath, which she now unleashes on the Ax Gang. Once the Ax Gang confronts her, she erupts, hairpins exploding in a leonine howl that shakes buildings to their foun-dations. In *Hero* authority was presented with due respect afforded to the

Figure 1.1 *Kung Fu Hustle* (2004, Hong Kong) a.k.a. *Gong Fu* . Credit: Sony Pictures Classics/Photofest © Sony Pictures Classics.

imperial aspirations of a legendary emperor, a theme dear to the political world view of Beijing regimes. *Kung Fu Hustle* removes the veneer of dignity from authority, first by making the police cower in fear when confronted with the gangs and second with characterization of martial arts heroes as an aging husband and wife along with their seconds, a hairdresser and a butcher. The heroes in *Kung Fu Hustle* lack the historical gravitas of the protagonists in *Hero*, but the narrative structure and cultural commonplaces are vividly similar in both films: misogynistic characterizations, aspirations of power facing opposition from individuals anointed with martial arts expertise. In both films the plot depicts a status quo that must confront challenges from anointed individuals whose martial arts abilities are evident not only of a physical advantage but also of spiritual and religious teachings. In *Hero* a segment of the film emphasizes the importance of writing for the creation of civilization in spiritual as well as material terms, a theme repeated by Yimou Zhang in the opening ceremonies for the 2008 Beijing Olympic Games. In *Kung Fu Hustle* spiritual elements are an essential part of the Kung Fu masters' art: from the spectral string instrument of the aging landlord to the acquisition of cloudy Buddha-like control by the ultimate hero of the film, the landlords' long lost son.

As the story continues, the Ax Gang arranges a jailbreak for the Beast, a bullet-stopping menace, in order to destroy the landlord couple. This Beast

character, like the aging landlords, actually seems like a harmless little fellow until he displays earth-shattering, bullet-stopping powers. But as stated above the film's real hero is the long-lost son of the landlord couple, previously presented as an incompetent oaf eager to join the Ax Gang. Once the son claims his martial arts birthright, he descends from the heavens blessed by a cloudy Buddha to reestablish patriarchal order. He defeats the Beast and the Ax Gang and extracts revenge not only for the abuse of his parents and their tenants by the Ax Gang but also to settle an old score. When he was a child, the Ax Gang had stolen a lollipop from his mute sweetheart and then urinated on him, an embarrassment seemingly at the heart of his loss of patriarchal legitimacy. Therefore besides expressing a certain proclivity for the cheapness of life, *Kung Fu Hustle* is a film about the reestablishment of patriarchal and Confucian order. When the son attains his Kung Fu super hero status and powers, harmony returns. His mother, the apocalyptically screaming landlady, an archetype for the negative, yin-yang upsetting female in Chinese film, gains a cooing, maternal composure. After the son wins final victory over the Beast and Ax Gang, he opens a candy story and reclaims his childhood sweetheart, a shy mute whose retiring demeanor contrasts to her screaming future mother-in-law. The son replaces the female figure whose wrath and power had signaled that the world was out of balance with her seeming opposite, a demure, unthreatening female.

Kung Fu Hustle is also important for the manner in which it attenuates the xenophobic currents in twentieth-century China, which identified Western technology and influence with colonialism and the defeat of traditional Chinese values and culture. *Kung Fu Hustle* features cameos of Hollywood icons, from Astaire-Rogers films in particular, which emphasize the similarity between the nonverbal communication in marital arts and classic Hollywood dance routines. The cameos offer a clear link between Western cinematic iconography and Chinese identity. In *Kung Fu Hustle* the martial arts fight sequences serve as a measure of power relationships between characters just as in classic Hollywood musicals the ability to sing and dance indicated prestige in status contests for a protagonist interested in wooing a love interest.

The martial arts combat sequences have choreography that removes elements of mechanized or technologically enhanced violence from consideration, as if they were indeed dance routines. This is a carryover from the Chinese theatrical tradition that involved acrobatics and dance displays as an aid to plot development. In Chinese martial arts films like *Hero* and *Kung Fu Hustle*, the physical body has power not only over the ruling hegemony it seeks to challenge and transform but also over technology and the very laws of physics. In a film like *Kung Fu Hustle*, the martial arts body

floats, bends, and is generally unconstricted by gravity. The fantastic aspect of martial arts sequences could simply be a preternatural fantasy for the reestablishment of the military and honor codes from Confucian culture predating Western technological military influences. In many martial arts films, especially those set in contemporary times, hand-to-hand combat is an ahistorical convention, and this may be a key to understanding the martial arts film's appeal as a confirmation of Chinese cultural heritage. China became subject to Western powers due to its technological backwardness into the eighteenth century. The martial arts lost currency as Western weaponry reduced the relevance of individual combat in mechanized warfare. Chinese interest or even fixation with martial arts has roots in ancient forms of theater and dance. But martial arts enjoy a central role in the entirety of Chinese cinema—not only in films calculated to span the borders of Chinese transnationalism and break into world markets.[14] Through marital arts, the yin-yang imbalance caused by Western technological dominance is put back into harmony. Individual skill can defeat any army because masculine power is not determined by access to weaponry but by the mastery of the ancient martial arts codes that, like the Confucian concepts basic to the formation of Chinese central government, predate Western influences. The point at which these influences come together is through female appropriation of martial arts mastery, a combination that touches upon themes guaranteed to resonate in a Chinese audience: the call to establish patriarchal authority for the collectivity under Confucian morality tempered by overt misogynistic apprehensions.

2

Finland's Rural-Urban Split

Scholarly investigations have no compunctions about identifying a rural essence in the Finnish cinema. A 1975 British Film Institute study of Finnish cinema provided the following generalization: "The atmosphere of Finnish cinema up to the 1960s was determined mainly by an agrarian outlook on life, according to which the city was a sinful place, since man has his roots in the countryside, in a life lived close to nature and in harmony with it."[1] This broad description was seconded more recently by Peter von Bagh in a survey of Finnish film history that identifies the thematic origins of the Finnish cinema as dependent on the themes of rural life first developed in Finnish literature.[2] When the Finnish film canon is examined in light of these comments, analysis reveals an oft-repeated narrative pattern of rural-urban contrast with deep literary, historical, and cultural roots.

The appearance of an officially sanctioned Finnish cultural and national identity is a relatively new phenomenon. The country suffered Swedish domination until 1809 and Russian imperial rule as an autonomous region until 1917 when the Finns finally gained the independence that they have stubbornly defended ever since, particularly in repelling Russian invasion in 1939, one of the initial events of World War II. Finnish cultural identity was finally emphasized in the nineteenth and early twentieth centuries by the country's intellectual elite with a focus on rural and agrarian roots as part of the national romantic period of the nineteenth century. The composer Jean Sibelius (1865–1957) explored musical motifs such as his *Finlandia* Symphony in a similarly nationally romantic vein. The poet Elias Lönnrot published the oral traditions of the national epic, the *Kalevala*, as late as 1849. During this period the Finnish language gained official status, as previously the official language had been that of the ruling Swedish nobility. To the present day there is a Swedish-speaking minority in Finland whose rights have been recognized and defended by the Finnish state. The first novel in the Finnish language, Aleksis Kivi's *Seven Brothers* was published in 1870. The painter Akseli Gallen-Kallela (1865–1931) exalted

Finland's rural and traditional roots in studies based on the national epic *Kalevala*. The establishment of a nationally sanctioned Finnish language was facilitated by these literary efforts that sought in the dialects of central and western Finland a koine that contrasted in grammatical severity and rational aplomb with the more free-flowing and creative dialects from Karelia in eastern Finland. The Finnish cinema, radio, and especially newspapers did much to promote the national tongue as Finns have historically enjoyed one of the world's highest *pro capite* relationships between printed media and population. During the early sound period, the fledgling Finnish film industry offered the nation a product in a standardized tongue that did much to reinforce the cultural commonplaces from the artistic and literary sources from the national romantic movement of the nineteenth century for the definition of a Finnish national identity.

The idea of the close relationship between the Finnish land and people became so ingrained that character traits and practices observed in rural Finland became treasured signs of national identity. The bucolic essence of Finnish national culture resulting from the national romantic period in Europe has always been contrasted and tempered by the aspirations of the Finns to maintain pace with the cultural and political currents of continental Europe. The capital city Helsinki became not only the nation's most populous city but also a magnet in the sparsely populated nation for internal migration, the development of industry, and educational structures. Nevertheless the Finns have guarded their bucolic origins with determination, with urban dwellers maintaining country homes deep in the Finnish wilderness so that the artificial veneer of urban living would never completely change the essence of the Finnish experience.

What has this meant for the cinema? The nineteenth-century high cultural interest in indigenous pastoral culture remained a mainstay of Finnish culture into the twentieth century and had a deep resonance in the conventions found in the narrative patterns in Finnish film from the early sound period to the present. Recurring and dominant plot lines in the Finnish cinema are stories of rural characters facing economic or cultural influences from the city. The flip side of this narrative convention are stories of urban characters displaced in the Finnish countryside who regain a sense of their identity after coming into contact with the pastoral essence of Finnish cultural heritage. Whether city-country story lines may be considered as a master narrative pattern for the Finnish cinema will depend on how extensive and long-lived such conventions have been in Finnish cinema from the early sound period to the present, whether these city-country themes are present in the work of noted Finnish directors, and finally whether films with such themes have been continually well-received and supported by Finnish audiences.

As with other regional cinemas, in Finland the industry adapted technical innovations and generic influences from abroad. However if a narrative pattern developed in the early sound period has continued to characterize Finnish film production thereafter, it would provide evidence of how national cinemas, including an extremely local and linguistically impenetrable culture like Finland, develop essentialist narratives that are not merely expressions of dynamic and shifting ideological or economic forces but that reflect a national culture. The Finnish film industry offers a hermetic case of one of the many mini-Hollywoods that rose in European countries during the early sound period.[3] Finland may have been at the vanguard in many artistic and technological sectors during the twentieth century—the cases of architecture or cellular telephone technology immediately come to mind. However, the Finnish film industry cinema was not characterized by any particular technical innovation. As with other regional cinemas, in Finland the industry adapted technical innovations and generic influences from abroad. By the 1930s the Finnish film industry established itself as a major voice in the country's culture despite the limitations of serving a total population fewer than 4 million. Once sound technology came into play, Finnish film companies were able to offer products to audiences in their native language without relying on government support, surviving on box office receipts of the domestic market. Other national cinemas, for example in France, Italy, and the United States, enjoyed varying degrees of success exporting their films. At times producers in these countries even catered products toward not only a national but also an international market, a situation not applicable to the Finnish film industry since the total number of Finnish films distributed internationally is so small. The few exceptions like the *Valkoinen peura* (*White Reindeer*; 1952), *Tuntematon sotilas* (*Unknown Soldier*; 1955), or recent Kaurismäki brothers' titles like *Mies vailla menneisyyttä* (*Man Without a Past*; 2001) have been so rare that international distribution has never been a reliable outlet for Finnish film producers and thus not a consistent factor in production choices. Thus the Finnish film industry, particular in the early sound period, is almost hermetic in the attention that it paid to the development of local, indigenous themes that imitated the essence of cultural heritage through narrative conventions in a standardized tongue for the propagation of a national culture. Given the course of Finnish history, the establishment of a Finnish national culture and state is an inherently fragile entity. The country's independence after centuries of foreign domination by Sweden and Russia is extremely recent and tenuous as the country's epic struggle to maintain independence in the face of Russian invasion during World War II demonstrated.

The Rural-Urban Split

The Finnish film industry offers a hermetic case of one of the many mini-Hollywoods that rose in European countries during the early sound period.[4] During the economic crisis of the 1930s, Finnish production was consolidated under two major production companies—Suomi Filmi and Suomen Filmiteollisuus. The concentration of production and reliance by the major producers on box office returns rather than state subvention meant that the Finnish film industry was quite sensitive to audience tastes. The rural-urban split was an important aspect not only in terms of narrative patterns but also for producers' tracking of spectator preferences. For example, Suomi Filmi kept box office records from the 1930s in sections divided between urban and rural box office results arguably in order to track potential differences between the urban and rural spectators.[5] The films that they produced were made under careful apprehension of losing the pulse of popular taste.

Of course, imagery and narrative themes based on the contrast between urban and rural life is a common theme in early world cinema, not limited to Finland. Chaplin's tramp character often worked in narratives where an innocent encounters and eventually overcomes the challenges of a hostile, urban setting. Walter Ruttmann's *Berlin Symphony of a Great City* (1927) offered dynamic imagery of a thriving metropolis that enthralled rural spectators whose first exposure to city life may have been via film. But such themes were not as prevalent in other national cinemas as they are in Finland where there has been a consistent reliance on literary sources that emphasize Finland's rural roots. Many early Finnish films made specific reference to the early classics of Finnish nation building with adaptations of literary sources centered on rural themes. This trend continued well after the introduction of sound in the 1930s. *Sylvi* (1913) based on the play by Minna Canth, directed by Teuvo Puro, and remade in 1944 by T. J. Särkkä, is the story of a May–December marriage gone awry. A naïve young girl marries an established city burgher whom she betrays and murders. In each film adaptation of the Sylvi tale, the unwitting young girl is introduced with bucolic imagery in contrast to the cityscapes that identify her unfortunate, cuckolded husband. Other early Finnish films examined the city-country contrast, including logging melodramas such as *Koskenlaski-jan morsian* (*Rapid Shooter's Bride*; 1923) from the novel by Väinö Kataja, directed by Erkki Karu, remade in 1937 by Valentin Vaala or *Ihmiset suvi-yössä* (*People in the Summer Night*; 1948), a melodrama in which the desire to leave the country leads to a senseless murder and the destruction of the main character. *Juha* (1937), directed by the *enfant prodige* (whiz kid) of early Finnish talkies, Nyrki Tapiovaara, based on the Juhani Aho novel

was remade by T. J. Särkkä in 1956 as a color film and remade in black and white by Aki Kaurismäki in 1999. The tragic story of *Juha* contains an oft-repeated theme of the sweet-talking outsider who arrives in a country setting and seduces a naïve Finnish girl. In the tale the appearance of an attractive, gypsylike wanderer brings out the potential threat to rural existence by defying the behavioral commonplaces of both rural and urban life. He is unwilling to remain in the countryside to farm the land. He is unable to exist in the city under the restrictions of the law and civilized behavior. The girl is attracted to his magnetic personality and the ensuing tragedy ironically reestablishes a sort of equilibrium between the two poles of behavior: rural and urban.

Perhaps the clearest example of this urban-pastoral conflict is *Sietsemän veljestä* (*Seven Brothers*; 1939), directed by Wilho Ilmari, based on the Aleksis Kivi novel about a group of simple and energetic country bumpkins who flirt with the trappings of civilization like literacy, sobriety, and religion. Kivi's novel is one of the foundational works of Finnish national culture with descriptions of character types and natural exuberance tempered by the requirements of civilization. These themes resonated with the populace of the young nation and have continued to be central to the concept of Finnish identity. *Pohjalaisia* (*Northerners*; 1925) by Jalmari Lahdensuo and remade in 1936 by Yrjö Norta and T. J. Särkkä is another literary adaptation, which like Kivi's *Seven Brothers*, is a sort of foundational tale of Finnish character. In the story a rural community defends itself against external influences including a group of roving toughs from a nearby village and a perfidious Russian overseer. *Kuin uni ja varjo* (*As Dream and Shadow*; 1937) by Yrjö Norta and T. J. Särkkä, based on the Eero Railo novel, follows a similar narrative tract. The arrival of an educated, young surveyor into a rural setting coincides with sexual awakening, questioning of religious values, and struggles with alcoholism where excessive drinking has the effect of creating an artificial mind-set in the Finnish male.

The two most critically acclaimed directors of the 1930s, Nyrki Tapiovaara and Teuvo Tulio, made films steeped with rural and natural imagery. In fact, the frequency of nature montages in their films perhaps indicates a style more indebted to the silent than sound era. Tapiovaara has been hailed as a lost promise of the Finnish cinema due to his untimely death at age 29 during the Winter War of 1939 with Russia. *Miehen tie* (*The Man's Road*; 1940) by Tapiovaara, based on the F. E. Sillanpää novel, repeats the theme of city-country conflict. A humble farmer marries the daughter of a landowning farmer who requests that his daughter's lands be returned after her death and the subsequent death of the couple's young son. After these tragedies, the distraught husband abandons his rural lifestyle and turns to the bottle. He loses contact with his sense of Finnish natural

culture and begins to frequent the local town where he finds trouble. In the finale his first love saves him by removing urban influences and restoring the rural equilibrium that opened the film. *Unelma karjamajalla* (*Cottage Dreams*; 1940) by Teuvo Tulio, based on the Henning Ohlson play, repeats a similar story line. After a montage of nature scenery, a young man racing in his carriage runs down a country girl carrying a basket of mushrooms. After impregnating her, he leaves for the city due to a quarrel over a family inheritance. After gypsies steal his son, the mother is accused of infanticide and imprisoned. In the final sequences the wayward hero returns to his rural home to his forgiving family and marries the girl as their son reappears. The threatening introduction of foreign elements (gypsies and city living) are eliminated for a return to rural equilibrium. *Yli rajan* (*Beyond the Border*; 1942) by Wilho Ilmari based on the Urho Karhumäki novel, is about the struggles of a couple divided by the Russo-Finnish border. The girl comes from a population of ethnic Finns who had long been subject to Russian rule. She agrees to cross the border to marry in expectation of the outbreak of war. However, she encounters a Finnish establishment indifferent to her plight. The film emphasizes the difference between the authenticity of the sentiments of the young couple and the intransigence of the town pastor who insists that her identity papers be in order before their marriage can be sanctioned by the Lutheran Church. The artificial requirements of urban culture provide the plot convention that must be overcome for the couple to achieve a happy ending.

In each of these films, narrative convention centers around conflict between rural characters struggling to overcome foreign or urban influences. In some films the rejection of rural values leads to tragedy as is the case of *Juha* and *Sylvi*. Other films feature a reestablishment of rural values as in *Koskenlaskijan morsian, Beyond Borders, Like Sleep and Shadow, Northerners, Man's Road,* and *Cottage Dreams.* In the case of *Seven Brothers*, a sort of foundational tale of Finnish nation building, the brothers' attempts to assume the guises of civilization through literacy, agriculture, and religious conversion eventually lead to economic success. Herein lays the key to understanding the narrative conventions in Finnish culture, and by extension, in Finnish film. In other narrative formats that feature a conflict between natural wilderness and civilization, such as the Hollywood western, according to Peter Wollen, the frontier is something that must be tamed and its savage essence brought under control. In a film like John Ford's *My Darling Clementine* (1946), the heroic sheriff must remove uncivilized elements to achieve the requisites for nation building and the possibility for a territory to become a state in the union.[6] In Finnish film, the uncivilized elements ironically derive from urban influences. The obstacles in Finnish film, alcohol, gypsies, inheritance squabbles, upset the pastoral

equilibrium of traditional Finnish life and provide the plot tension for the narrative conventions that resonated among the Finnish public.

Helsinki—An Invented Urban Finland

The narrative patterns developed in the Finnish cinema are dominated by cultural and historical assumptions that imply comparison between the rural hinterland and Helsinki, the port city that draws people from the countryside like an urban magnet. Even in films with totally rural settings, the influences of the capital city are never far from the thoughts and actions of protagonists as the other, urban world. The paradox is that the Finnish film industry of the early sound period and thereafter actually had to invent a cinematic Helsinki with the trimmings of an urban metropolis. Even after the turn of the millennium, the population of Helsinki proper hovers around half a million souls. This cinematic, urban Helsinki is a fiction, an artifice created to satisfy the desires of spectators who rewarded films with plots based on urban-rural themes. For example, the Finnish film industry used Helsinki as the backdrop for espionage dramas depicting the clandestine independence movement in the early twentieth century. In these films Helsinki exists as a place of mystery and contact with the continent. The rural essence of Finnish culture may be seemingly absent in these espionage thrillers set in the capital, and yet it is continually evoked. *Korkein voitto* (*Highest Victory*; 1929) by Carl von Haartman is the tale of a Finnish nationalist who falls for a girl who is actually a Russian imperial spy. However, when he takes her to the countryside, he is able to cure her of her urban and foreign affectations as well as her anti-Finnish politics. Removal from the insidious influence of the city transforms her, as indicated by the film's happy ending. The independence and espionage thriller *Varastettu kuolema* (*Stolen Death*; 1938) directed by Nyrki Tapiovaara is based on a Runar Schildt novel. During the tragic finale, the hero escapes the city on a horse-drawn sled, fleeing to the countryside with his wounded love interest. The city had been the place of intrigue, danger, and defeat, and in order to have a chance at survival the hero must leave the city entirely. *Aktivistit* (*Activists*; 1939) directed by Risto Orko has a similar narrative. The conspirators work within the labyrinths of Helsinki until their proindependence plots are foiled. They flee to a summer house in the dead of winter to make a last stand against Russian troops. *Jääkärin morsian* (*Soldier's Bride*; 1938), a half-silent, half-sound production starring the great Finnish actor Tauno Palo, follows a similar theme. The film opens with a chase scene on a frozen lake where the heroes have a shootout with a Russian patrol. Eventually the good-hearted Finnish lad played by Palo

saves a Russian girl from the urban influences of a decadent Russian noble-man as the film shifts between rural and urban settings in the backdrop of the Red-White civil war that followed Finland's independence in 1917. The Finnish cinema also produced sophisticated, romantic comedies set in an urban Helsinki that was largely a cinematic invention. *Mieheke* (*Surrogate Husband*; 1936) is a Valentin Vaala screwball comedy with montages of Helsinki city life that demonstrates how Finnish films created an urbane image of the capital city. In one sequence a young man asks a cab driver to take him to the night spots in Helsinki so he may find his secretary. The ensuing montage of city lights and Helsinki night life gives the impression of a sophisticated metropolis, which is again a cinematic invention. The film has plot conventions common in romantic comedies. The femme fatale, a film star, has appropriated urban and continental vices of promiscuity, drinking, and speaking French. The film even features a segment set in the offices of a fictional Finnish film production company as the boy's father enjoys the company of a vapid starlet. The scene plays up the commonplaces about affected urban culture in a creation of a Helsinki that existed in the imagination of rural spectators.

Juurakon Hulda (*Hulda from Juurako*; 1937), another comedy directed by Valentin Vaala, is based on another play by Hella Wuolijoki who, incidentally, began her career with a male pen name, Juhani Tervapää. The film was remade by Hollywood as *The Farmer's Daughter* (1947) with Loretta Young and Joseph Cotton. *Juurakon Hulda* could be read as a feminist version of Capra's *Mr. Smith Goes to Washington* (1939). But the film has a strong feminist undertow as an almost archetypal depiction of the urban-pastoral themes in Finnish cinema, in particular for the manner in which a female character is presented as the vessel of rural values. Just as Italy is identified geographically as a boot, Finland, geographically, until losing territory to Russia in World War II, had the shape of a woman, arms outstretched over a long, flowing skirt. This identification of Finland as a matriarchal culture needs to be emphasized, as Finland was among the first countries on the planet to promulgate female suffrage.

In *Juurakon Hulda*, the female protagonist is Hulda, a typical country girl's name. She leaves her family farm to flee the economic plight of the 1930s. Hulda takes the train to Helsinki in the company of a young man who promises to let her sleep at his sister's house. However, once in Helsinki he absconds with Hulda's money to go drinking. The urban setting is immediately identified with the loss of basic moral values that has a devastating effect on male characters. The arrival in the city leads to abuse of alcohol and the denial of traditional attitudes about thrift. Hulda, penniless and abandoned, sits on a park bench and is accosted by a group of politicians who mistake her for a prostitute. Again the city rather than the

countryside is the milieu that is uncivilized and dangerous. Hulda's straight talk and genuine country manner convince a judge, played by Tauno Palo, to hire her as a maid. In the judge's household Hulda demonstrates that she is physically stronger and mentally tougher than her city counterparts. She stands on a high ledge to clean windows, unafraid of heights. She does not mind working long hours and studies late into the night in an attempt to raise her class status and defeat the new wilderness, the city, where she now finds herself. When the judge expresses concern about the strain on her eyes reading in poor light, Hulda explains that her eyes are strong and accustomed to poor lighting. Yet exposure to the judge's socially elevated world gives Hulda an understanding of the power of education. She studies at the university and hopes to win election to parliament. However, the bleached blond rival for the judge's affections spreads rumors about Hulda's origins on the park bench, an allusion to prostitution, effectively ruining her political career. This stereotypical bad girl drinks and boasts of her frequent travels to France. Her urban values and the allusions to sexual appetites contrast with Hulda's steadfast refusal of the judge's attempts to make her his mistress. The climax of the film is Hulda's speech about *sisu* (Finnish for stubborn resolve). She describes suffering in rural Finland of ruined harvests, sickness, and death in a manner that leaves her city acquaintances speechless. However, even Hulda cannot entirely overcome the negative influences of the city. After defeat in the election Hulda arrives at a party and starts drinking heavily, copying the dress and manner of the city girl. The judge, alarmed at her abandonment of rural values, proposes marriage despite her protests. The ending of the film is indicative of a feminist current in Finnish cinema and culture. In the film's last lines the judge states that he will not send his aunt away just because he is to marry Hulda. Someone will have to look after the children after Hulda is elected to parliament.

Although there are no definitive box office statistics in Finland for the 1930s, production figures have led to estimates that up to one million spectators viewed *Juurakon Hulda*, a colossal figure for a country whose total population at the time was about four million. This popularity gives an indication of how deeply the themes in the Hulda story resonated with the general populace. The move from country to city, the victory of rural values of hard work and stubborn perseverance against the falsity of urban affectation are a crystallization of Finnish collective consciousness of the time. The Hulda character also embodies the ideal of the "perfect blond" superwoman in a country where parity between male and female was not the result of politically correct posturing but of recognition of the undeniable strengths of Finnish women.

A male version of Hulda is the sports fantasy *Avoveteen* (*Into Open Water*; 1939) by Orvo Saarikivi. In *Into Open Water* a young man leaves the country for Helsinki, although not before impregnating his girlfriend, incidentally played by Irma Seikkula, the actress who starred as Hulda in *Juurakon Hulda*. Unlike Hulda, the young hero is unable to apply his rural values in the city. After he is swindled, he begins to adapt to urban behavior and tells a series of lies in order to find employment. His break comes when he chases a bus to go home and overtakes a group of athletes doing road training. As in *Juurakon Hulda* there is a Darwinist undertone in the film, especially during the sports fantasy finale when he wins a track race in the Helsinki stadium. The clean living and steadfast character of the rural character provides a natural advantage over city folk. In the 1930s the Finnish state placed cultural resources in areas other than in film, most notably in sport with an application to host the 1940 Summer Olympics, eventually held in 1952. The young man's track victory allows him to return home as a hero and reclaim his love interest and son. As in *Juurakon Hulda* the vitality of the country wins over the falsity of the city.

Another Vaala film, *Rikas tyttö* (*Rich Girl*; 1939) repeats the urban-rural theme in a class tension melodrama. A seemingly spoiled rich girl runs over a humble girl with her horse. The poor girl, again played by Irma Seikkula, heroine of *Juurakon Hulda*, displays such aplomb that the rich girl is deeply embarrassed and decides to improve her behavior. The encounter with the country girl, combined with a life-threatening illness of her father, changes the rich girl's attitudes. The film ends on an optimistic note. At the family country home, under the windows of her convalescing father, the girl's entire family expresses thanks for their blessings in the Finnish countryside.

Anu ja Mikko (*Anuu and Mikko*; 1940) is a rural drama by Orvo Saarikivi, based on the Kertsi Bergroth play remade in 1956 by Ville Salminen. The hero Mikko goes to Viipuri, the second most populous city in Finland before Russian conquest and annexation during World War II. Once in Viipuri, he finds work in a factory but is swindled in a manner similar to the recently arrived country bumpkin in *Into Open Water*. Mikko returns to the village with the lessons learned in the city to start a factory and marry his sweetheart. The conflict in the film arises from Mikko's agreement with a city bank that threatens the participation of the villagers who doubt Mikko's project mainly due to his involvement with a bank. The film also includes a village expatriate returned from New York dressed in finery and jewels intent on finding a husband. She describes the skyscrapers and modern civilization of New York to a throng of curious villagers. The city-country drama is emphasized by the reactions of the man to be swindled in

Viipuri and the unsure although admiring reactions of the villagers to the expatriate's tales of American wealth. *Suomisen Perhe (The Suomisen Family*; 1941) by T. J. Särkkä is set in Helsinki but abounds in themes of Finnish connection to genuine agrarian values. A family man arrives home and smells the air and declares his delight at finding his wife preparing pea soup, a clear expression of his appreciation for simple Finnish cuisine. Conflict arises when a former school chum whose every fourth or fifth word is in English tempts him with shady business deals that unsurprisingly go awry after the two go on a drinking binge. Just as in *Anu ja Mikko*, with the affected Finn visiting from New York, in the early 1940s Anglo-American influence was seen as negative in a Finland increasingly under the political sway of Nazi-Germany. Under the financial strain of the father's business mistakes, the family begins to fall apart. The elder daughter falls prey to film producers whose affected manners represent the apex of urban artificiality as in *Surrogate Husband*. The film ends as the mother reunites the penitent family members for a return to their authentic values symbolized by another meal of pea soup.

The city-country theme continued after the war. *Rakkauden risti (The Love Cross*; 1946) is a Teuvo Tulio film in which an innocent girl lives in a remote lighthouse with her father. She falls for a shipwrecked stranger who takes her to Helsinki where she becomes a prostitute and eventually kills herself. In a final dream sequence this ideal blond is portrayed in mock crucifixion, the victim of the evil influence of city life. The arrival of the stranger and the girl's descent into the squalor of city life is a continuation of the city-country conflict at the heart of Finnish film narrative.

The creation of a cinematic urban Helsinki is also clear in the Inspector Palmu detective series of the early 1960s, directed by Matti Kassila and based on the novels of Mika Waltari with a heavy debt to Georges Simenon's Maigret series. *Kaasua, komisario Palmu! (Step on the Gas Inspector Palmu*; 1961) opens with a zoom of the fashionable Swedish waterfront district in Helsinki where the well-kept buildings contrast with the docks set aside by the city for summertime rug washing in the Baltic Sea, a rural pastime still accommodated by municipal authorities. The sets of the films, including Palmu's office, feature window views of the dome of the Helsinki cathedral, as if the dome were clearly visible from multiple locations in the city. The murderer eventually kills himself in a penthouse, which set designers decorated with a panorama of urban skyline. The plots of the Palmu series invariably center on urban characters whose affected behavior is decoded by the simple-mannered, straight-talking detective.

Matriarchy and the Motherland

Part of the city-country dichotomy lies in the matriarchal societal setup in many films. The Finnish motherland, the home, is often represented under the control of a female figure. The male, more apt to the pitfalls of alcoholism and the sacrifices of war is less frequently identified with cultural and societal stability. *Niskavuoren naiset* (*Women from Niskavuori*; 1938) directed by Valentin Vaala is based on the Hella Wuolijoki play and was remade by the same director in 1958 and again in 1984 as *Niskavuori* by Matti Kassila. The Niskavuori tale is a melodrama about the arrival of an attractive city girl who upsets the equilibrium of a rural Finnish town. The finale confirms a matriarchal organization in Finnish society. The man leaves with the new woman but society remains intact since matriarchal structure has not been altered. One of the final films of the Niskavuori series was *Niskavuori taistelee* (*Niskavuori Struggles*; 1957) directed by Edvin Laine in which the Niskavuori matriarch finally passes away. As with other films in the series, and in Finnish cinema in general, plot conflict arises with the introduction of an urban influence, the illegitimate son of the matriarch's husband who arrives from Helsinki and is able to reconnect with his origins.

Matriarchy is not always identified with rural values. *Evakko* (*Evacuees*; 1956) by Ville Salminen is based on the Unto Seppänen novel. The Russian invasion of World War II brings an abrupt introduction to the impersonality of city life for evacuated villagers whose homes were burned by the village elder under orders from the Finnish army. In a key scene a young woman whose family has fled the Russian invasion in Eastern Finland is treated poorly by the well-to-do mother of her fiancé. The rural values of cooperation and reciprocal respect that allow the refugees to face their predicament are contrasted with the cold reception of an urban matriarch.

Kulkurin valssi (*Vagabond's Waltz*; 1941) written by novelist Mika Waltari and directed by Särkkä is another seminal film in Finnish film history and the only film of the 1940s to rival the popularity of *Juurakon Hulda*. A Finnish nobleman, played by Tauno Palo, living under Russian rule in the nineteenth century must go into hiding after killing a Russian in a duel. The decision to hide in Finland surprises his seconds, but going to Finland also means leaving the corrupting influence of city and foreign life—the gambling, drinking, and dueling that led to his predicament. Once in hiding he undergoes a series of masquerades: as a music conservatory student, circus performer, gypsy, and finally a footman. In each of these masquerades, he comes into contact with the common people of Finland. His ability to win the girl in each situation is a testament to his natural abilities. But his downward-class bounding points to a variation of the city-country

theme. The Finnish nobleman in hiding learns about life at all levels of society. In the conclusion he wins the heart of a rich girl and steals her away from an unwanted engagement banquet to a vain suitor whose affectations personify the artificiality of urbane living. Matriarchy is restored when the mother of the nobleman in hiding commands the rich girl to kiss and marry him even though he had masqueraded as a gypsy footman. In *Vagabond's Waltz* matriarchy may not be identified with rural life, but the film still relies on the urban rural split as a narrative basis. The colossal popularity of the film during World War II may be explained in superficial terms by the frequency of banquet scenes that appealed to a populace suffering the deprivation of wartime rationing.

The Postwar, Urban-Rural Split: From *Unknown Soldier* (1955) to the 1980s

The urban-pastoral narrative themes continued into the 1950s. A remarkable example of urban-rural themes is in *Villi Pohjala* (1955), a film that could be read as a Finnish western musical farce anticipating Joshua Logan's *Paint Your Wagon* (1969). The hero wears the facsimile of a Daniel Boone–type coonskin cap and confronts swindlers in a logging town in remote Finland. The film is a musical farce but it is based on a narrative of the conflict between pastoral and urban life. The love interest is a city girl won over by Villi's genuine nature.

The rural-urban split is also evident in the highest grossing Finnish film of all time, *Tuntematon sotilas* (*Unknown Soldier*; 1955) by Edvin Laine, based on the Väinö Linna novel. Like *Juurakon Hulda* and *Vagabond's Waltz*, *Unknown Soldier* is a key cultural document for the identification of possible narrative patterns within Finnish cinema. There is a rich tradition in Finnish war films whose themes begin in the silent period with the espionage films mentioned above. Laine's *Unknown Soldier* (see Figure 2.1) appeared in the mid-1950s when the nation was finally distilling the experience of defeat in World War II. The city-country theme is at the basic structure of the film in a manner that recalls Hollywood treatments of the subject such as *Sergeant York* (1941) by Howard Hawks.

When *Unknown Soldier* opens a platoon of Finns from all over the country finds itself faced with the challenges of nature, marching off into the forest to fight a faceless Russian military. Their first encounter with a city is when the Finnish army takes the Russian town of Petrozavodsk. The troops meet Russian women and get drunk in scenes that owe much to military farces like *Jess ja Just* (1941), which portrayed good timing Finnish soldiers getting the better of a stern Russian female commissar. The

Figure 2.1 *Tuntematon sotilas* (1955, Finland) a.k.a. *The Unknown Soldier* .
Credit: Sveafilm/Photofest © Sveafilm.

city-country conflict and its importance to the narrative structure of *The Unknown Soldier* are clear in the middle section of the film. The men are forced into a hastily constructed trench city for the winter, and the introduction of a faux urban reality spells doom for morale and foreshadows the fate of the Finnish army. After a further stall in fighting, the men make a home brew while the officers indulge in bottled liquors. Thus the equation of urban living and alcohol abuse extends to Finnish war movies. There is a confrontation between Rokka, the Karelian farmer hero, and Lamio, a straight-laced officer who disdains the folksy attitudes of some of his men and believes army rules and regulations to be the bastion of civilization. Even though Rokka is his elder, Lamio insists that Rokka address him as "sir," a break with country etiquette in which age is respected. When Lamio threatens Rokka with court martial, Rokka captures a Russian officer, proving his ability to conquer the ultimate threat to Finnish identity. The tense truce between Rokka and Lamio underscores the two mind-sets in Finnish culture: a reliance on traditional peasant culture in contrast to the pull of modernity and the rule of civilization and civic order. When Rokka is wounded and taken from the field of battle, the war is lost. The rural essence of Finnish national identity gives way to foreign aggression.

The film companies that formed the mini-Hollywood centered in Helsinki began to decline in the 1960s due to a series of actors' strikes and competition from television, a phenomenon that first affected Hollywood and then spread to other national film industries with the increasing affordability of television sets. The decline of the Finnish film industry actually led to experimentation, allowing some Finnish directors to apply continental influences to Finnish settings. Maunu Kurkvaara's *Yksityisalue* (*Private Territory*; 1962) is about personal alienation in a manner that recalls Michelangelo Antonioni's films like *L'Avventura* (*The Adventure*) (1959) or *Il deserto rosso* (*Red Desert*; 1964). In *Yksityisalue* an architect commits suicide in his country house. The film presents the personal crisis of a man successful in architecture, a field where Finland was internationally recognized due to the efforts of Alvar Aalto and Eero Saarinen. The choice of a death in a summer cottage becomes emblematic of an urban life that gave no satisfaction.

As may be expected, Finnish filmmakers also explored themes of sexual liberation in the 1960s. *Käpy selän alla* (*Under Your Skin*; 1966) by Mikko Niskanen, is about a group of city youths camping in the countryside. Their bucolic interlude of sexual exploration and liberation breaks when they are forced to return to Helsinki. Such themes were also explored by Risto Jarva, another promise of the Finnish cinema who like Tapiovaara also died young. Jarva's *Työmiehen päiväkirja* (*A Worker's Diary*; 1967) uses an experimental cinematic style reminiscent of the French New Wave. His brutal honesty in the exploration of the myths and commonplaces recall the films of Pasolini. The alienation of a young man in his factory job is juxtaposed with images of his father during the war, but the point of contention is modern city life. The theme of urban corruption was common in other Jarva films like *Kun taivas putoaa* (*When the Heavens Fall*; 1972), a film about a physiotherapist ruined by a tabloid picture that insinuated that she had a relationship with a politician. Jarva's most important film, *Jänikisen vuosi* (*The Year of the Hare*; 1977) based on the Arto Paasilinna novel, is a clear example of the persistence of a pastoral tradition in the Finnish cinema. However, the agrarian themes are updated by Jarva through references to the green ecological movement and the youth rebellions of the late 1960s. The main character is an ad man who must invent a campaign to sell aerosol spray cans. When his taxi accidentally grazes a rabbit, the ad man resolves to abandon his urban existence to dedicate himself to the wounded animal. Unlike the films from the 1930s, the alternative to the city is not an agrarian life with the formation of a stable pair bond according to the precepts of national romanticism. Instead the ad man seeks a more archaic existence, as a hermit in the woods and lakes of Finland. The film has supremely evocative moments. The ad man and a cab driver abandon

the pace of modern life to gather herbs to cure the rabbit's constipation. In the concluding sequences the ad man blacks out after a drinking binge and wakes up in the company of a woman lawyer who, with typical Finnish matriarchal efficiency, informs him that she solved all of his legal problems while he slept. When he sees that she has also put the rabbit into a cage, he flees to the woods with the rabbit.

Täältä tullaan, elämä (*Right on Man*; 1980) directed by Tapio Suominen is a film about disillusioned youth in the early 1980s that could be read as juvenile version of Jarva's *The Year of the Hare*. In Suomisen's film an alienated boy runs away from home and encounters the brutality of city life in Helsinki near the train station. The boy's only positive influence is a pet store owner who allows him to keep a hamster, a child's version of Jarva's rabbit and a symbol of connection with the natural world.

The Kaurismäkis

The most successful and internationally recognized Finnish filmmakers are the Kaurismäki brothers, Mika and Aki, who began their careers working together but by the mid-1980s had formed their own production companies. Despite their attempts to reclaim a space in the traditions of European art cinema, the Kaurismäkis share a thematic tendency of introducing urban or foreign elements in plots that recall the city-country tradition in Finnish cinema. An early collaboration, *Arvottomat* (*The Worthless*; 1982), directed by Mika Kaurismäki and costarring Aki, is an urban alienation film that alternates between city and country locations. Life in the city is a compromise and a defeat for the stoic Finnish male played by Matti Pellonpää. In the film's concluding sequence, the main characters avoid gangsters and the law by meeting at the Paris train station, ironically leaving one set of urban challenges for another. The solitary aplomb of the Finnish protagonists in their films must be read in the tradition of the pastoral-urban conflict in Finnish film history where the Paris of *Arvottomat* is a paradoxical metaphor for an escape from the challenges of urban Helsinki.

Mika Kaurismäki would repeat these plot schemes in *Rosso* (*Red*; 1985) in which a Sicilian hit man travels to Helsinki on assignment. He also abandons the city in order to avoid having to carry out the contract on his girlfriend. He meanders in the woods of northern Finland, unable to betray his ex-girlfriend until he is in turn killed by a proxy sent by his employers. Mika Kaurismäki's *Zombie ja kummitusjuna* (*Zombie and the Ghost Train*; 1991) is a story about an alcoholic bass player who eventually moves to Istanbul where he can afford to be a drunk. Like the Paris of *Arvottomat*, or the Lappish settings of *Rosso*, the main character escapes urban life.

The more recent example of a Kaurismäki urban-country conflict film is Aki Kaurismäki's *Mies vailla menneisyttä* (*Man without a Past*; 2002). This film won the grand prize at the Cannes Film Festival and is worthy of the best De Sica-Zavattini collaborations like *Miracolo a Milano* (*Miracle in Milan*; 1951). Like the protagonists of *Juurakon Hulda* or *Into Open Water*, the protagonist of *Man without a Past* comes to Helsinki to flee an uncomfortable reality in northern Finland. However, at the Helsinki train station he immediately encounters the hostile and seedy side of city life. He is beaten so severely that he loses his memory and is left for dead on a hospital gurney. He rises with a bandaged face and is nursed back to health by a family living in an abandoned railway car. He then falls in love with an aptly employed Salvation Army volunteer. Several key scenes point to a continuity with the bucolic themes in Finnish film history. In two sequences the man plants potatoes near the boxcar that is his new home in Helsinki, careful to keep several potatoes as seeds for the next planting. The postindustrial outskirts of abandoned factories in Helsinki become a pastoral setting. In another sequence he meets a construction company owner who robbed the bank that ruined his company in order to pay his debts to his workers before committing suicide. The rural code of debts owed and promises made resonate in a film where the division between country and city, between genuine and pastoral existence, are the focal points of the narrative. Once his memory is restored, the man chooses his new life in the city over his former existence in northern Finland. His discovery of love and friendships in subproletarian Helsinki is a re-creation of pastoral community that contrasts to his ex-wife's comfortable suburban abode in northern Finland. In Kaurismäki's film northern Finland is ironically depicted as rich and impersonal. In contrast subproletarian Helsinki is a vibrant community of Salvation Army dance bands and homeless vigilantes.

Uuno Turhapuro and Rural Triumph

The most ubiquitous Finnish series of the postwar period was the decidedly low brow, if brilliant, Uuno Turhapuro series produced by Spede Pasanen. The name "Uuno Turhapuro" roughly translates as "Numbskull Empty Brook."[7] Yet the name Uuno, as indicated in the title song to the series, is also similar to the Italian for the number one, *uno*. Uuno may be a rough numbskull, but he is also number one—the best.[8] The Uuno character is a paradoxical resurgence of an archaic Finland and the common lower bodily instincts of the historic peasantry. Uuno's appearance on the national entertainment scene in the mid-1970s came during a period when

women's magazines criticized Finnish men for being less loquacious and charming then their southern European counterparts.[9] Uuno's costume of permanent razor stubble and torn fishnet t-shirt recalls the animal-like characters of the premodern, commedia dell'arte theatre tradition. Like Harlequin or a commedia dell'arte clown, Uuno's apparent goals are to avoid honest labor and to scheme for free meals and adult beverages. Yet Uuno is also the heir to a long line of rural Finnish film protagonists whose clever schemes triumph in Helsinki. Uuno arrives from the countryside and outwits his urban counterparts. He marries the daughter of a wealthy Helsinki businessman in *Häpy endkö? Eli kuinka Uuno Turhapuro sai niin kauniin ja rikkaan vaimon* (*Happy Ending? How Uuno Turhapuro Got Such a Rich and Beautiful Wife*; 1977). He tricks a zoning board to save his father-in-law's summer cottage in *Uuno Turhapuro muuttaa maalle* (*Uuno Turapuro Moves to the Country*; 1986). He buys a violin kit and becomes a world-class violinist in the first film in the series, *Uuno Turhapuro* (1975). He feigns a nervous breakdown when he realizes that his fame as a great artist has made his friends shun him as an urbane snob. Despite his poor dental hygiene and unkempt appearance, he also has no trouble in courting women in *Uuno Espanjassa* (*Uuno in Spain*; 1985). He becomes president of the republic *Uuno Turhapuro, Suomen tasavallan herra presidentti* (*Unno Turhapuro President of the Finnish Republic*; 1992), a secret agent *Uuno Turhapuro kaksoisagentti* (*Uuno Turhapuro Secret Agent*; 1987), and a comically successful business man in *Johtaja Uuno Turhapuro - pisnismies* (*Boss Uuno Turhapuro Businessman*; 1998). Like Hulda, Uuno may initially appear to be a dupe, but his abilities are infinite. He is another country lad who conquers Helsinki.

Uuno is the direct heir of male figures in comedies like *Aatamin puvussa ja vähän Eevankin* (*In Adam's Shoes and a Little in Eve's as Well*; 1931), the first Finnish sound film remade in 1940 and 1972 about two men who lose their clothes on a hot summer day. Uuno's domestic pranks also recall the henpecked husband comedies like Tapiovaara's *Herra Lahtinen lähtee lipettiin* (*Mr. Lahtinen Sneaks Off*; 1939) or the *Lapatossu* (1937) series films about a crafty male who tries to avoid regular work. Uuno is also an heir to musicals like *Rovaniemi markinoille* (1951) in which bucolic jokesters gain the upper hand on more urban characters who have underestimated them.

The most popular of the Uuno films was an army farce, *Uuno Turhapuro armeijan leivissä* (1984). The tradition of military farces began with films like Särkkä's *Rykmentin murheekryyni* (*The Regiment's Black Sheep*; 1938) or Orko's *Jess ja just* (1943) where the Finnish army represents precisely the sort of civilizing influence that crafty Finnish men must deconstruct. Military farces worked to attenuate the tensions of a populace under threat

of Russian invasion, yet they also continue the rural-urban division within Finnish cinema. The main characters in military farces are often a pair of wisecracking soldiers who combine as a national unit in plots that often poke fun of the foreigners (Russians) who pose a threat to Finnish identity. The soldier comedians of *Jess ja just*, for example, are steeped in common-sense antics as bucolic jokesters misplaced in a war.

Given the numerous examples of city-country themes from the Finnish cinematic canon cited above, this narrative pattern seems to be an imbedded characteristic of Finnish production. Instances where films in the Finnish canon do not fall back on a city-country theme are the exception rather than the rule. A superficial explanation of this continued pastoral romanticism might claim an influence from continental expositions on the same theme dating back to Rousseau or determine that the films are a result of hegemonic conditioning due to the centrality of Helsinki in national economic and social life. However, the bucolic insistence in Finnish culture and cinema is due to deeper factors such as geography, migration patterns, and a collective historical consciousness that is more profound than other theoretical, philosophical, or ideological considerations. In the Finnish cinematic narrative, the return to equilibrium is often enacted through stories that emphasize the bucolic and urban split in contemporary Finnish culture, a narrative pattern resolutely ensconced in popular Finnish cinema, culture, and history.

3

A Certain (Suicidal) Tendency in French Cinema

One of the highest grossing domestic films in the history of French cinema is *La Grande vadrouille* (*Don't Look Now We're Being Shot At*; 1966) directed by Gérard Oury. The film recalls the narrative of the famed, long-running comic book series *Asterix and Obelix* in which a bubbling pair of mismatched Gauls delight in tricking an incompetent conqueror. The film relies on slapstick and visual gags arising from the difference in height, class, and disposition between a comic pair: an orchestra conductor played by Louis de Funès and a house painter played by Bouvril. The film touched a chord in a France that welcomed a comic portrayal of victory over the Nazi Germans as a Gallic rather than American and Russian exploit. *La Grande vadrouille* also comforted a nation under true generational duress in the aftermath of the Algerian War as the republican culture of France would be challenged by Maoist currents during the student protests of the 1960s. The film also is of key importance in French cinema history. *La Grande vadrouille* is the best example of a film rewarded at the French domestic box office that contrasts to the narrative favored by the French cultural elite's tendency to produce and critically praise films that are not box office draws. French films that were critically lauded and promoted since the 1930s are almost uniformly absent from the nation's all-time box office rankings. Under elitist cultural influences, the French cinema has promoted and subsidized films since the 1930s that at their heart are based on tragic elements thematically light-years away from the farce history of *La Grande vadrouille*. In fact one of the few French films to seriously challenge the reign of *La Grande vadrouille* as domestic box office champion is *Bienvenue Chez les Ch'tis* (*Welcome to the Sticks*; 2008) by Dany Boon, a comedy that celebrates the genuine vibrancy of French regional culture.

Dudley Andrew has noted the frequency of Tristan or Werther-like narratives in 1930s French cinema, describing a cinematic template based on currents of identity and nationalism as part of a wider cultural phenomenon during the World War II period.[1] When the French film canon is examined in light of Andrew's comment, analysis reveals the persistence of an entrenched narrative pattern that draws from deep-seated literary, historical, and cultural sources that consolidated during the early sound cinema of 1930s and has continued to define the French cinema in the work of noted directors across genre divisions. The early sound period reveals an often-repeated narrative pattern in the French cinema that recalls Albert Camus's statement in *The Myth of Sisyphus* (1942) that suicide is the only truly serious philosophical issue worth considering. Perhaps due to romantic and later existentialist philosophical influence into French culture popular in the prewar period, the early sound French cinema produced important films that have taken up Camus's proposition with a story line similar to Goethe's tragic and suicidal *The Sorrows of Young Werther* (1774) or the similarly tragic Tristan and Isolde tale. In many important films in the French canon, the protagonist faces difficulties often of a romantic nature, which remain unresolved until the protagonist suffers severe setbacks, even suicide, as an expression of a reaction against an indifferent world. The French cinema has cinematic traditions in terms of economics, directors, or genre, which may function as allegories or projections of identifiable political representations through genre or stars.[2] But given the frequency of doomed protagonists in important films, the French cinema also has a narrative tendency that filmmakers may accept, ignore, or even be completely unaware of but that seems to be an imbedded and identifying characteristic of French cinematic culture.

The development of French culture has been undoubtedly determined by the rise of the capital city of Paris as a cultural and political mecca. In terms of geography the vast plains surrounding Paris from the Beauce to Normandy have effectively made the capital city a magnet for national development and for centralized authority after the consolidation of the French monarchy following the Hundred Years' War (1336–1453). The source of a self-destructive narrative in French cinema could be read as a larger expression of the historical defeats of French nationalism and imperialism in the modern period and particularly the decline of French imperial opportunities following defeat in the Seven Years' War (1756–63). Defeats continued in the failure of Napoleon's attempt at world conquest in the early nineteenth century. Had Napoleon been victorious, one may speculate that Abel Gance's silent epic *Napoleon* (1927) could have planted the seed for the sort of victorious national narrative for France along the lines of the Hollywood three-act drama with its goal-oriented protagonists.

In fact with *Napoleon* Gance originally planned an epic retelling of Napoleon's entire career but only completed a recounting that ended with the successful Italian campaign. One may speculate that had Gance known of Napoleon's recently revealed suicide attempt in 1814, as reported by his general Caulaincourt, that even *Napoleon* may have taken a more suicidal turn.[3] In any event Gance's film ends well before the spiral of defeats that would continue in French history from the sale of Louisiana, Waterloo, the 1870 Siege of Paris, Vichy, Vietnam, Suez, and Algeria. Ultimately French national cinematic narrative could be interpreted as a romantic expression of the need to enact a sacrifice as a stubborn expression identity in the face of seemingly inevitable and continuing defeats. French history also has a current of violence that has retained a place in public consciousness and influenced French literary culture such as the September Massacre of 1792 during the revolutionary period or the St. Bartholomew's Day massacre of Huguenots (Calvinists) in 1572.

There is a French literary tradition of seventeenth-century tragedy as the doomed Gérard Depardieu character recites in Claude Berri's *Uranus* (1990). The works of Racine such as *Phaedra* have themes of suicide, although Corneille features moral growth rather than suicide, one of the principle differences between the two authors. There are further literary origins to this narrative sequence in the works of Chateaubriand such as *René*, Hugo's *Les Misérables*, Rostand's *Cyrano de Bergerac*, Balzac's *Les Illusions perdues*, Zola's *Thérèse Raquin*, Flaubert's *Madame Bovary*, and Malraux's *La Condition humaine*, to name only a few examples.[4] There is an abundance of doomed intellectual heroes in French novels from the decline of the Romantic period to the decadentist, naturalist, and existentialist periods.[5] Rather than solely literary, the self-destructive narratives in French cinema could be read as a larger expression of the historical defeats of French nationalism, a romantic expression of the need to enact a sacrifice as a stubborn expression of identity in the face of continuing setbacks.

Like the other countries studied herein, the French cinema has also had a role in the propagation of a national language. The diffusion of the French language (*langue d'oil*) of northern extraction rather than the southern (*langue d'oc*) occurred centuries before the advent of the cinema. The push for a national standard in language and culture occurred in France in a manner similar to other European countries where the bestowal of approval by the royal court whose power center was in Paris helped establish the commonplaces for a national culture, including the move toward a standardized tongue. France was arguably at the vanguard in terms of identifying itself as a nation due to the pull of the royal court and later due to the romantic and messianic strain of nationalism in the Napoleonic era. The nationalism first expressed successfully in France was taken up

as an example across the planet thereafter as many of the conventions of national cultural governance have French roots. Other European nation-states actually lagged behind France, not even introducing the concept of citizenship until the early twentieth century.[6] However, it must be remembered that France too has its regional cultures. The *Académie française* in defense of the French language was founded as early as 1635, yet during the revolutionary period reportedly only 15 of 83 departments actually spoke what Parisian bureaucrats could recognize as standard French.[7] The promotion of a linguistic French identity has been taken up by French elites as a global civilizing mission, perhaps as a vestige of the period of vitality in French literature and science in the eighteenth century. The idea of a civilizing role for French culture could also be seen as a rationalization for French colonialism and a manner to defray the pain of the defeats of French imperialism by which military and political setbacks have been attenuated by propagating the cultural imperialism of *civilisation française* (French civilization). Of course much of the expansion of French culture between the seventeenth and twentieth centuries was quite voluntary, as French culture enjoyed remarkable attractive power in the period following the French Revolution and the Enlightenment. Expatriate artists from Chopin to Picasso took up the cultural banner of Voltaire's France to become important figures in French culture. Many of Europe's ruling classes were openly Francophile in the period before World War I and remained so even until World War II. In the early twentieth century, this tradition of French cultural exceptionalism continued with the development of modernism in painting, art, music, and dance centered in Paris. The French cinema and in particular French sound cinema is heir to a cultural patrimony that saw in French culture a heritage of exceptionalism and achievement. The concept of *francophonie*, the idea of cultural identity based on the French language, has been the center for the attempts by French governments to assimilate immigrant groups as well as promote French cultural achievement so that the idea of French identity is not based on an individual's physical attributes or ethnic origins but on the assumption of the cultural codes of French lay civilization. The promotion of the grandeur of French culture has been a means to retain the international prestige associated with French culture in previous times. Thus the French sound cinema not only had to promote a common national culture based on the French tongue but also had a role in the continued diffusion of French culture worldwide. For the cinema this has meant that the French cinema industry has been less concerned, at least in critical and historiographical terms, with box office results than other national cinemas. This concept of a special cultural heritage has also meant that whether consciously or not, the French cinema has produced a canon in evident opposition to the world's

dominant cinema culture from Hollywood whose industrial culture is driven by attempting to achieve audience satisfaction as measured through the profitability of box office success. The French nation may have suffered numerous political and military defeats from the end of the eighteenth to the beginning of the twenty-first centuries, but this has not meant that the keepers of the flame of French civilization have abandoned their belief in the messianic and universal value of French culture. If anything the combination of political defeat and cultural exceptionalism has had an echo in the basic narrative conventions in French cinema whose tragic essence was formed out of the literary canon of the nineteenth century and has continued thereafter.

Early Sound Cinema

France was a dominant country in the world cinema market before the Hollywood film industry made significant gains into the French market after World War I. Directors and producers working in the French film industry in the early sound period of the 1930s were well-aware of the competition they faced from Hollywood and used the advent of sound to reclaim their national audience with domestic productions in the French language. The French government even passed laws demanding that the dubbing of foreign films be done in France with French personnel, a move that in part led to the establishment of the Joinville studios by American major studios.[8] In narrative terms, the self-appointed role of global cultural guarantor has meant a conscious attempt to differentiate French cinema from Hollywood. The emphasis on tragic tales has roots in the grand era of the French novel in the nineteenth- and early twentieth centuries in particular when Francophone authors like Baudelaire or Zola worked at the avant-garde of literary creation. In fact the early French avant-garde sound cinema latched onto self-destructive themes reminiscent of French literature. French film critics first began to apply the literary term *roman noir* (dark novel) from American and French novels to French films such as Michel Carné's *Hôtel du Nord* (1938) adaptation of the Eugène Dabit novel, *Le Dernier tournant* (*The Last Turn*; 1939) based on the James Cain story *The Postman Always Rings Twice*, and *La Bête humaine* (*The Human Beast*; 1938) based on the Emile Zola novel.[9] One of the most frequently remade novels in French film history is the story of the suicidal and abused boy in Jules Renard's novel *Poil de carotte* (*Carrot Top*; 1925, 1932, 1952, 1971). This tragic undertone extended to experimental films like Jean Cocteau's *Le Sang d'un poet* (*Blood of a Poet*; 1931) with the surrealistic death of the card-playing man, which is applauded by an audience of elegant

playgoers as his female card-playing companion is turned into a statue and walks offstage. The procession of events and characters in Luis Buñuel's *L'Âge d'or* (*The Golden Age*; 1930) is conducted to strains of Wagner's "Liebestod" death interlude from the opera *Tristan and Isolde*.

A clearer indication of the tragic narrative pattern in French cinema is in the career of actor Jean Gabin (see Figure 3.1). In the 1930s Gabin was a French national masculine icon often playing a doomed character headed toward death.[10] Bazin commented that in the 1930s he seemed to play "Oedipus in a cloth cap."[11] In Julien Duvivier's *Pépé le Moko* (1937), adapted from the Henri La Barthe novel, when Pépé is apprehended by the police he commits seppuku as his love interest Gaby sails home to France. In *Pépé le Moko* Gabin's performance recalls the Hollywood gangster roles in films like *The Public Enemy* (1931), *Scarface* (1932), and *Little Caesar* (1931) as played by James Cagney, Paul Muni, and Edward G. Robinson, respectively. Gabin's persona is trapped in an Algerian labyrinth that prevents him from communing with his French identity. The counterparts of this cultural separation are the references to American dynamism in the film as reminders of his failure. When Pépé laments about being trapped in the Casbah, Tania sings a song that mentions images of America as the counterpoint to a nostalgic and beatified Paris, a theme that continues in the repartee between Pépé and Gaby whose list of chic Parisian landmarks

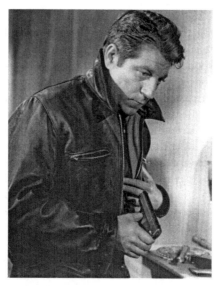

Figure 3.1 *Le Jour se lève* (1939, France) a.k.a. *Daybreak* . Credit: AFE Corporation/Photofest © AFE Corporation.

are a counterpoint to Pépé's list of popular working-class sites.[12] In Jean Grémillon's adaptation of the André Beucler novel *Gueule d'amour* (1937), Gabin is a doomed playboy officer who loses a love interest. In Marcel Carné's melodrama *Le Jour se lève* (*Daybreak*; 1938), François commits suicide before the police arrest him for the murder of Valentin. In Marcel Carné's *Le Quai des brumes* (*Port of Shadows*; 1938) based on the Pierre Dumarchais novel, Gabin plays Jean who also ends badly after a tangled love story. The difficulties of Gabin's characters and the frequency of doomed narratives in the 1930s could simply be read as an allegory for the defeat of the Popular Front in French politics in the years before World War II. However, the number of important films within the French canon in the 1930s and beyond with Werther-like narratives is too high not to be part of a larger cultural expression. Gabin would continue to appear as a doomed protagonist well into his declining years with films such as *Le Chat* (*The Cat*; 1971), which features the demise of two quarrelling pensioners played by Gabin and Simone Signoret.

Jean Renoir, the undisputed auteur prestige director in the French cinema made a notable number of films with suicidal or doomed protagonists in the prewar period including *Boudu Sauvé des eaux* (*Boudu Saved from Drowning*; 1932), *Madame Bovary* (1933), and *Les bas-fonds* (*The Lower Depths*; 1936). In Renoir's *La Bête humaine* (*The Human Beast*; 1938), Gabin plays an epileptic who kills his love interest and then himself. One of the few prewar films in which Gabin does not end in death or suicide is Renoir's *La Grande illusion* (*The Grand Illusion*; 1937). However, the theme of self-sacrifice is enacted by another character, the aristocrat de Boeldieu, whose death allows the escape of Maréchal, the character played by Gabin.

On the surface Renoir's *La Marseillaise* (1938) seems to be a foundational retelling of the French revolution and such historically set films might be expected not to feature tragic, Werther-like narratives but rather offer themes of nation building. Renoir's *La Marseillaise* has themes of the optimism that characterized the doomed Popular Front, yet the film also has a tragic undertone. The stonemason Bomier may die a hero's death in the arms of his Parisian girlfriend after being mortally wounded at the storming of Versailles. But in terms of the tragic elements in French cinematic narrative, Renoir's film opens and closes with vignettes depicting Louis XVI's subjugation to his Austrian wife Marie Antoinette. Louis's decision to follow Marie's advice to allow the Prussian general Brunswick de facto sovereign rights over French territory seals his fate. In the sequence when Louis discusses the matter with his ministers, he clairvoyantly states that to support Brunswick is to risk his own neck.

One of the most important films in the French canon, Renoir's *La Règle du jeu* (*The Rules of the Game*; 1939), clearly follows the narrative tract

of a doomed protagonist outlined above. The heroic pilot Jurieux breaks records with his solo Atlantic airplane crossing but is distraught that his girlfriend, the married Christine, is not at the airport to greet him. He attempts suicide by deliberately crashing his car, to the dismay of his friend Octave who is a passenger in the vehicle. Jurieux's final demise is due to an absurd role exchange in which he is shot by the gamekeeper, Shumacher. Renoir's film has been justifiably lauded for its portrayal of the decline of the French-landed aristocracy, a theme already explored in a military setting in *The Grand Illusion*. Yet in terms of plot structure, *The Rules of the Game* is actually a Werther-like story of love suffering that ends with a tragic, absurdist twist. Renoir's *The Rules of the Game* is part of a current of 1930s dramas depicting the decline of aristocratic culture featuring romantically suicidal protagonists. There is the retelling of the love suicide pact by the heir to the Hapsburg throne with his girlfriend in Jean Delannoy's *Le Secret de Mayerling* (*The Secret of Mayerling*; 1936), Anatole Litvak's *Mayerling* (1939), Maurice Tourneur's *Katia* (1938), and Max Ophüls's adaptation of Goethe's love suicide tale, *Werther* (1938).

Vichy

As in Italy, when trade barriers against Hollywood allowed the Italian film industry centered at the *Cinecittà* film studios in Rome to flourish in the late 1930s, the French film industry under Nazi-Vichy rule enjoyed a heyday.[13] But narrative reliance on doomed protagonists continued into the Vichy period. French directors expressed indigenous cultural identity through the subterfuge of dramas that avoided overt references to occupation. In Maurice Tourneur's supernatural thriller *La Main du diable* (*Carnival of Sinners*; 1943), Roland sells his soul to the devil in order to retain the affection of Irène and his fame as a painter. After meeting the previous owners of the cursed hand that imparts diabolic talent, he dies in a mountaintop struggle with the devil in order to regain his soul. Another devil tale as morality play is Marcel Carné's *Les Visiteurs du soir* (*The Devil's Envoys*; 1942), in which a pair of devils wreaks havoc on a medieval castle until true love intervenes. The doomed lovers end as stone statues in an eternal embrace. This ending reappears in *L'Eternel retour* (*The Eternal Return*; 1943), a Jean Cocteau–scripted film directed by Jean Delannoy, which is a retelling of the Tristan and Isolde myth. Jean Marais and Madeleine Sologne play Aryanized, doomed lovers who also end as stone figures in a final embrace. *L'Eternel retour* was reportedly one of the most popular films of occupation period and continued themes of suicide and self-destruction already seen in Cocteau's *Le Sang d'un poete* (*The Blood of*

a Poet; 1931) that would continue in his postwar *Orphée* (*Orpheus*; 1950). Another key film in the French canon is Marcel Carné's drama *Les Enfants du paradis* (*The Children of Paradise*; 1945) that features a slate of doomed protagonists. Many of the film's male characters suffer tragic fates in the tradition of *liebestod*, love-death suffering due to their infatuation with the femme fatale played by actress Arletty.

Postwar Drama

The tragic narrative in the French cinema continued unabated after Allied victory, particularly in the *policier* crime-thriller genre. In Georges Clouzot's adaptation of Georges Arnaud's novel, *La Salaire de la peur* (*Wages of Fear*; 1953), Mario (Yves Montand) and his sidekick Jo are trapped in a South American limbo where the paunch overseers of an American oil company control the future. Mario and Jo's desire to return to Paris, like Pépé in *Pépé le Moko*, is symbolized by Mario's construction of a shrine for a used Paris metro ticket in his humble room. As in *Pépé le Moko*, there is a progression between Mario and Jo's desire to return to France and their demise as Mario childishly swerves his truck to his death after successfully transporting nitroglycerin across a treacherous mountain range. In Clouzot's adaptation of Pierre Boileau's novel *Les Diaboliques* (*Diabolique*; 1955), Nicole and Christine plot to murder Michel. Gabin is poisoned to death by his impenitent wife in Henri Decoin's adaptation of the Georges Simenon novel, *La Vérité sur Bébé Donge* (*The Truth about Bebe Donge*; 1951). Gabin returns to the *policier* with Jacques Becker's adaptation of Albert Simonin's novel *Touchez Pas au grisbi* (*Hands off the Loot*; 1953), which ends in the death of Max's companion Riton, due to the indiscretion of his prostitute girlfriend. In the final sequence a middle-aged Gabin sits in a cafe in a mood of defeat that recalls his roles in the 1930s. Jean-Pierre Melville's *Bob le flambeur* (*Bob The Gambler*; 1955) and Jules Dassin's adaptation of Auguste Le Breton's *Du Rififi chez les hommes* (*Rififi*; 1955) have similar plots in which capers are foiled and protagonists are doomed by the indiscretions of their prostitute girlfriends.

A suicidal or self-sacrificial theme is also prevalent in later thrillers with Alain Delon such as Jean-Pierre Melville's *Le Samouraï* (*The Godson*; 1967). Delon's detached killer bursts into a nightclub with an unloaded gun in order to be shot by the police, committing de facto suicide. In Joseph Losey's Holocaust drama *Monsieur Klein* (*Mr. Klein*; 1976), the venal art dealer played by Delon returns to Paris to take the place of his Jewish double at the infamous Nazi-Vichy velodrome deportation of Parisian Jews. Delon continued to appear as a doomed protagonist in films such as *La*

Veuve Couderc (*The Widow Couderc*; 1971) and in films by his own pro-
duction company such as *3 Hommes à abattre* (*Three Men to Kill*; 1980).
Yves Montand appears as the doomed protagonist of Henri Verneuil's
I . . . Comme Icare (*I as in Icarus*; 1979), a state paranoia drama with a plot
recalling Alan Pakula's *The Parallax View* (1974). Tragic narratives were
not limited to thrillers; they also appear in the films of the *cinéma du papa*
(daddy's films) generation of filmmakers so criticized by François Truffaut
in films such as *En Cas de Malheur* (*In Case of Adversity*; 1958), a Claude
Autant-Lara adaptation of a Simenon novel. *Le Plaisir* (*Pleasure*; 1951)
is a Max Ophüls episodic film that features a painter forced to marry his
model/mistress after she botches a suicide attempt.

Nouvelle Vague/New Wave

In the late 1950s New Wave directors, most notably François Truffaut,
rejected postwar literary adaptations like Christian-Jacques's *La Chartreuse
de Parme* (*The Charterhouse of Parma*; 1948), a film firmly in the roman-
tic, Werther tradition.[14] However, the tragic narrative pattern in literary
sources for film adaptations in the French cinema are indicative of a narra-
tive essence that runs deeper than Truffaut's desire to break with the gen-
eration that preceded him, especially given the prevalence of Werther-like
plots in Truffaut's own films and those of his New Wave colleagues.

Despite claims about generational renewal, in narrative terms French
New Wave directors of the late 1950s and 1960s who sought to bring vital-
ity into the French cinema actually continued the tragic penchants of their
predecessors. In Jean-Luc Godard's *À Bout de souffle* (*Breathless*; 1960),
Michel waits for death at the hands of the police, arguably in order to prove
his love for Patricia. In *Vivre Sa Vie* (*My Life to Live*; 1962), Nana goes from
shopgirl to prostitute and is finally shot by two pimps who argue over her.
The narrative plot of an absurd or accidental death appears in Chabrol's
films such as *Le Beau Serge* (*Handsome Serge*; 1958) and *Les Cousins* (*The
Cousins*; 1960). In Chris Marker's science fiction masterpiece *La Jetée* (*The
Pier*; 1962), the protagonist's desire to reunite with the woman of his time-
travel reveries ends in his own murder at the hands of his superiors from
the future.

Storylines featuring doomed protagonists are a constant in Truffaut's
production from *Les 400 coups* (*400 Blows*; 1959), to his adaptation of the
Ray Bradbury novel *Farenheit 415* (1966), to the morbidity of *La Chambre
verte* (*The Green Room*; 1978). In the romantic tragicomedy *Jules et Jim*
(*Jules and Jim*; 1960), three confused lovers drive off a bridge to absurd
deaths. There are doomed protagonists in *Tirez Sur le pianiste* (*Shoot the*

Piano Player; 1960) and *La Peau douce* (*The Soft Skin*; 1964), in which a philandering intellectual is shot by his enraged wife. A particularly curious example is *La Sirène du Mississippi* (*Mississippi Mermaid*; 1969). Louis, (Jean-Paul Belmondo) correctly accuses Julie/Marion (Catherine Deneuve) of poisoning him to death. But when he declares his willingness to accept death as proof of his love for her, she concedes him a respite as the film ends. In *L'Homme que amait les femmes* (*The Man Who Loved Women*; 1977), the protagonist tragicomically is run over by a car after being distracted by a woman's legs, a sequence repeated in the hospital when he falls to his death after wiggling to ogle a pretty nurse's legs.

Louis Malle's *Le Feu follet* (*Will o' the wisp*; 1962) is a tale of suicide and self-denigration. Even Jacques Demy's *Lola* (1961), with its echo of the cabaret musicals, follows a similar narrative pattern. The protagonist, Roland, is willing to send himself off as a pawn in a compromised smuggling ring after he realizes that he does not appeal to Lola or to her young double Michelle. There are American undercurrents in *Lola* as there were in *Pépé le Moko* and *The Wages of Fear*. Roland's failure is emphasized by comparison with Frankie, Lola's ex-lover, who appears masquerading as an American wearing a Stetson and driving a white Cadillac. The dominance of themes of entrapment within a sterile French milieu negatively compared with American imagery continues in *À Bout de souffle* (*Breathless*; 1960) with Belmondo's mimicry of Humphrey Bogart's mannerisms. The entire Lemmy Caution series, including Godard's *Alphaville* (1965) with the hard drinking, bilingual FBI agent played by Eddie Constantine offers a counterpoint to the doomed French protagonists of the films mentioned in this chapter. As an American FBI agent, the Lemmy Caution character seems immune to the tragic tradition of French cinema—in fact most of his films have a Hollywood ending. These themes of comparison with America would continue in later dramas such as André Téchiné's *J'embrasse pas* (*I Don't Kiss*; 1991) in which a young French provincial falls into male prostitution in a darker version in Paul Schrader's *American Gigolo* (1980). Or in Mathieu Kassovitz's *La Haine* (*Hatred*; 1995) when Vinz, caught in the labyrinth of a Parisian banlieue, mimics Robert De Niro's mirror soliloquy from Martin Scorsese's *Taxi Driver* (1976), continuing the tradition of imitating Hollywood actors, which arguably dates back to Gabin's debt to James Cagney and Paul Muni for his performance in *Pépé le Moko*.

Recent Dramas

A later incarnation of French masculinity, Gérard Depardieu, has appeared in numerous dramas with doomed protagonists. In Daniel Vigne's *Le*

Retour de Martin Guerre (*The Return of Martin Guerre;* 1982), the imposter played by Depardieu faces execution with a sense of acceptance—a plot sequence repeated in Andrzej Wajda's *Danton* (1982), a French production about the doomed revolutionary era general. In Claude Berri's *Jean de Florette* (1986), the hunchback's search for water leads to his demise. Daniel Auteuil performs a grim love suicide complete with *ex voto* imagery in the sequel *Manon des sources* (*Manon of the Spring* (1986). In Jean-Paul Rappeneau's *Cyrano de Bergerac* (1990), Christian willingly goes to his death in battle due to his amorous disappointment over Roxanne. The fatally wounded Cyrano insists on keeping his rendezvous with Roxanne instead of seeking medical attention. Claude Berri's adaptation of the Zola novel *Germinal* (1993), also by Yves Allégret in 1953, follows the narrative pattern of ecstatic success and decline into despair of many Zola works. In Yves Angelo's adaptation of the Honoré de Balzac novel *Colonel Chabert* (1994), also a Vichy era film by René Le Hénaff in 1943, Chabert returns from Napoleon's unsuccessful Russian campaign and accepts social obliteration. In the more recent drama, Roland Joffé's *Vatel* (2000), the master steward unexpectedly kills himself to express his unwillingness to change his station, despite having enjoyed a night of passion with the king's comely mistress and gaining promotion as master of ceremonies at the court of Versailles. In terms of narrative consistency in French cinema history, *Vatel*'s seppuku could be seen as reenactment of Jean Gabin's absurd suicide in the final sequence of *Pépé le Moko*.

The Werther-like narrative in French cinema remains strong in recent dramas including Patrice Leconte's *Mr. Hire* (1989) adaptation of a Simenon novel and Belgian director Jaco Van Dormael's *Toto le héros* (*Toto the Hero;* 1991) and *Le Huitème jour* (*The Eighth Day;* 1996). Films like *L'adversaire* (*The Adversary;* 2002) by Nicole Garcia or Dominik Moll's *Harry un ami que vous veut du bien* (*With a Friend like Harry;* 2002) offer a ritual of doom that has become a commonplace in French cinema.

Some recent French films have appropriated a more populist style in a bid for international distribution such as the Kung Fu, pre-Revolution drama *Le Pacte des loups* (*The Brotherhood of the Wolf;* 2001) or Luc Besson's *Le Grand bleau* (*The Big Blue;* 1988). Yet even *Le Pacte des loups* (*The Brotherhood of the Wolf;* 2001) is structured around a doomed protagonist. The film has a cadre, a framework, in which the tale is recounted as a flashback in the memory of the aging Thomas d'Apcher. He tells the tale of the famed wolf that terrorized the French countryside in the eighteenth century on the night vengeful revolutionaries reach his holdings. In the final sequence the count walks into a crowd of angry peasants, an allusion to his future appearance under the guillotine. Besson's *Le Grand bleau* (*The Big Blue;* 1988) is a tale of a dual suicide by diving enthusiasts. The

rationale for suicide may be a murkily defined desire for asphyxiation for environmental reasons. When the two protagonists take turns diving to their deaths, they are continuing the narrative tradition established by Jean Gabin in the 1930s.

The French Female Protagonist

Interestingly, this Romantic tradition of doomed protagonists in the French cinematic canon extends to females. Since revolutionary times and the 1848 uprisings, the French nation has been symbolized, on currency and in popular iconography by the heroic figure of Marianne holding the torch of liberty at the ramparts. The designation of French cinematic heroines as the models for statues of Marianne from Brigitte Bardot to Catherine Deneuve to Laetitia Casta is a unique symbiosis between political and cinematic imagery.[15]

An initial and recurring example of a doomed protagonist in French cinema is Joan of Arc. The themes of self-abnegation and voluntary sacrifice in the history of Joan were among the first national tales told by the French cinema by Georges Méliès and Danish director Carl Dreyer in *Jeanne d'Arc* (*Joan of Arc;* 1899) and *La Passion de Jeanne d'Arc* (*The Passion of Joan of Arc;* 1928), respectively. Joan's canonization occurred in 1920, the moment that France was developing a national cinema and in an historical period when nationalist themes were emphasized politically, militarily, culturally, and industrially as an expression of national prestige.[16] The story of Joan of Arc has retained its vitality in French cinema as attested by Luc Besson's recent version *Jeanne d'Arc* (*Messenger: The Story of Joan of Arc;* 1999) although perhaps an even more indicative example of a Besson film featuring a doomed and self-destructive female protagonist is *La Femme Nikita* (1990).

Doomed female protagonists appear in the work of New Wave directors. The emotionally damaged and promiscuous protagonist of Alain Resnais' *Hiroshima Mon amour* (1959) comes to Japan after having experienced ostracism in her hometown of Nevers due to her relationship with a German soldier. Perhaps the most renowned representative of the theme of a negatively charged female protagonist is in Godard's *Le Mépris* (*Contempt* (1963). The film creates a forced parallel between the classical tale of Ulysses and Penelope and the marital troubles between the screenwriter Paul played by Michel Piccoli and his capricious wife, Camille, played by Brigitte Bardot. In the conclusion Camille leaves with an American film producer. When the pair is killed in a car crash, their deaths are neither cathartic nor exemplary. Despite the allusions to the heroic model of the

Odyssey, Godard's narrative resolution is a reversion to the sort of absurd, tragic ending that is a constant in canonical French film.

There are also films where the self-destructive impulses originate in a female protagonist such as Agnès Varda's *Cleo de 5 a 7 (Cleo in the Afternoon;* 1961), *Sans Toi ni loi (Vagabond;* 1985), Godard's *Vivre Sa vie (It's My Life to Live;* 1962), Truffaut's *The Story of Adele H,* Bruno Nuytten's *Camille Claudel* (1988), or the baroque musical drama by Alain Corneau, *Tous les matins du monde (All the Mornings of the World;* 1991). More contemporary-themed dramas include Jean Becker's *L'été Meurtier (One Deadly Summer;* 1983) or films featuring Sandrine Kiberlain such as Laetitia Masson's *À Vendre (For Sale;* 1998) and Pascal Bonitzer's *Rien Sur Robert (Nothing About Robert;* 1999). Patrice Leconte's *Tango* (1993) and *La Fille sur le pont (Girl on the Bridge;* 1999) bring a misogynistic edge to the traditional theme of self-destruction. More recent films place female protagonists in roles of suicidal self-examination—previously the domain of male protagonists such as Brigitte Roüan's *Post Coitum animal triste (After Sex;* 1997), Chervier's *Du Poil sous les roses (Hair Under the Roses;* 2000) or André Téchiné's *Les Voleurs (Thieves;* 1996), with the suicide of the distraught professor played by Catherine Deneuve. *Entre Ses mains* (2005) directed by Anne Fontaine stars Isabelle Carré as a woman whose self-destructive impulses lead her to fall for a serial killer played by Benoît Poelvoorde.

Extra-French Directors

Of course, Werther-like narratives are not universal in French cinema. Noted directors like Éric Rohmer have narratives without tragic, romantic *liebestod* themes. Perhaps the best place to prove narrative essence in French cinema is the paradoxically large numbers of non-French directors who have found work in the French film industry. The idea that there are defining narratives within national cinemas could be adopted to understand the cross pollination that occurs when directors work in the industry of one national cinema but express the national narrative of their country of origin or educational and cultural background. For example, Luis Buñuel worked in the French film industry and made a number of tragically resolutive films as mentioned above, but he also produced films such as *Cet Obscur objet du désir (That Obscure Object of Desire;* 1977) that has a picaresque narrative structure that betrays his Iberian origins. *Trois Couleurs: Blanc (White;* 1994), a French film by the Polish director Kieslowski, breaks the French cycle of male doom to add an element of revenge. Once in Poland the protagonist fakes his own death, which leads to the imprisonment of his ex-wife.

Italian director Gillo Pontecorvo had a French governess in the tradition of upper-class Italian households in the early twentieth century. Pontecorvo also came of age during the heady days of the Popular Front in Paris before World War II. His films end with self-sacrifices typical of French national narrative. In *La grande strada azzurra* (*The Wide Blue Road*; 1957), Squarciò played by Yves Montand is mortally wounded by one of his own fishing bombs. In *Kapò* (1959) Edith sacrifices herself so the other prisoners may organize an escape. In *La battaglia di Algeri* (*The Battle of Algiers*; 1965), a film that owes much to *Pépé le Moko*, Ali le Point allows himself to be blown up rather than leave his hiding place in the Casbah. In *Queimada* (*Burn!*; 1969) José Dolores prefers the gallows to Walker's offer of help to escape.

Bernardo Bertolucci has never hidden his Francophilia. When his first film *La comare secca* (*The Grim Reaper*; 1962) was released, he insisted on conducting an interview with an Italian journalist in French. His interest in French themes is particularly evident in the Parisian settings of his films such as *Il conformista* (*The Conformist*; 1970), *Ultimo tango a Parigi* (*Last Tango in Paris*; 1972), and most recently the Paris, May 1968 nostalgia drama, *The Dreamers* (2003). Bertolucci's *Last Tango in Paris* in particular has a narrative that fits a French scheme. In fact the film was initially supposed to be set in Milan but was moved to Paris and enjoys references to French cinema such as the casting of Truffaut's alter ego Jean-Pierre Léaud or the canal sequences in the film, which recall Vigo's houseboat in *L'Atalante*. Of course Bertolucci has also made films with Italianate narratives that are more fatalistic and circular such as *Prima della rivoluzione* (*Before the Revolution*; 1964) or *1900* (1976). He provides an interesting case of a director able to mix national influences in his films.

French Comedy and the Box Office–Canon Disconnect

One genre where a Werther-like narrative would not be expected is comedy. The presence of a tragic undercurrent in critically acclaimed French comedy proves how the Werther narrative has crossed genre boundaries. In Jean Vigo's *L'Atalante* (1934) when the barge captain jumps into the canal after a marital spat, his shipmates are convinced he has attempted suicide. There are no suicidal themes in René Clair's musical comedy *Le Million* (*The Million*; 1931). However, when Clair reprised the penniless artist theme in *Les Belles de nuit* (Beauties of the Night; 1952), the tragic undercurrent is more explicit. The hero in *Les Belles du nuit* is a musician who lives in a dreamworld inhabited by fantasy visions of a compliant Gina

Lollobrigida. But he is also in such desperation that his friends set up a suicide watch after seeing him buy tranquilizers.

There are no overtly suicidal storylines in Jacques Tati's critically acclaimed *Hulot* series, yet Hulot's estrangement from his fellow vacationers in *Les vacances de M. Hulot* (*Mr. Hulot's Holiday*; 1953) could be read as an indication of societal obliteration, a continuing theme of critically lauded French comedy. In recent French comedies such as *Le Père Noël est une ordure* (*Santa Claus Is a Stinker*; 1982) by Jean-Marie Poiré, Coline Serreau's *Trois Hommes et un couffin* (*Three Men and a Cradle*; 1985), *Romuald et Juliette* (*Mama There's a Man in your Bed*; 1989), and *La crise* (*The Crisis*; 1992) or Francis Veber's *Le Diner de cons* (*The Dinner Game*; 1998) and *Le Placard* (*The Closet*; 2001), protagonists' social personae are obliterated. In *The Closet* the divorced and soon-to-be redundant accountant Pignon contemplates suicide from his apartment balcony. He is saved by a retired industrial psychologist who convinces him to pretend to be homosexual as a ploy to regain his job. In *La crise* Victor is rejected by his employer, friends, wife, and family and contemplates suicide before a chance meeting with the glutton, Michou, who inspires him to reinvent himself. In *Trois hommes et un couffin*, three swinging bachelor housemates excise their gregarious lifestyle to care for a baby girl. A twist on this social alienation plot mechanism is in Jean-Pierre Jeunet's *Le Fabuleux destin d'Amélie Poulain* (*Amélie from Monmartre*; 2001). The film touches upon suicidal themes in the opening montages depicting Amélie's youth. A Quebecois commits suicide by leaping from a church steeple squashing Amélie's mother to death. Amélie's social isolation results not only from her father's hypochondriacal misdiagnosis of her heart condition but also from his morbid dedication to his wife's tomb. The level of infiltration of the Werther tract in French film is seen in Harriet Marin's *Épouse-moi* (*Marry Me*; 2000) in which a distraught wife goes to a fortune-teller in hopes of learning how to reconcile with her husband. The fortune-teller presents versions of the future in a Werther love-death gesture until the wife demands a happy ending.

A telling aspect of French comedy is the disconnection between the genre's domestic popularity and its critical reputation. The French even have a term, *copinage* (cohabitation), for the tendency for the French film industry to fund projects with the closed circle of intellectual elites and thereby aimed for critical rather than public appeal. In fact the top-grossing films in French film history are almost uniformly critically disdained comedies. Of the top 50 films between 1945 and 1999, 30 were comedies including the top 5, and 7 of the top 10.[17] There are no suicides in war farces like Gérard Oury's *La Grande vadrouille* (*Don't Look Now We're Being Shot At*; 1966) and Claude Autant-Lara's *Traversée de Paris* (*Four Bags Full*; 1956) or in Louis de Funès's cooking comedy *L'aile ou la cuisse*

(*The Wing and the Thigh*; 1976) or in films by Claude Zidi with Coluche such as the *Medicins sans Frontières* (*Doctors without Borders*) farce *Banzai* (1983). Recent comedies strong at the domestic box office, like Jean-Marie Poiré's time travel comedy *Les Visiteurs* (*The Visitors*; 1993), the popular *Asterix* series or *Bienvenue Chez les Ch'tis* (*Welcome to the Sticks*; 2008) by Dany Boon are also outside the Werther vein. The popularity of these films points to a separation between domestic taste and the critical preferences of French elite that influences the allocation of state subventions and critical blessing. The French government began protecting the domestic film industry in response to Hollywood market dominance. During the 1930s the French government passed protectionist legislation mandating that the dubbing of foreign films be done in France with French personnel, a move that led to the establishment of the Joinville studios by American studios.[18] These governmental subsidies have reinforced and allowed the artistic and political ideal of an engaged cinema in opposition to Hollywood as an attempt to preserve the essence of French Romantic and existentialist high culture.

The fact that Gérard Oury's comedy *La Grande vadrourille* (1966) retained the position as the all-time, top-grossing domestic French film for over 40 years has probably only exacerbated critical disdain. The film avoids political overtones whether Gaulist, Leftist, or pro-Atlantic. An interesting aspect of the film is the assignment of an active Resistance role to a nunnery. This Catholic undercurrent in *La Grande vadrourille* is in opposition to the Werther-like narratives discussed above and grounds the film in a cultural milieu outside the dominant narrative in French cinema. In fact the top 50 grossing French films of 1945–99 include other Catholic-themed films besides *La Grande vadrourille*. Duvivier's *Le Petit monde de Don Camillo* (*The Little World of Don Camillo*; 1952) and *Le Retour de Don Camillo* (*The Return of Don Camillo*; 1953) starring comic icon Fernandel were the most viewed domestic films in the years of their release. The resonance of overtly Catholic films with a large sector of the French film-going public and the heroic role of the nunnery in the all-time, top-grossing French domestic film, *La Grande vadrouille* in particular, points to a Catholic undercurrent often undervalued in critical histories.

Catholic themes have appeared in more critically accepted French films such as Robert Bresson *Journal d'un curé de campagne* (*Journal of a Country Priest*; 1951), the story of an insecure priest whose faith is shaken by the rumored suicide of an atheist. The priest eventually succumbs to stomach cancer seemingly caused by his diet of stale bread soaked in wine. Despite the religious setting the priest's personal crisis has a Werther-like narrative tract of self-doubt and self-destruction. Bresson's film never reached a public as large as Maurice Cloche's biopic of St. Vincent de Paul, *Monsieur*

Vincent (1947), which remained in the French top 50 as the twenty-sixth top-grossing film between 1945–99. Cloche's film is a riveting dramatization of a protagonist whose mission to serve the poor contrasts with the solipsistic crises of Werther-like protagonists so persistent in the French canon. The existence of a Catholic undercurrent in French cinema in opposition to the Werther narrative should hardly be surprising given French religious history and the lay foundations of the French republic and French intellectualism. Perhaps the cultural and historical explanations for the tragic essence of the French narrative tract is not only a hangover of Romanticism and the twentieth-century manifestations of surrealism and existentialism but also the tensions between French lay and religious traditions.[19]

Different national traditions resolve conflict with narratives that express cultural identity. In French cinematic narrative, the return to equilibrium is often enacted through the destruction of the protagonist.[20] The Werther-like insistence on individuality ending in self-sacrifice attempts to express a universal truth through a paradoxically futile gesture of self-inflicted defeat. With such narratives, there is a temptation to refer to classical sources about the expiation of hubris or the practice of communally assigned scapegoats, a phenomenon closely aligned with the classical era Saturnalia festival in which chosen individuals, usually of base station, were first celebrated and then marginalized in order to expiate community impurity.[21] Perhaps in French cinema the reestablishment of narrative equilibrium after defeat or sacrifice is a cathartic vehicle of community purification. However, the sacrifice of the protagonist has an individual focus, an exaltation of personal affectation that is a seeming hangover of the Romantic spirit. Of course the narrative pattern discussed above is not a universal aspect of French cinema. But the persistence of Werther-like narratives within the French cinematic canon that are in direct opposition to the French public's taste for comedy are evidence of the manner in which French film critics have stubbornly favored films with tragic narratives.

4

The Promises of India

India's myriad of ethnic, religious, and linguistic identities makes it perhaps the most culturally and geographically diverse nation on the planet. Historians have often opted to consider the narrative of Indian history under a Hindu nationalist light in terms of the influences brought by invading groups on the subcontinent. Within the currents of Hindu historiography particularly into twentieth century, there was recognition of the legacy of periods of Islamic rule, in particular on the inequities manifested by an elite of Muslim rulers subjugating a Hindu majority. However, social and caste division and oligarchic rule are actually millennial traditions in India that continued with the British colonial period that added an extra-Indian layer to social stratification. Independence from Great Britain in 1947 brought not only self-determination but also the partition of former British colonial territory between Hindu-dominated India and Muslim-ruled Pakistan. Despite partition, present-day India is still home to numerous ethic and religious groups with a vibrant film industry as varied as the country itself.

The Indian film industry centered in modern Mumbai, known as Bollywood, has historically featured an interesting mix of cultural influences. The Bollywood film industry catering to dominant Hindus is but one of many functioning movie industries in the country serving different ethnic and linguistic groups. The Aristotelian method used in this study to determine the characteristics of national cinemas could arguably be applied to any of the regional cinemas in the Indian subcontinent. To put things into perspective, an entire chapter in this book discusses the Finnish cinema, a nation with barely five million souls. The Kannada cinema based in the region of Karnataka serves over 40 million inhabitants with access to over a thousand cinema theaters, numbers that should abundantly qualify as a separate national identity.[1] Since India's regional entities are so pronounced, the Bollywood film industry has enjoyed a centralizing function in the development of a cinematic culture that has been accepted through

the entire subcontinent. One could argue that the influence of the Bollywood cinema has been important for the creation of a hegemonic culture that seeks to attract Indian citizens of all ethnic backgrounds and all castes. Delay in the proliferation of electricity and home television sets has allowed the Indian film industry to retain a high level of output, particularly if compared to the relative decline in production in the West after the introduction of television in the mid-1950s. Bollywood film stars such as Amitabh Bachchan have enjoyed the sort of universal recognition and celebrity that existed in the West during the silent film period for actors like Chaplin or Valentino. In a sense the Bollywood cinema operated as somewhat of an anachronism in the late twentieth century, catering to massive audiences with limited access to the distractions of modernity.

The diffusion of standardized Hindi has been one of the major achievements of Bollywood cinema, although again, the sheer number of ethnic identities within the country marks any discussion of standardization of language. As in China the assimilative power of language in cinema has been tempered by the difficulty in distributing films in so vast a territory. Since the cinematic language is Hindi and the governmental centers are located in Hindi-speaking regions, the communicative power of the cinema has had a role in the development of a national linguistic culture. Critics have identified the essence of Bollywood cinema with Hindu culture both in cultural and religious terms. In the early post-British and prepartition period, the tensions surrounding issues of identity were enormous, and subsequent films such as *Mother India* (1958) tended to promote a Hindu nationalist message.[2] The studio system that developed into the 1930s and particularly after independence took the traditional essence of Indian culture to an enormous audience under a definite political, ideological, and cultural message. With the multiple cultural influences in India, the Bollywood cinema is a dominant cultural force, appealing across class, ethnic, and caste boundaries to an immense audience. On the surface, finding common themes within such a nation would seem improbable, yet that is precisely where the power of the cinema comes into play. Like other nations, the Bollywood cinema has developed master themes and plots that are reflective of the political pull of the Hindu majority. Vijay Mishra has identified how the central themes of the classic Hindu texts, the *Ramayana* and the *Mahabharata*, are fundamental to the Bollywood cinema. The popularity and cultural and religious resonance of these texts is uncontestable. Ramanand Sagar directed a television miniseries of the *Ramayana* that became the most popular television series in Indian history, followed by a similarly popular adaptation of the *Mahabharata*.[3] Indeed the basic stories from the *Ramayana* and *Mahabharata* offer a key to the Bollywood cinema. Mishra has written that "One may even claim that all Indian

literary, filmic, and theatrical texts rewrite the *Mahabharata*," and he identifies several character types from the sacred texts that have reappeared continually in Indian cinema such as the mother figure or the antihero.[4] A look at Bollywood cinema reveals that there are master themes taken from the sacred texts in tales of oaths and respect of customs according to the dictates of caste and economic status, which are maintained regardless of individual desire. The plots of Bollywood cinema use the commonplace of the declaration of duty, honor, or promise as a seed of conflict between desire, revenge, tradition, and innovation. Mishra has defined the essence of the influence of the ancient texts upon Indian cinema in terms of the need to ascribe to a law, the dharma, and a code of behavior that enforces and reinforces class boundaries. The essence of the ancient texts uses such commonplaces to develop tales that engulf entire worlds. The Bollywood cinema has followed the narratives of the ancient and sacred texts to attract a mass audience.

The basic story of the *Ramayana* revolves around an oath taken by the prince Rama, who promises to wander in the countryside when his coronation is blocked after a family disagreement. Out of a fit of jealousy, the queen, Rama's stepmother, asks Rama's father, the king, to recall his promise to grant her a boon, and then she demands that the crown go to her own son rather than to her stepson Rama. This storyline of a vow or promise, which according to the precepts of honor codes once taken must be fulfilled no matter the consequences, forms the underlying structure of the text. A seemingly idle promise from the king to his wife leads to Rama's exile. The effort to honor the king's vow results in misunderstandings, delays, and conflicts. Rama temporarily relinquishes his princely status for anonymity in the wilds, offering the opportunity for a series of adventures. Rama refuses to marry the demon Kamavalli, who disguised herself as the maiden Soorpanaka, because of caste difference. Rama is of the warrior caste and Soorpanaka presents herself as a Brahmin. Rama's refusal ignites another series of conflicts noted by Mishra as a cycle of desire, dharma (law), order, and revenge. Rama's rejection of Kamavalli enrages her brother, the demigod Ravana who in turn abducts Rama's wife, Sita. The result is an all-consuming and cataclysmic war. On his way to rescue Sita, Rama meets a monkey king, Surgiva, who complains about a misunderstanding between himself and his brother Vali. A vow and a misunderstanding of mistaken intentions and oaths taken and broken provide the narrative for a digression from the main story. Surgiva claimed that he began his reign when he thought his brother, Vali, was dead. When Vali returns to reclaim his throne, he exiles Surgiva and reclaims his wife. The story has the same structure of vow, misunderstanding, and dire consequences of the tale of Rama and his brother. Similarly the *Mahabharata* revolves around tales of vows and

misunderstandings with devastating consequences.[5] In the *Mahabharata* Bhishma (which means one of firm vows) vows celibacy so his father can marry a river goddess girl. This leads to the disastrous feud between the Pandava and Kaurava clans and eventually the death of Bhishma. The narrative course in these tales is that once a promise or a curse is uttered, it remains as an entracted theme.

One of the aspects of political life in contemporary India, in conjunction with the noted economic boom, as the country increasingly abandons command and control economic policies, is the demand for power from the nation's subaltern classes. According to some counts the *Dalit* (the "untouchables" who make up 16 percent of the population) and the *adivasi* (the country's aboriginal peoples who make up 8 percent of the population) form up to a fourth of the Indian population.[6] The term to describe the caste system, *varna*, actually means cover or color, and the various divisions such as the priestly class (the Brahmin) and the warrior caste (*Kshatriya*) are the focus of the sacred texts. Many stories of the *Ramayana* and the *Mahabharata* revolve around *Kshatriyas* (warriors) who go into exile in order to keep some promise and must be demoted, temporarily to Brahmin. The merchant class *Vaisya* came up with the philosophy of nonviolence as violence was bad for business (Mahatma Gandhi [1869–1948] was a *Vaisya*). The most numerous and abject caste, the Sudra, also called Other Backward Class (OBC), historically have comprised 50 percent of the population. They rarely own land and are victims of virulent prejudice despite the institution of the antidiscriminatory policies in recent years. India has attempted social evolution as underclasses seek participation in the increasingly dynamic economy by claiming rights via participation in the electoral process. If these peoples have only recently become active in Indian politics, they have on the other hand been the bulwark of the Bollywood audience. The narratives favored in Bollywood cinema may have actually perpetuated the mentality of traditional Indian society where a fatalistic acceptance and forbearance of the consequences of status boundaries and promises are symptomatic of social ossification. Much of the violence in Bollywood film occurs in such circumstances. Revenge films are a popular template for Bollywood cinema. The atrocities depicted in the Indian cinema, such as the particularly gruesome motif of lopping off limbs or immolation, have been historically inflicted on members of the Indian subcastes as a matter of recourse by privileged classes in reaction to attempts to challenge caste taboos. These taboos have extended within the cinema to representation of sexual material where India upholds censorship codes that one could suspect as being directly related to the desire of the ruling elites to maintain social boundaries.

Mother India (1958)

A film central to the canon of Bollywood cinema for the manner in which it reflects deep currents in Indian culture and obtained a resounding success at the box office is *Mother India* (1958) by Mehboob Khan. *Mother India* has clear overtones from the classic texts of Indian mythology and was influenced both by rural melodramas and by currents in socialist realism. The film has become an icon of the Indian cinema and was one of the few Indian films to attain international critical recognition in the early postwar period.[7] The underlying message and narrative of the film has deep roots in Indian mythology with archetypical characters and plot lines that resonated deeply with the domestic audience explaining the film's popularity and longevity.

The opening sequences of *Mother India* have clear references to the sort of Hindu socialist nationalism of which the film is a purveyor with montages of industrial machinery and a government public works project (a dam). When a committee of Nehru-capped officials asks the aged protagonist of the film, Nargis, to inaugurate the civic dam/canal project, she is reticent. A long flashback to her wedding day and the suffering endured over her life explains the reverence in which she is held by the village. The ensuing plot flashback revolves around the difficulties Nargis suffered following her mother-in-law's decision to mortgage their land to the village usurer, Sukhi, in order to pay for a lavish wedding ceremony. The men in Nargis's family seek vainly to free the family from their sharecropper status. Her husband tries to till more land but his arms are crushed while clearing a field. Her son, Birju, rejects the obligations of the past and seeks to revenge his father and kill the usurer by becoming a bandit. But the barriers that entrapped the family are eventually reinforced by the self-sacrificing protagonist, Nargis, seen Figure 4.1 with her children, who insists on adhering to codes of behavior and obligation that benefit the village rather than her nuclear family.

The basis of Western melodrama is the struggle of an individual to attain higher class status despite societal barriers. In *Mother India* Birju discovers that according to the terms of the loan accepted by his grandmother, the accruing interest has become much larger than the original loan amount, and thus the loan can never be paid off at the original terms. The original promise to make good on the loan becomes more and more remote in time, yet it continues to determine Nargis's tragic fate and those of her husband and children. After the husband loses his arms and abandons the family, the usurer claims the family's cooking pots, then their land and livestock, reducing them to near starvation, a situation aggravated by catastrophic floods. Nargis must overcome not only the inequities of the caste system

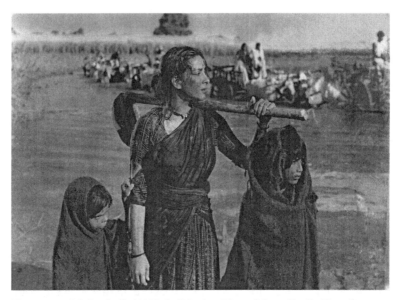

Figure 4.1 *Mother India* (1957, India) a.k.a. *Bharat Mata* . Credit: Photofest
© Photofest.

but also the capriciousness of nature that alternates between extremes of drought and flood. In fact if there is an explanation for the tenacity of Indians to cling to their societal duties, it is precisely in this hostility of nature in which community becomes a defense against the unpredictability of the natural world. Birju then swears to refuse to pay the usurer with the family harvest. He insists on reclaiming his mother's jewelry and threatens to kidnap and dishonor the usurer's daughter on her wedding day. Nargis in turn swears to the village that she will kill her son Birju if he bothers any of the village girls, including the usurer's daughter. Thus Birju is ostracized by the village, losing his position as a member within the collective identity of the village, so touted at the film's opening. The decision by the heroine Nargis to kill her son Birju after he becomes a bandit follows a code of behavior more loyal to the collective than to the individual or family.[8]

The plot of the film recalls the promise and catastrophe cycles from Hindu classic texts applied to the socialist and nationalist Hindu ideology of postwar India. The mother-in-law's original promise leads to other promises and conflicts that do not revolve around the defense of individual or family honor but around the defense of the collective identity of the village. The Hindu nationalism of the film's political Nehru-era message of community solidarity is played out in Nargis's declaration of loyalty to all

the girls in the village. But the plot really hinges on an offhand, almost casual arrangement: the loan for Narju's wedding expenses that becomes a seed of catastrophe, a narrative with deep roots in classic Indian mythology.

By Western preconceptions, the son Birju is entirely rational in his refusal to participate in a system that had enslaved his relatives in share-cropping servitude for generations. His futile attempt to learn to read and his eventual discovery of details of the usurer's nefarious loan could be interpreted as elements of great individual initiative. In fact the outlaw Birju is one of the most sympathetic figures in the film, and outlaw char-acters like Birju enjoy a level of popularity among Bollywood audiences who identify with the impulse to reject the social and economic system and attain revenge. One of the most popular characters in the *Ramayana* is Ravana, the demigod who swears he will avenge Rama's refusal of his sister Soorpanaka. Ravana is a doomed character, fatalistically locked into a role that must lead to defeat, a condition that has evoked empathy among generations of Indians.

Given the dearth of options, Birju's oath to kill the usurer and burn the accounts that had bound the villagers into sharecropping is actually quite rational. In contrast Nargis's decision to act on the behalf of the ruling elite and to place the dictates of caste and village above those of family and self only seems rational if interpreted in the context of Hindu identity. The narrative of the film is entirely consistent with the millennial narratives of ancient Hindu texts like the *Ramayana* or the *Mahabharata*. Every charac-ter that consciously takes an oath, or feels obliged to continue the promises made by previous generations, remains true to promises that perpetuate the essence of societal relations, no matter how unjust or remote. Nargis endures suffering due to her mother-in-law's promise to mortgage their land. But Nargis's act is merely one in a sequence of self-destructive oaths that form the narrative of the film. Her husband, once armless, resolves not be a burden on his family and disappears into the night to end his days either in suicide or as a beggar. Once Birju resolves to retrieve his mother's jewels, kill the usurer, and kidnap his daughter, he also cannot go back on his word. Finally Nargis shoots her son Birju, chillingly main-taining faith to her oath to protect the village girls rather than following her natural maternal instincts. The film takes inspiration from the ancient texts but applies the message of duty and loyalty to socialist, nationalist, Nehruist designs of postindependence India. As a reward for killing her son in the film's final sequences, Nargis is respected and honored by the community. There is a concluding montage of the progress enjoyed in the collectivist vision of postindependence India as a parallel to Nargis's choice of community allegiance over maternal allegiance. The message of the film, and here one must mention the undoubted influence of the narrative of

socialist realism, has much to do with the socialist ideology of the time whereby individual sacrifice was equated with community development. This collectivist message makes the film somewhat of an anachronism as the economic explosion of the "New India" has not been the result of top-down government planning but of the efforts of individual entrepreneurs whose expertise and vision has significantly raised India's standard of living and its prospects for future economic development. One of the challenges for the Bollywood cinema of the future will be whether it will be able to mix the ancient promise and suffering narrative from the sacred Hindu texts with the realities of a growing economy.

Sholay

Another film that enjoyed incredible popularity among Indian audiences is *Sholay* (*Flames of the Sun*; 1975) by Ramesh Sippy. *Sholay* was clearly influenced by westerns from Hollywood and Italy and has been branded a "curry western" due to stylistic elements reminiscent of Sergio Leone's *The Good, the Bad and the Ugly* (1966) and especially *Once Upon a Time in the West* (1968), such as the train imagery in the opening and closing sequences, the child-killing antagonist, the harmonica-playing protagonist, and the alteration of comic and tragic contests between strong personality types. The film also borrows from the buddy genre with the two main characters: small-time criminals Veeru, the joker, and the melancholy Jai played by Amitabh Bachchan, an actor who would acquire monumental star status within Bollywood cinema. The film alternates between flashbacks for character development and places the antiheroes, Jai and Veeru, at the service of an armless law-and-order figure, Thakur, who seeks revenge against the bandit Gabbar who murdered his family and cut off his arms. Amjad Khan, the actor playing Gabbar, also gained wide fame as a result of his role in the film. Khan's mannerisms and lines from the film were widely mimicked, recalling the bittersweet admiration for antagonists in ancient texts like the *Ramayana* where Rama's adversary, Ravana, enjoys a following in Indian religious culture despite his negative role.

In the film Jai promises the armless jailer Thakur that he will deliver the villain Gabbar to him alive. When Jai sacrifices himself to rescue Veeru and his love interest Basanti from Gabbar, Thakur reminds Veeru of Jai's promise. It is at this point that the legacy of the ancient texts becomes evident, for Veeru resolves to respect Jai's promise even though it means denying himself the opportunity to take revenge. Gabbar is also driven by an oath of revenge against Thakur for capturing him in the first place. When

Gabbar had escaped from prison, he immediately had set out to massacre Thakur's family. He then cut off Thakur's arms, an emasculation equivalent for blindness in Greek tragedy, which also appears in *Mother India* when the husband loses his arms under a boulder while trying to clear a field. *Sholay*, like *Mother India*, has other signature elements of Bollywood cinema, which arguably have roots with the ancient literature such as the numerous digressions that appear in the films as dance sequences. There is also an attention to the seasonal cycle and the celebration of key festivals within the religious calendar, in particular the Holi Festival of Colors spring rites. But the unifying theme in these films is derivative of the narratives of the ancient Hindu texts where oaths or promises lead to misunderstanding and suffering and a perpetuation of social arrangements.

The persistence of the narrative scheme outlined above remains vital in Bollywood cinema. A UK production set in India that has received intense international attention is *Slumdog Millionaire* (2008) directed by Danny Boyle. Although marketed for an international audience, the film has many of the narrative commonplaces of Bollywood cinema. The tale is a coming-of-age story not only for the Cain and Abel brothers of the film but also for the Indian nation as an impoverished Bombay is transformed into the economically dynamic Mumbai. The younger brother's ultimate victory of a sizable fortune on a game show is followed by the masses of India's population on television, marking a shift in a country where television set ownership had been a rarity, and the film industry was able to flourish as the country's main source of entertainment. The brother's television show victory contrasts with a flashback from his boyhood in which he retrieves a photo of the male icon of Bollywood cinema, Amitabh Bachchan, from the pit of an outhouse. The film documents the country's progression from cinema to television as the predominant entertainment medium. The film also highlights the diversity of India's population and particularly the symbiosis between Muslims and Hindus within Bollywood. The two brothers in the film, Jamal and Salim, are Muslims whose mother is killed in rioting in the opening sequences of the film. Yet the film makes nods to Muslim culture with sequences from the greatest expression of Muslim art in India, the Taj Mahal. The plot's relevance to traditional Bollywood cinema is revealed in two key sequences. After the riots the brothers see a young Hindu boy dressed as Rama, the Hindu god, (in Figure 4.2) whose story of abandonment and wandering, defense of his love interest, and rise to power in the *Ramayana* is echoed in the plot of *Slumdog Millionaire*, particularly in the obstinacy of the younger brother not to abandon to his love interest, Latika. The other key sequence is when the brothers and Latika swear allegiance to one another in homage to oath taken by the heroes of

Figure 4.2 *Slumdog Millionaire* (2008, India). Credit: Warner Bros./Photofest
© Warner Bros.

Alexandre Dumas's *The Three Musketeers*: "All for one and one for all." The
traditional narrative of promise keeping and oath fulfillment from the cul-
tural heritage of ancient Hindu texts is retained in a contemporary setting
of an economically transformative India.

5

The Iranian Divide

Iran is bordered by mountain ranges to the west and the north and features two fertile regions: one an extension of the fluvial plain region historically known as Mesopotamia and another in the plains south of the Caspian Sea. These areas of fertile land contrast sharply with the plateaus of ancient deserts that feature some of the most inhospitable real estate on the planet.[1] Iranian historical narrative has developed around a sense of being surrounded by hostile forces: Greeks, Romans, Turks, or Arabs to the west; Hindus and Mongols to the east; and Slavs to the north. The country harbors bitter memories of foreign invasion and domination whether by Arabs, Mongols, Turks, or more recently by the British and Americans. More recent contemporary strife such as the period when Mohammad Mossadegh (1882–1967) was prime minister in the early 1950s or the repressive policies of the present Islamist regime that took power in 1979 mark the resonance of this millennial historical position. Another telling aspect of the country's makeup are the numerous ethnic groups living under the domination of a Farsi-speaking majority—a fluctuating 50 percent of the population actually would list Farsi as a mother tongue.[2] Other ethnic groups (Arabs, Armenians, Baluchis, Kurds, Luri, and Turkomen) live with the understanding that their minority status has never been favored under Iran's long absolutist governmental tradition. Politically the country has been dominated by an absolutist governmental tradition that has always sought to quell ethnic division. In 1971 the last Shah of Iran ironically celebrated the 2500-year anniversary of the establishment of monarchy by Cyrus the Great just before the Islamic revolution toppled his regime and forced him into exile.

If geography and ethnic identity are factors of cultural separation encouraging absolutist tendencies politically, then a unifying force has been religion, as reflected in the vigor of the theocratic putsch that brought a theocratic regime to power in 1979. The indigenous religion in Iran, Zoroastrianism founded by Zoroaster (628–551 BC), advocated an early

form of monotheism with a duality between the benevolent Ahura Mazda and the malevolent Angra Mainyu as arbiters of a universe where humans enjoyed enough free will to determine their fate. Another religious influence came from the philosophy espoused by Mani (AD 216–276), founder of Manichaeism, which also interprets reality as a duality between good and evil, light and dark, and individual free will and fatalistic acceptance of larger forces.

A Zoroastrian or Manichaesitic dualism between good and evil and light and dark is evident in Iran's national epic, the *Shahnameh* (*Book of Kings*), composed by the tenth century poet Ferdowsi (935–1020). At the turn of the first millennium, the last Zoroastrian regimes faced increasing Arabic invasion. Subsequent Mongol and Turkish invasions would further threaten the dominance enjoyed by the Farsi-speaking majority. The *Shahnameh* has been a cornerstone of Iranian cultural and linguistic identity as the contemporary Farsi language is derived directly from the *Shahnameh* and has been as vital to the form of contemporary Farsi as Dante's *Divina commedia* has been important for contemporary Italian. In part due to the *Shahnameh*, Iran has retained a Farsi linguistic identity despite Arabic, Turkish, and Mongol invasions. The *Shahnameh* features tales of the heroes Rostam and his illegitimate son Sohrab that have been adapted either directly or indirectly into film in Iran since the advent of cinema. Abdolhossein Sepanta, the director of the first Iranian talkie, *The Lor Girl* (1933), made a biopic of the life of the poet Ferdowsi in 1934 with a narrative that describes the commission the poet received from the sultan to write the national epic, the *Shahnameh*. In a key sequence the poet Ferdowsi, played by the director Sepanta, recites the tale of Rostam and Sohrab before the Sultan Mahmud Ghaznawi. In few other cases than Iran is the relationship between national literary culture and cinema so clear, given the centrality of Ferdowsi's epic to the defense and the propagation of the Farsi tongue.

After the Arab invasions Islamic proselytizing gradually eliminated Zoroastrianism as the country's dominant religion. However, Iran retained echoes of indigenous traditions within the framework of Islamic culture. Sufism and above all Shi'ism, which spread during the Safavid dynasty in the sixteenth century, contrast Sunnism, the format observed by many Arabs west of Iran. Within Shiite culture martyrdom exists as a paradoxical vehicle for the expression of individualism. Just as the Farsi language was retained through works such as the *Shahnameh*, despite periods of Arabic, Turkish, and Mongol dominance, Iranian Shi'ism and Sufism have been pointed out as an expression of national identity in reaction to the Sunni Arabs. There is consensus about the influence that these ancient sources as "Iran's ancient civilization, the Persian Empire, and particularly its Aryan elements, and the features of Islamic Shi'ism have been the main sources of

identity in Iran for centuries."[3] A film such as *Siyavosh at Persepolis* (1967) by Fereydoun Rahnema, for example, reflects the concept of martyrdom as willingness to accept death, which recalls the tale of the mythical hero Siyavosh from the *Shahnameh* who is martyred because he rebelled against what he could not hope to defeat.[4]

Pivoting off the influences listed above, it is possible to describe Iranian identity in terms of opposing forces whether between "extreme individualism [that] contrasts with a readiness to accept authority," which are consistently present in Iranian history, or as a reaction to "Iran's destiny, torn between anti authoritarianism and autocracy."[5] These themes are prevalent not only in classical Iranian literature but also in the Iranian cinema. Many Iranian films feature an "individual stoically accepting the status quo due to impotence in the face of a force too powerful to be surmounted."[6] The sources of this bipolar essence in Iranian culture derive from ancient sources, particularly from religion as listed above where "The struggle between good and evil, or light and darkness, from the ancient religion of Mazdaism, and the concept of martyrdom from the Shia Islamic tradition, reflect the spiritual side of Iranian national identity. Socially and politically, that identity has been bound to a resistance against those who would use absolute power to deny people justice."[7] The contrasting and volatile nature of the Iranian character mirrors the country's duality in geography and ethnic identity with themes of fatalism versus zealotry, light and darkness, and above all individual initiative versus submission to authoritarian power.

The depths of the linguistic divisions within Iran (again with an oscillating 50 percent considering the dominant Farsi as a mother tongue) has meant that the sort of educational plans for the creation of a national linguistic culture have historically faced tremendous obstacles not only due to the challenges of basic infrastructure within Iran's geography but also due to the divergences between official culture and minority ethnic identities. Many nations on the planet are former empires, but Iran with its Persian historical heritage still has an imperial identity through its rule over significant ethnic and regional minorities. In short, an indigenous film industry had little profit motivation to produce films only half the population would be interested in seeing and hearing. As mentioned above, political centralization has a millennial history in Iran, and the cinema has introduced a new facet to the often highly oppressive history of centralized, authoritarian control. In fact the history of the cinema in Iran has been somewhat sporadic with the total disappearance of an indigenous industry following World War II. The iconoclastic Islamist regime that came to power in the revolution of 1979 enforced severe censorship of cinema. Iranian films have, therefore, historically been quite acquiescent to the whims

and ideologies of the ruling regimes, whether the Pahlavi dynasty or the Islamist regime that deposed it in 1979. The ideological undertone and the content of Iranian cinema has shifted accordingly from the mimicry of Western and Indian film styles before the Islamic revolution; to attempts of Iranian filmmakers to practice their craft under an Islamic culture dominated by paranoid iconoclasticism. However, unlike other nations examined herein in Iran the promotion of a national language was not the sort of turning point in the development of a national cinema culture. The emphasis of much of the Iranian cinema after its period of hiatus following World War II was in the production of musicals influenced by Hollywood and Bollywood. Even in the present period, many of the more renowned Iranian filmmakers have opted for a cinematic style dependent on long takes that emphasize the visual rather than the oral aspects of the cinema. This is not to say that an indigenous film industry was not able to form a cinematic culture based on indigenous themes. In fact the weight of the cultural heritage of a nation as ancient as Iran has been determinative of the manner and process in which the Iranian cinema formed its identifying characteristics.

The first Iranian sound film *The Lor Girl* (1933) by Ardeshir Irani and Sepanta was heavily influenced by the Indian Bollywood cinema especially in the film's song-and-dance sequences. The film was actually produced in India where it was distributed for the Farsi-speaking minority. The film was a huge box office success and offers an early indication of the master plots and themes that would come to define the Iranian cinema. In the film a dancing girl in a remote area is rescued from a seedy, remote teahouse and its unscrupulous owner by an urban, government agent hero. On the surface, the film's story line seems to be a standard adventure rescue tale with narrative tensions between rural-urban and a heroic figure rescuing a love interest with a revenge motive. However, the film gives a precise indication of the manner in which Iranian films, and especially those popular with an uneducated and even illiterate Iranian public, have a strict and submissive relationship with the dictates of political power. The references in *The Lor Girl* to banditry in remote areas and collusion between corrupt local figures and the bandits against the political aims of the central government had a precise connotation in early-1930s Iran. The Reza Shah regime that took power in 1925 made a point of increasing the central government's control over remote areas, a millennial goal of Persian autocrats that persists to the present day. The female protagonist in the film, Golnar, is a member of a minority tribe, the Lor. The coffeehouse where she dances is frequented by another minority in Iran, Arabs. The film's antagonist, Ramazan, the coffeehouse owner, is in cahoots with a local bandit, Gholi Khan, with whom he shares information about arriving caravans

in exchange for a share of the stolen booty. The dancing girl Golnar had been captured from her hometown by these raiders who also murdered her family. She thus ended up as a dancing girl, a position with very low social status especially considering the strict restrictions on female display in Islamic culture. The film's protagonist, Ja'far, played by film's director Sepanta, is an undercover government agent who defeats and extracts revenge on both the bandits and the innkeeper and marries Golnar for a happy ending. The Iranian public responded well to a product in their language, but they also responded to the film's narrative that has themes of a hero resolving a situation and extracting personal revenge while working for the benefit of ruling interests—in this case the Reza Shah regime. The hero's individuality becomes an asset for the realization of the larger political goals of the government.[8] This early film hints at the master plots and themes that would become important in the Iranian cinema, in particular the reliance on heroic story lines that relate tales of sacrifice recalling martyrdom traditions but more important the contradiction of a split between individualism and subjugation to the dictates of authority.

These themes of individuality bring forth the other central issue of how the film handles female representation. The plotline of a fallen woman and the female displays are central to the cinematic essence of *The Lor Girl*. The film's producers had to overcome the obstacle of casting a Farsi-speaking woman willing to appear on-screen for the leading role. In fact, as mentioned, the film was apparently produced not just in Iran but also in nearby India. The film's enlightened treatment of female representation reflects the period in which the Reza Shah regime attempted to follow the example of Kemal Ataturk's Turkey by promoting lay society and reversing the centuries-old tendency in Islam to focus iconoclastic phobias not only on pictorial representation but also on female display. The very fact that the first Iranian talkie is also the first film to star a dancing and speaking woman points to some of the inherent contradictions in Iranian culture between the validation of authority and the desire for individuality. These nods to authority would also be a theme in Sepanta's second talkie, the biopic of the national poet Ferdowsi mentioned previously, which did not enjoy the box office success of *The Lor Girl* but which also has a theme of individuality dominated by omnipotent authority figures where the protagonist uses his individual brilliance to serve the ruling power. The story line in *The Lor Girl* of a dance hall girl rescued by a male hero with a revenge theme repeats in various guises throughout the history of Iranian film, often with results popular among the populace. Such tales of reacquired honor and revenge in which a heroic male reasserts a lost equilibrium were common in the Iranian cinema in the postwar period.

Film production in Iran actually came to a standstill from the late 1930s until 1948. The Iranian film industry stifled during the late 1930s with no films made between 1936–48. Production started again in 1948 under British colonial control with films made for profit by studios such as Farsi Films often featuring song-and-dance melodramas or historical dramas in which an individualistic hero fights to further the power of an absolutist ruler. The films of this period, especially those made by Farsi Films, featured happy endings with heavy emphasis on song-and-dance routines recalling Hollywood and Bollywood cinema and even some nudity in the 1970s. This period has been somewhat dismissed by film historians who note the low production values used and the practice of dubbing the singing voices of famous actors with popular singers.[9] Under the influence of foreign cinema, especially Bollywood and Hollywood, many of the indigenous elements were watered down. However, the story line of a heroic protagonist whose individuality was used to assert a ruling power remained in films such as *Joseph and Potiphar's Wife* (1956) as an example of the contrasting nature of the narratives at work in Iranian cinema. The Iranian cinema also produced films about Iran's origins such as *Siyavosh in Persepolis* (1967) or *The Son of Iran Does Not Know His Mother* (1976) by Fereydoun Rahnema.[10]

When Iranian films achieving box office success examined themes at a more intimate level in melodramas such as *The Treasure of Croesus* (1965) by Syamak Yasami, the contrasting nature of Iranian film reached a higher level of expression. In the film a wealthy, terminally ill man who had expelled his wife and child over a question of honor meets his son who is now lower class. The father realizes the error of his ways and the family reunites with a narrative that recalls elements of the Rostam and Sohrab tales about estranged father and son from the *Shahmenah*. Similarly in *The Storm of Life* (1948), by Ali Daryabegi, a young woman forced into marriage with an older man, eventually accepts her fate and the requirements of family and society in negation of her individuality.

One of the most important films in the Iranian canon is *Gheisar* (*Ceasar*; 1969) directed by Masoud Kimiai starring film icon Behrouz Vossoughi. This film adapted the melodramatic currents from classical Iranian literature to achieve immense box office success. The film took the social phenomenon of gangs of toughs in Tehran known as *luti*, whose knife-wielding honor code has ancient roots. In the film a younger brother avenges the rape and subsequent suicide of his sister and the murder of his brother who died while attempting to extract revenge for the abuse of the sister. The film ends when the police shoot the protagonist in a railway car, reestablishing state control after the suspension of state power through a revenge bloodbath. The film struck a chord with the Iranian populace for

the manner in which an individualistic antihero reacts to injustice with references to melodrama within the violent essence of ancient warrior codes. The film actually became the basis for the formation of an Iranian genre, the *luti* film, featuring as protagonists young, violent urban men not directly connected to the ruling faction politically but able to express their individuality within the structure of existing cultural codes and authority constraints. The directing/acting team of Kimiai and Vossoughi would team up for seven other films.

Gheisar *also touched a common chord with the Iranian populace for the manner in which it depicted the traditional revenge-honor story line that took into account spiritual matters with an awareness of the ancient tenets of Iranian culture and similarities with the mystical hero Siyavosh and Shiite martyrdom cults. A key sequence in the film is when the protagonist decides to accompany an elderly widow on a religious pilgrimage to a holy city for a self-purification ritual before the final showdown, which he understands will result in his violent death.[11] The film features an adhesion to ancient codes both religious and cultural as well as the extreme individualism of the protagonist who eventually must cede to the dictates of the authority. The luti current allowed for themes of extreme individualism existing under the weight of authoritarianism, whether theocratic or monarchical, which is a continuing current in Iranian cinema from the films of the 1930s to those of the postrevolutionary period. Iranian hero films whether made under an autocratic monarchist or a theocratic regime feature individualistic protagonists who display great ingenuity but remain subservient to the dictates of the system.*

Like many national cinemas, Iranian directors took influence from the art cinema in the West for the development of an oppositional style influenced by alternative cinema styles such as Italian neorealism facilitating production of films without the budget constraints of commercial cinema. Farokh Ghafari's *The Night of the Hunchback* (1965), adapted from a story in the *One Thousand and One Nights*, is about a hunchback actor who suffocates on a bone in his throat. The resulting paranoia about the direction of a police investigation reveals the underbelly of Iranian society. In *The Cow* (1969) by Dariush Mehrjui, a cow, important to the economic life of a small village, dies when the owner is away. Upon returning the owner starts acting like a cow. Other films like *Brick and Mirror* (1965) by Ebrahim Golestan developed a tradition of Iranian films that took simple stories, in an echo of art cinema, to present human drama.[12]

As mentioned the rise of Shiite fanaticism in the years preceding the 1979 Islamic revolution brought the destruction of cinemas in accordance with the iconoclastic tenets of Islamic theology hostile to pictorial representation. The burning of cinemas with spectators still inside, often explained as

an act of defiance against the Shah's regime, actually has roots in the icono-clastic fury of religious extremism. During the revolutionary upheavals 31 cinemas out of 177 were torched in the capital city of Tehran, and 125 cinemas were burned nationwide. Out of a nationwide prerevolution total of 524 cinema houses, only 314 remained intact following this period.[13] For once burned down cinema theaters were rebuilt only with great difficulty.[14] The last film of the directing/acting team of Kimiai/Vossoughi, *The Deer* (1975), is about a bank robber and drug addict friend on the run with the morbid distinction of being on the screen when Islamist fanatics blocked the exits of the Cinema Rex in Abadan in 1978 for the murder of over 400 people who died in the fire.

After the Islamic revolution, the film industry offered films that repeated the themes of the prerevolutionary period with appropriate political changes in which "the protagonist usually a devout Muslim, would rebel against tyranny and do battle with the forces of disorder."[15] *Hellraisers* (1982) by Iraj Ghaderi was a Farsi film production that attempted to adapt the style of past commercial film to the dictates of the Islamist regime. In *Hellraisers* starring prerevolution male icon Fardin, Iranians attempting to flee the revolution demonstrate their national allegiance in the defense of an Iranian town during the lead up to war with Iraq. There was also the reemergence of revenge films echoing the *luti* genre targeting anti-Islamic targets. Films developed a tone of propaganda that in many ways recalls the Socialist realist films of the Stalinist period. Characters find themselves in situations in which their understanding of an ideology (Communism for Socialist realism and Islamicism for the postrevolutionary films of this type) leads to victory for the collective whether the proletarian state or the *uumah*—the general, worldwide Islamic population.

After the 1979 revolution the Iranian cinema developed into one of the greatest paradoxes in the history of world cinema. The severe censorship of the regime actually has seemed to raise the quality of Iranian films despite the fact that the regime actively discouraged filmmaking as an un-Islamic activity, although not to the point of attempting a total ban as was report-edly the case with chess and musical instruments.[16] Ironically the Iranian cinema has become one of the most lauded in the world, triumphing at film festivals worldwide where oppositionality is defined in terms of cin-ematic narratives in contrast to Hollywood (or Bollywood) commercial cinema, although this critical success outside Iran has not been matched at the domestic box office. Nevertheless the success of the Iranian cinema and its ability to evoke political and social themes has been a significant boon to recent political efforts to resist the regime. As such the current Iranian cinema provides an example of the manner in which ruling elites must treat the cinema as a potentially double-edged sword that not only may

serve a regime for the propagation of approved messages but also has the capacity to become a vehicle for dissent. Many recent Iranian films so lauded internationally feature children as protagonists within a narrative structure that adheres to the Iranian tradition particularly in terms of individual reaction to and compliance with the dictates of authoritarianism. In the films children are in an obvious position of physical, economic, and social inferiority and must live according to the whims of figures of authority, whether the state, parents, teachers, or neighbors. According to noted cultural theorist Edward Said, the idea of infantilism as an aspect of oriental identity should be questioned as a product of Western prejudice.[17] However, given the tension between a rigid and oppressive regime and the desire for adequate self-expression on the part of Iranian cinéastes, this manner of framing a reaction to authoritarian rigidity is too cohesive to be dismissed out of political correctness. Above all the children in these films are apolitical, asexual, and as such, unrestricted by the iconoclastic paranoia of the regime's bans on imagery. Children offered a perfect vehicle for filmmakers to depict an otherwise hermetically rigid milieu so intransigent in the defense of its theocratic ideology. The children's films made under the Islamist regime actually began as a cultural project under the auspices of the previous regime that supported film institutes promoting children's art. These institutes became a haven for the development of an important generation of Iranian filmmakers.

Bashu the Little Stranger (1986) by Bahram Beizai depicts a young boy who escapes from the Iran–Iraq War (1980–88) to northern Iran. Neither the boy nor his host family are of the Farsi-speaking majority and yet they learn to coexist within the economic and cultural constraints of the country in which they live. In *Children of Heaven* (1997) by Majid Majidi, a brother and sister must share a pair of sneakers after the sister's shoes are accidentally lost. They must work together behind the backs of their parents and authority figures (principle, teachers, and shopkeepers) against whom the children have no recourse but to appeal for pity. In *The White Balloon* (1995) by Jafar Panahi, a girl wants a chubby goldfish and leads her brother on a voyage of discovery of Iranian society. Kianoush Ayari offered *The Abadanis* (1994), a remake of Vittorio De Sica's *The Bicycle Thief*, revealing an influence of Italian neorealism in Iranian cinema. The cinematic style developed out of this current of children's films was recognized by international critics for its use of long takes that helped communicate the psychological interior of characters. These films feature nonprofessional actors and on-location shootings, often pragmatic consequences of a lack of funds and studios as well as a conscious, aesthetic approach. Ironically the use of these spare techniques has allowed the Iranian cinema to develop a style, which due to the seemingly harmless subject matter of the narratives

featuring children, has been able to skirt the most severe of the iconoclastic prohibitions from the regime. In this vein the Iranian cinema has been able to turn its obstacles into advantages for the creation of one of the most vibrant and creative cinemas of the latter twentieth century.

The other aspect of recent and lauded wave of Iranian cinema is paradoxically in female themes, which have risked censorship from the Islamist regime. Women have legal status in patriarchal Islamic societies largely on par with minors, thus in practical terms the narratives of films featuring women as protagonists have a similarity to films with children. In *Leila* (1996) by Dariush Mehrjui, a newlywed bride cannot conceive and must suffer the consequences in a patriarchal society. In *Two Women* (1999) by Tahmineh Milani, female architecture students find their paths blocked by social and religious prejudices. In *Offside* (2006) by Jafar Panahi, adolescent cross-dressing girls sneak into a stadium to see the Iranian national soccer team, but they are detained by army guards since women's attendance at sporting events is restricted. The film is interesting for the manner in which it puts a human face on the Draconian restrictions of the regime. In fact, the rigid punishments for females attending a game do not seem to frighten the rebellious and independent-minded girls, who place their passion for soccer above their personal safety. Despite their outward spirit of rebellion, once arrested the girls display a submissive fatalism when faced with the dictates of gender segregation from the Islamist regime. *Women's Prison* (2002) by Manijeh Hekmat, (see Figure 5.1) banned from theatrical release, has been interpreted as a metaphor for the postrevolutionary period with the incarcerated women and their warden as victims of the same system, with each becoming more and more willing to bend the rules of the regime as the years pass. Yet if the film is viewed within the context of an Iranian national cinematic narrative, it is about the acquiescence of the individual to authority. The heroine, Mitra, enters the prison as a rebellious youth and has a battle of wills with the strict warden. Their ability to come to terms concludes with Mitra's release for good behavior despite her murder conviction. As she departs she is celebrated by the next generation of individualistic and rebellious youths who like her will undergo the same process of submission to authority.

The master of this puerile-themed cinema, at least in terms of international recognition is Abbas Kiarostami, a director who began his career in the Shah regime's film institutes and has actually been able to tackle themes not limited to children. In his films *Life and Nothing More* (1991) and particularly *Taste of Cherry* (1997), individuals face an indifferent world, and their reactions against obstacles, whether natural or societal, express an essence of fatalism. In *Taste of Cherry*, a rich, suicidal, Farsi-speaking man accosts a series of poorer men from Iran's minority ethnic groups

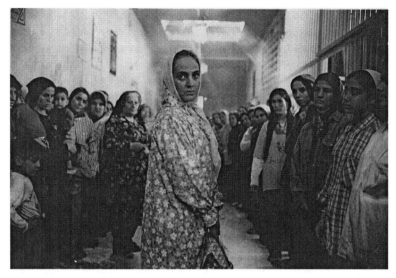

Figure 5.1 *Women's Prison* (2002, Iran) a.k.a. *Zendan-e zanan*. Credit: Bamdad Film/Omid Film/Photofest © Bamdad Film/Omid Film.

including a Kurdish soldier, an Afghan seminarian, and a Turkish taxidermist. The film presents a version of the fragmented Iranian nation among dry, urban outskirts and construction sites that seem like a netherworld on the fringes of official culture. The protagonist wants to be buried correctly after having committed suicide. In the Middle East it is a common practice to require burial by the evening of the day of death. Despite making lucrative offers his request is rejected on religious and legal grounds by all except the Turk. The reality of the man's request is given by the fleeting images of crows hovering over the dirt road near his intended place of self-interment. The man is not only concerned about customs but also arguably apprehensive that his corpse will be defiled by scavenging birds. The Turk tries to dissuade the man from his desperate act by recounting how his own plan to hang himself from a cherry tree was thwarted by the innocence and life-affirming vitality of children. Although the film does not have child protagonists, it retains the narrative simplicity of the current of Iranian children's films. The Turk recounts that when some children saw him in the tree preparing to kill himself, they asked him to stop what he was doing to help them pick cherries. The act of picking cherries became a life-affirming act that dissuaded the Turk from suicide. The anecdote, however, has no effect on the protagonist. Suicide is an inherently individualistic act, but

the process of the protagonist's death involves an act of acquiescence to cultural and religious tradition. The film combines elements of individual initiative in a negative sense, with the protagonist's suicide plans and his adherence to the dictates of burial customs required by larger authority.

Besides critically acclaimed films, there has also been a tradition of spoofs, which have been well-received by the Iranian public. In *Snowman* (1998) by Davood Mir-Bagheri, a man poses as a woman in order to attain a visa to the United States. In *The Lizard* (2004) by Kamal Tabrizi, a man comically impersonates a Mullah. Yet even in these more popular films, the essence of the Iranian cinema with its tension between individualism and submission to authority that has deep roots in Iranian history, literature, and religion shine through.

Like China and India, the Iranian cinema is the heir to one of the great cultural traditions of the planet. Despite changes in government the Iranian cinema has established a thematic identity reflecting roots in geographical and cultural heritage. At present the Iranian cinema is the purveyor of one of the great ironies in world cinema history whereby severe iconoclastic censorship has actually fostered an oppositional film culture that has justifiably received praise. Due to its imperial past and technological backwardness, Iran did not complete the process of modern nation building in the nineteenth and early twentieth centuries whereby cultural identity and linguistic assimilation occurred in concert with the development of narrative conventions reflective of national cultural heritage. Yet even in the case of a cinema like Iran, which was actually inactive in much of the early sound period, the cinema reacted to public taste to develop a national cinema that reflects deep themes within Iranian culture.

6

Italian Circularity

When reduced to basic plot elements, Italian films are often structured like moralizing melodramas where the characters return to the same basic situation in which they started. If the Italian film canon is examined in this interpretative key, analysis reveals an oft-repeated narrative pattern that draws from deep-seated literary, historical, and cultural sources.[1] The narrative commonplaces consolidated during the early sound cinema of the 1930s and continued in the neorealist period and beyond have in fact been a characteristic of the Italian cinema in the work of noted directors across genre divisions.

The cinema first appeared in Italy at the turn of the twentieth century when the country was dominated by the national romantic model of a heroic Risorgimento, the resurgence of Italian nationalism in the nineteenth century that led to unification under a Piedmontese monarchy in 1870. The first Italian film, *La presa di Roma 20 settembre 1870* (*The Taking of Rome 1870*; 1905), is a re-creation of Giuseppe Garibaldi's Red Shirts' conquest of papal Rome, the last obstacle to Italian unification under a Piedmontese monarchy. The Risorgimento ideology was promoted by a social and intellectual elite influenced by romantic nationalism as well as post–1848 republicanism and anticlericalism. However, the Italian nationalism championed by nineteenth-century nationalist republicans like Giuseppe Mazzini (1805–72) and continued by twentieth-century nationalists like Gabriele D'Annunzio (1863–1938) and national socialists like Benito Mussolini (1883–1945) never displaced Italy's regional cultural and historical roots that were simply too deep to be altered by the rhetoric of romantic nationalism.

Perhaps the simplest explanation for this situation is geographical. Italy is covered by two extensive mountain ranges: the Alps in the north and the Apennines through central Italy. Unlike England, France, or Spain where geography aided the gravitation toward a national capital, the mountainous characteristics of the Italian peninsula allowed regional identities to

flourish. To this day inhabitants of the peninsula are apt to define themselves by their city or region rather than as Italians. This would be a disadvantage in political terms but an advantage in cultural terms for the wealth of regional cultural identities has bestowed Italy with an artistic heritage unrivaled on the planet.

Besides the Risorgimento the other potential foundational narrative for a newly unified Italy, particularly popular in the national culture espoused by Mussolini's Fascist regime, was an attempt to identify the newly united Italy with the past glories of Rome. The Rome of peplum sand and sword epics has appeared steadily in the Italian cinema since its earliest days in works such as *Last Days of Pompeii* (1908), *Nero's Burning of Rome* (1909), *Spartacus* (1909), *Quo Vadis* (1913), and *Anthony and Cleopatra* (1913). It was continued with regularity and even distributed internationally through the 1950s in films like Mario Camerini's *Ulysses* (1955) or the peplum serials in which American muscleman Steve Reeves played Maciste or Hercules. However, the Italian peplums do not explicitly express aboriginal Italian cultural identity. In fact the source material for the Italian peplum was often from Christian novels such as Nicholas Patrick Wiseman's *Fabiola*, adapted to film by Enrico Guazzoni in 1916 and Alessandro Blasetti in 1949 or Henryk Sienkiewicz *Quo Vadis*, adapted by Guazzoni in 1912 and again in 1924 by Arturo Ambrosio from a script by Gabriele D'Annunzio.

An indicative attempt to turn the peplum into an Italian foundational narrative was *Cabiria* (1914) directed by Giovanni Pastrone and scripted by Gabriele D'Annunzio. *Cabiria* links Italian nationalism to the ancient Roman republic rather than to tales about the foundation of Christianity like *Quo Vadis* and *Fabiola*. *Cabiria*'s hero, Fulvio Axilla, and his balding, barrel-chested, Mussolini-like African servant, Maciste, relate a republican-era Rome fighting a rival Mediterranean empire (Carthage) and a foreign religion (Baal or Moloch). Italian audiences in 1914 could recognize similarities between Rome's victory in the Second Punic War over the Baalite Carthaginians and the Italian defeat of the Islamic Ottoman Empire during the 1911 invasion of Libya. *Cabiria* reflects the political and ideological currents that culminated in the efforts of pro–World War I interventionists such as D'Annunzio and Mussolini instrumental in the decision of the Italian government to enter World War I in 1915. *Cabiria* was rereleased as a sound film in 1931 and remade as *Scipione l'africano* (*The Defeat of Hannibal*; 1936) under the personal patronage of Fascist dictator Mussolini. However, like the Risorgimento foundational myth of the *padri fondatori* (founding fathers) of the Italian nation, the recasting of ancient Rome in protonationalist and Fascist garb whether in 1914 or 1936 did not break down the collective consciousness of an Italian public that continued to identify itself in regional terms.

The essence of Italian cultural outlook is regional, tempered by a calculating *trasformismo*, the idea of the static nature of Italian political and cultural life as defined by Prime Minister Agostino Depretis (1813–87) whose early postunification governments had difficulty enacting social and political reforms. The discourse of *trasformismo* is itself a centuries-old concept with roots not in the Risorgimento but in Renaissance-era, *ago della bilancia* (balancing needle) politics of figures like Florence's Lorenzo de'Medici (1449–92) and the *particulare* (self-interest) policies of papal statesman Francesco Guicciardini (1483–1540). These Renaissance-era figures strove to maintain regional powerbases in an Italy subject to foreign invasion in the fifteenth and sixteenth centuries. Whether the world-weary and cynical political attitudes of Italians are defined as Depretian *trasformismo* or Guicciardinian particularism, the result is the same. Italy was the richest and most technologically advanced country in Europe until the sixteenth century when the peninsula became the battleground for the more consolidated monarchies in Europe seeking to establish continental hegemony. The republican culture and the vibrant artistic and technological flowering of the Renaissance gave way to a period of subjugation to foreign courts with northeast Italy under the control of Austrian rulers, southern Italy under the control of Hispanic noblemen, and northwestern Italy under the cultural and military influence of France. The lesson of Italian political and cultural identity is to conserve regional autonomy through subterfuge that inevitably maintains the social and political status quo.

When Italy was finally unified in 1870, the country did not share a common language, much less a common historical identity. To cite one example one of the courtly languages the Piedmontese kings who fought to become the kings of Italy was French. The Piedmontese court also was simply acting like much of the elite of Europe in the nineteenth century, and in particular Eastern Europe, which was unabashedly Francophile. Along with this lack of indigenous political culture, there has been the persistence of dialects in the Italian peninsula. The contemporary Italian state has recognized as many as 17 separate dialects, which in some cases have differences as marked as between Castilian, French, or Romanian. The task before the first education ministers of the newly unified Italy to create and to diffuse a national tongue was immense and not really completed until a majority of Italian households had not only a radio but also access to a television set. A standardized Italian based on the texts of Tuscan writers of the thirteenth and fourteenth centuries (Dante, Petrarca, and Boccaccio), sanctioned by a national educational system, has finally become a national tongue due to the influence of television. Before and during the struggle for Italian independence in the nineteenth century, this was not the case. Milanese novelist Alessandro Manzoni (1785–1873) decided to rewrite his

novel *Fermo e Lucia* as *I promessi sposi (The Betrothed)* after spending a period in Florence familiarizing himself with the Tuscan dialect that is the source for standardized Italian. This division between regional identity and national culture has been a continuing aspect of the Italian experience.

When silent film appeared Italians launched into the new media excitedly with peplums, comedies, disaster movies, and melodramas derivative of the plot structure of musical opera. But for Italian cinematic culture to truly establish itself, the nation would have to wait until the early 1930s when sound allowed indigenous filmmakers a chance to compete with the Hollywood film industry, which had begun to dominate world film production and distribution after World War I. The early sound period was concurrent with a political climate in which many countries in Europe underwent right-wing political turnovers before the outbreak of World War II. This global right-wing political tendency included a reliance on protectionism in trade that extended to cultural policies. National interests were emphasized politically, militarily, culturally, and industrially as an expression of prestige. In Italy the appearance and diffusion of sound film coincided with the cultural and political moment of Mussolini's Fascist regime (1922–43). By the mid-1930s after the conquest of Ethiopia and subsequent international economic sanctions from the League of Nations, the Mussolini regime sought to foster autarkic national economic policies that extended to culture. Fascist civic organizations such as the National After work Organization (OND) and youth groups such as the *Balilla* were the cultural arms of the economic and political programs of autarky, or self-sufficiency, in defiance of League of Nations sanctions. Steps were taken toward creating a stable and vital Italian film industry with the establishment of *Cinecittà* studios in Rome and celebration of the Venice film festival. The *Minculpop* (Ministry for Popular Culture) encouraged the development of the Italian film industry. The regime also renegotiated distribution contracts to the extent of creating a de facto boycott of Hollywood films. Italian filmmakers able to use the extensive film studios at *Cinecittà* bounded into the vacuum, and one of the most creative periods of Italian filmmaking ensued.

The autarkic backdrop and the socially reactionary politics of the regime created a climate for cinematic narratives that not only discouraged the breaching of class boundaries but also reflected the basic fatalistic lessons of Italian history, which had been inculcated by centuries of Catholic education and imagery. A recurring narrative pattern of Italian film in the early sound period is a circular storyline in which a protagonist faces an obstacle and then has a series of adventures, which brings him or her back to the same situation and class status that began the story, having acquired varying levels of wisdom. This circular and somewhat fatalistic

narrative pattern, established during the early sound period of the Italian sound cinema as a seeming reflection of Italian society under the Fascist regime, has become a staple feature of the Italian cinematic canon, as the examples below will illustrate.

Although the regime tended to be inconsistent in its linguistic film policy, at times restricting local dialects and at times favoring them, the very appearance of Italian films in Italian rather than in dubbed dialogue did much along with radio broadcasts to consolidate the standardization of the Italian language. A standardized form of Italian was definitely evident in the newsreels that gave many Italians attending the theaters their first real taste of modern journalism subservient to governmental controls or hegemony. Mussolini, a former journalist, was apparently initially more concerned with the production of newsreels than with fiction films, establishing government entities to produce and distribute regime-sanctioned newsreels. Mussolini was particularly attentive to the power of the news media to shape and even create public opinion.

Telefoni bianchi (White Telephones)

A circular narrative is prevalent in the *telefono bianco* (white telephone) romantic comedies of the 1930s and 1940s, particularly in the films of Mario Camerini starring Vittorio De Sica. In Camerini's films comedic elements derive from a masquerade in which roles are exchanged between different economic classes via the theft of a class-identifying object. In *Gli uomini, che mascalzoni (Men, What rascals*; 1932), Bruno borrows his boss's luxury car in order to court Mariuccia. In *Darò un milione (I'll Give a Million*; 1935), the millionaire Gold disguises himself as a pauper in order to woo his love interest. In *Il Signor Max (Mister* Max; 1937), Gianni assumes the alter ego of a member of the leisure class on a luxury liner in order to impress lady Paola. In *I grandi magazzini (The Big Stores*; 1939), Lauretta steals a set of clothes to impress Bruno. In each film the plot is centered on the theft of a class-related object (car, camera, outfit), which makes the breaking of class boundaries credible. The imbalance is restored when the masquerade is discovered and the object is returned for the preservation of class status quo.[2]

These films were party to a narrative current whose storylines featured an affected *fatalona* (femme fatale) whose xenophile attitudes threaten a virtuous but naïve male protagonist who eventually resigns himself to his original class status. Examples include the films of Mario Bonnard such as *Io suo padre (I His father*; 1939) in which a *fatalona* played by Clara Calamai bewitches a young boxing champion or *Campo de'fiori (Peddler and*

the Lady; 1943) in which Aldo Fabrizi's virtuous fishmonger is tempted to ignore class boundaries and reject the *popolana* played by Anna Magnani. In these films after a series of adventures, the protagonist comes to his senses and accepts his original class status. Another example lies in Alessandro Blasetti's *Quattro passi fra le nuvole* (*Four Steps in the Clouds*; 1942), a drama in which a traveling salesman returns to his urban life after masquerading as a pregnant girl's husband in the countryside. The salesman takes temporary delight at his new role in bucolic surroundings before returning to his drab family obligations in the city. The films previously mentioned were part of a dominant current in Italian cinema in the early sound period and established narrative expectations among the film-going public.

Costume Dramas

The circular narrative pattern of the films described previously in the early Italian sound cinema is not only limited to romantic comedies or melodramas but also extends to military adventure films and even historical dramas, the other genres most prevalent in Italian production of the period. Alessandro Blasetti used a circular narrative in his military adventure films such as *1860* (1933) in which a couple divided by the Risorgimento return to their everyday life after Garibaldi's heroics at the Battle of Calatafimi. Blasetti's Renaissance drama *Ettore Fieramosca* (1938) depicts Italian nationalist pride and military virtue of the Renaissance-era *disfida di Barletta* (challenge at Barletta). In the film the Italian knights may vanquish their French counterparts in individual battle, but they do nothing to end foreign domination of the Italian peninsula. These films reflect the historical cultural heritage of Italy through narrative conventions that met with public approval.

Neorealism

After World War II the Resistance movement against the Nazis and Fascists became identified with the naturalistic style of neorealism, retelling the story of World War II not only as a defeat for Mussolini's Fascist regime but also as a victory for the anti-Fascist Resistance. Films like Roberto Rossellini's *Roma città aperta* (*Open City*; 1945) and Aldo Vergano's *Il sole sorge ancora* (*Outcry*; 1946) depicted the Resistance as a moment of choral unity among Italy's Catholic and Communist political factions against Nazi and Fascist oppressors. The model of the heroic Resistance or a Catholic restoration became a foundational model for the postwar Italian republic before

being challenged by new ideological and political moments such as Cold War bipolarism, the economic boom culture of the 1950s and 1960s, the iconoclastic 1960s youth movements and 1970s eurocommunism. Yet as we will see in the following examples, despite the differences in these political and cultural moments, the Italian cinema retained narrative patterns whose plots are circular, fatalistic, and socially static.

Socially conservative narratives discouraging class bounding continued in postwar Italian film. In his postwar films Vittorio De Sica (in Figure 6.1) relied on the circular narrative patterns and the plot convention device of class masquerade and theft of a class-identifying object theft from Camerini's romantic comedies of the 1930s. In De Sica's melodramas from the neorealist period such as *Ladri di biciclette* (*Bicycle Thief;* 1948) and *Umberto D.* (1952), the loss of status symbols (bicycle, dog) is presented from the perspectives of the owners, but class status is retained when the films conclude. Such circular story lines pervade other noted films of the neorealist period. Roberto Rossellini's *Roma città aperta* (*Open City;* 1945) begins with a scene of Don Pietro playing soccer with children at the church oratorio and ends with another scene of children walking into a panorama dominated by the dome of St. Peter's Basilica, an expression of

Figure 6.1 *The Gold of Naples* (1954, Italy). Credit: Paramount Pictures/ Photofest © Paramount Pictures.

Catholic identity and continuity despite the death of the protagonist. The decision of the showgirl Marina to betray her partisan boyfriend Manfredi to the Nazi/Fascists is depicted as the result of her desire for higher social and economic status as symbolized by the *telefono bianco* décor of her upscale apartment. When the Nazi spy Ingrid removes the fur coat from a Marina trembling in shock at the sight of her agonizing boyfriend, the act signifies Marina's return to previous class and economic status. This plot twist recalls the narrative patterns of the romantic comedies of the 1930s and the moralizing melodramas that have a circular narrative pattern. In postwar films collaboration with Nazism and Fascism is an indication of an impulse to upset social status as in Camerini's undervalued wartime drama *Due lettere anonime* (*Two Anonymous Letters*; 1944) in which a couple reunites to restore class equilibrium after a period of betrayal, a plot structure shared by Aldo Vergano's *Il sole sorge ancora* (*Outcry*; 1946). In Luigi Zampa's *Vivere in pace* (*Live in Peace*; 1947), a drunken German soldier temporarily suspends the violent course of events accompanying the German retreat in World War II, but after a tragic settling of scores, life goes on as before. In Luchino Visconti's *La terra trema* (*The Earth Trembles*; 1948), the hopes of 'Ntoni to improve his class status are dashed, and he must accept subjugation before his landlords. In each of these important Italian films, there is a circular narrative reflective of the basic lessons of Italian historical identity.

Strappalacrime Weepies

From the previous examples it may be argued that despite innovations in cinematic style, many films of the neorealist period have circular plots that echo the class rigidity of the *telefono bianco* period of the 1930s. A circular narrative structure continued beyond the neorealist period in melodramas such as Raffaello's Matarazzo's *Catene* (*Chains*; 1949) in which the misunderstanding between the husband and wife regarding her supposed adultery is resolved, and their pair bond is restored by the end of the film. Alberto Lattuada's *Anna* (1951) is structured as a flashback in which the nun/nurse played by Silvana Mangano recalls the twisted love triangle that led her to take religious vows. In Pietro Germi's *L'uomo di paglia* (*Man of Straw*; 1957), a family man has a tragic love affair that leads to the suicide of his lover. However, the film concludes with his return to the safety of his family and class surroundings. These films of the Italian weepie (*strappalacrime*) current are evidence that narrative circularity was not only a phenomenon limited to art cinema destined for foreign distribution but also a staple of Italian popular film. For example Germi's other films include

the mafia drama *In nome della legge* (*In the Name of the Law*; 1949) and the comedy *Divorzio all'italiana* (*Divorce Italian Style*; 1961), which both have plots that reaffirm class and societal boundaries despite interceding adventures.

Art Cinema

Narrative circularity, whether in structure or in character development, also pervades Italian art cinema. In Rossellini's *Viaggio in Italia* (*Voyage to Italy*; 1953), the protagonists' search for reconciliation ends without closure. Throughout his career Federico Fellini refused to end his films with the conventional intertext *fine* (end), because he felt that the stories of his protagonists' lives continued.[3] There is a circular structure to *Lo sceicco bianco* (*The White Sheik*; 1952) in which newlyweds reconcile to receive a papal blessing as if their interceding estrangement had never occurred. *La strada* (1954) begins and ends with Zampanò at a beach, first hiring and finally thinking about his assistant Gelsomina. In *Le notti di Cabiria* (*The Nights of Cabiria*; 1957), a naïve prostitute repeats the same errors in her personal life to begin and end the film. In *La dolce vita* (1960), the protagonist Marcello remains in his vapid world of celebrity journalism despite the interceding tragedy of his encounter with the suicidal intellectual, Steiner. *Amarcord* (1974) is structured on the circularity of the calendar year. The film ends as it begins with the arrival of puffballs in the spring. *Città delle donne* (*City of Women*; 1980) is a dream sequence that begins and ends with the protagonist on a train in the same situation that began the film.

Other important Italian directors contributed films with circular plots. In Michelangelo Antonioni's *L'Avventura* (1960), the heroine returns to the indecision and anxiety of her life after the disappearance of her friend remains an unresolved mystery. In the last sequence of *Blow Up* (1966), the protagonist meets the same mime troupe that annoyed him at the beginning of the film, as if his discovery of a murdered corpse in a London park had never occurred. Lina Wertmüller's *Travolti da un insolito destino nell'azzurro mare d'agosto* (*Swept Away*; 1974) revives the themes of class envy of the 1930s *telefono bianco* period with a plot in which an upper-class lady is tempted by the earthy authenticity of a working-class lover. As in the films from the 1930s, equilibrium and class positions are restored at the film's conclusion. Wertmüller's *Pasqualino Settebellezze* (*Seven Beauties*; 1975) also has a circular narrative in which in the interceding adventure is a severe lesson in the social Darwinian horror of the Nazi Holocaust. In the end Pasqualino returns to his prewar existence as a Neapolitan Latin lover with his earthy world view intact. Other examples of circular

narratives by important Italian directors include Ettore Scola's *C'eravamo tanto amati* (*We All Loved Each Other So Much*; 1974). The film begins and ends with three repetitions of a sequence in which the working-class couple Antonio, Luciana, and their failed intellectual friend Nicola spy on their nouveau riche friend Gianni in his luxurious Roman villa. Their collective and quizzical grunt, "Boh," reduces 30 years of experiences from the anti-Nazi/Fascist Resistance to postwar reconstruction to a fatalistic acceptance of an unchanging and unchangeable world. In Francesco Rosi's *Tre fratelli* (*Three Brothers*; 1981), the three brothers temporarily reunited for their mother's funeral return to their separate, distant, and unchanged lives. Even Rosi's *Salvatore Giuliano* (1961) begins as it ends with the police measuring and photographing Giuliano's assassinated corpse. The bandit revolutionary had no ultimate influence on a static Sicilian reality. Bernardo Bertolucci provides edifying examples of circularity with plots in which protagonists from privileged backgrounds flirt with radical political ideas before accepting their class status in the films' conclusions. Examples include *Prima della rivoluzione* (*Before the Revolution*; 1962), *Il conformista* (*The Conformist*; 1970), and even *Novecento* (*1900*; 1976) with Olmo and Alfredo fighting as old men in the sort of competition that began the film. Even *The Last Emperor* (1987) begins with a theme indicating circularity. Pu Yi's soul arrives as a butterfly in the opening sequence and departs in a similar manner in the film's conclusion, an opening and concluding image repeated in Roberto Benigni's recent *Pinocchio* (2002). In Giuseppe Tornatore's *Il nuovo Cinema Paradiso* (1988), the protagonist is returned to his Sicilian origins when he screens a montage of kisses cut from the films of his youth, affirming the essence of his character and cultural formation. In Tornatore's *Malena* (2000) an estranged couple reunites after the tragedies of the war. The wife who had wallowed in prostitution during German occupation buys fruit at the market in the closing sequences as an indication of her return to prewar class status.

Commedia all'italiana (Comedy Italian Style)

The circular structure is also prevalent in Italian comedy in films starring popular actors such as Totò, Alberto Sordi, Paolo Villaggio, and even Roberto Benigni as further evidence that narrative circularity was a standard format for popular Italian films and not limited to art cinema or prestige productions. Examples include Neri Parenti's *Fantozzi* (1974) series starring Paolo Villaggio where the clumsy accountant Ugo Fantozzi retains his unhappy place with his firm and family despite the comic disasters he provokes. Despite Cioni's suicide attempt in Giuseppe Bertolucci's

Berlinguer ti voglio bene (*Berlinguer I Love You*; 1979) and Dante's experience unknowingly impersonating a mafia boss in Roberto Benigni's *Johnny Stecchino* (1991), the protagonists of these films starring Benigni remain in unchanged social and physical settings in the concluding sequences.

This narrative circularity in Italian comedy could be explained by deeper influences from Italian literature and culture. The plot structure in the Italian theatrical tradition such as the commedia dell'arte is circular. In the basic plot scheme, the interplay between stock characters like Pantalone, Pulcinella, and Harlequin hampers the successful pair bonding of pairs of unwed youths. When the pairs of young lovers unite in the concluding act, the stock clown characters return to their former state of equilibrium. This circularity of the commedia dell'arte has origins in classical theater and the carnival in which there is a return to precarnival time after a period of transgression. The idea of the influence of the commedia dell'arte on the *commedia all'italiana* (Italian style comedy) film comedies of the 1950s and 1960s is a commonplace in Italian film studies. Films such as Mario Monicelli's *I soliti ignoti* (*Big Deal on Madonna Street*; 1958) have updated versions of commedia dell'arte stock characters and a circular narrative in which the efforts of the gang to rob an apartment leave them in the same condition as they began. The circus parades that ends Fellini's *8 ½* (1963) and *I nuovi mostri* (*Viva Italia*; 1978), an episodic film by Monicelli, Dino Risi, and Scola, recall these theatrical and cultural conventions. Besides the commedia dell'arte–inspired works of Carlo Goldoni, narrative circularity is also a basic pattern in the works of later exponents in the Italian theater with examples that include the plays of Luigi Pirandello or Dario Fo.

Spaghetti Western

Circular narratives in Italian film continued to cross genre boundaries in the postwar period. In Sergio Leone's western *Per un pugno di dollari* (*A Fistful of Dollars*; 1964), the mysterious stranger Joe exits the town of feuding warlords just as he arrived, riding a mule accompanied by the bell ringing of the town clown Pieripero in a plot Leone actually ascribed to a Goldoni source, *Il servitore di due padroni* (*The Servant of Two Masters*; 1945). This plot structure repeats in *Il buono, il brutto e il cattivo* (*The Good, the Bad and the Ugly*; 1966). In *C'era una volta il West* (*Once Upon a Time in the West*; 1968), and *Il mio nome è Nessuno* (*Nobody Is My Name*; 1973) Harmonica and Nobody, respectively, go on their ways after the interceding adventures are complete.

Instant Movie

In the instant movie genre that appeared in Italy beginning in the 1960s with films such as Giuseppe Ferrara's *Cento giorni a Palermo* (*100 Days in Palermo*; 1984), *Il caso Moro* (*The Moro Affair*; 1986), *Giovanni Falcone* (1993), and Marco Risi's *Il muro di gomma* (*The Invisible Wall*; 1991), politically controversial events in Italian current events and recent history were depicted in low-budget films for domestic consumption. In these films attempts by protagonists to change or even understand Italian political and social reality meet with failure as power structures and class status are preserved despite the suffering their corruption causes the Italian people.

Italian Horror

Like the peplum and the western, the Italian horror film appeared at a moment of retrenchment for the Hollywood film industry during the 1960s, which proved to be an opportunity for Italian productions, often disguised as international or Hollywood films. The Italian horror film, like the Italian western, often featured a multilinguistic cast, which did not trouble Italian producers since most Italian productions were made with postsynchronous sound, a holdover from the neorealist days that continued to be an economic consideration into the 1970s. In the Italian horror film, as with the western and the peplum, explicitly Italian cultural elements may initially seem difficult to discern. Yet these genres also have clear themes of narrative circularity.

To cite one important example, *Profondo rosso* (*Deep Red*; 1975) is an Italian horror film by Dario Argento that became a stylistic harbinger of horror films both in Italy and in Hollywood. Argento's camerawork and sets recall the sterile cityscapes of famed Italian surrealist De Chirico. The incessant and repetitive piano motifs in the film would become a signature of the later Hollywood *Halloween* (1978) series, as would the story line about childhood trauma later played out in a macabre fantasy world by perpetrators years after the original event. In *Profondo rosso* an English jazz pianist in Rome witnesses the murder of a psychic. The event temporarily tears him away from his normal piano bar lifestyle, and he becomes embroiled in the mystery. Once the film climaxes and the mystery is solved, the pianist returns to his previous life, class, and status unchanged. A solid element of Italianate fatalism in the film is the police inspector played by Eros Pagni. He treats the entire affair with an attitude of Roman detachment and world weariness, an indication of the cultural identity of the film and the narrative pattern that it inevitably follows. Once the murderer is

revealed and her son is killed in an absurd garbage truck accident, the English musician returns to his status as an itinerant jazz musician, his class and social position unchanged.

Il nuovo cinema italiano (New Italian Cinema)

Circularity has also been a characteristic of more recent Italian films that have not enjoyed international distribution. In the political corruption exposé, Daniele Luchetti's *Il portaborse* (*The Bagman*; 1996), the revelations of the idealistic protagonist do not change Italian reality; in fact, his experiences reinforce the idea of inherent corruption in Italian politics. Roberta Torre's *Tano da morire* (*To Die for Tano*; 1997), Paolo Virzì's *Ovosodo* (*Hard Boiled Egg*; 1997), Luciano Ligabue's *Radiofreccia* (*Radio Arrow*; 1998), and Marco Tullio Giordana's *I cento passi* (*100 Steps*; 2000) are all narrated as flashbacks in which the experiences of the subject/protagonists have little influence on the larger life in Sicily, maritime Tuscany, or the Po valley, respectively. In Giuseppe Piccioni's *Fuori dal mondo* (*Not of This World*; 1999), the brief encounter between a businessman and a nun who finds an abandoned baby ends with the child's adoption and the return to convent life and everyday business for the protagonists. In Virzì's *Ferie d'agosto* (1996), a brief vacation parenthesis reveals the contradictions and dissatisfactions in the lives of two extended families, which are once again repressed when the vacation ends.

Conclusions

The idea of Italian cinematic narrative circularity in the examples cited is not an absolute description of all Italian films. There are films by the directors mentioned previously that do not fit a circular pattern. For example Fellini's *Il bidone* (*The Swindler*; 1955) and Antonioni's *Il grido* (*The Cry*; 1957) end with the tragic death of a protagonist. Other directors have little or no circularity in their narratives such as Pier Paolo Pasolini, with the possible exception of *Il fiore delle mille e una notte* (*A Thousand and One Nights*; 1974). Visconti's films like *Morte a Venezia* (*Death in Venice*; 1970) or *La caduta degli dei* (*The Damned*; 1962) also have tragic endings. However Visconti also made films that reinforce class and echo the narrative structure of the *telefono bianco* comedies of the 1930s. For example in *Bellissima* (1951), Anna Magnani's character returns the familial and class situation that began the film. In *Senso* (1954) the countess returns to the security and boredom of her aristocratic life after eliminating her mendacious Austrian lover.

The resonance of circular and fatalistic narrative in Italian film could be a result of the preponderance of Italian artistic and cultural history. A list from the United Nations Educational, Scientific and Cultural Organization (UNESCO) of world heritage sites once optimistically declared that a majority of the world's cultural heritage sites are housed in Italy. Spain, the second-place country in the report, had fewer places included on UNESCO's list than the region of Tuscany alone. Under the weight of such past artistic achievement, Italian narratives could be well-expected to express skepticism about what humanists called exemplum, the didactic function of history to impart a lesson of moral education. Such a fatalistic attitude about the lessons of history is expressed in the Italian cinema in films such as Visconti's *Il gattopardo* (*The Leopard*; 1963) or Monicelli's *Il marchese del grillo* (1981), a comedy in which Alberto Sordi plays a nineteenth-century Roman nobleman who at one point uses antique furniture for firewood to the chagrin of his friend, a soldier in Napoleon's army invading Rome. Sordi's Marquis responds to the French soldier's complaints by explaining Roman fatalism about the folly of human vanity, a point easily made in a city littered with the ruins of past empires to a representative of the French nation soon to suffer defeat. One may even speculate that since the Italian film industry is housed in Rome, a sense of Roman fatalism has pervaded the Italian cinema through narrative circularity.

Of course there are literary sources of the circularity in the Italian cinema. In the novella (short tale) tradition, Giovanni Boccaccio organized the *Decameron* (1349) with a cornice framework in which the narrators remain in the Florentine countryside after each day's storytelling has concluded. This structure also exists in the tales themselves such as "Andreuccio da Perugia" in which a naïve protagonist enters and departs from Naples in the same economic and class condition as when he arrived despite a series of humiliating misadventures. Alessandro Manzoni's *I promessi sposi* (*The Betrothed*; 1840), often cited as the acme of the Italian historical novel, ends where it began, with the wedding plans of Renzo and Lucia. Giovanni Verga's *I Malavoglia* (*The House by the Meddlar Tree*; 1881), a noted example of Italian *verismo* naturalism and the source of Visconti's neorealist film *La terra trema* (*The Earth Trembles*; 1948) mentioned previously, has a circular plot in which characters' efforts to improve their station come to naught. As in 1930s romantic comedies, class status remains unchanged despite interceding experiences. Tomasi di Lampedusa's *Il gattopardo* (*The Leopard*; 1958), made into a film by Visconti in 1963, presents the essence of circularity with the fatalistic concept of De Pretian *trasformismo*, the idea that Italian political and social life is impervious to mutations despite changes in outer appearance.

National culture is a fluid concept, as attested by the affirmation of new or ancient identities during the postcolonial period. Plot formats that echo established cultural commonplaces, such as the circularity derivative of the commedia dell'arte in the case of the Italian cinema, solidify the cultural imprint of a film in an essentialist recursion through plot. In the case of Italy, the circular narrative is evidence of deep-seated and perhaps involuntary cultural and historical elements that manifested themselves in the early Italian sound cinema in the 1930s and have become commonplaces ever since. Given the numerous examples of circularity from the Italian cinematic canon cited above, a circular narrative pattern seems to be an imbedded characteristic of Italian production, even a master narrative. When the Italian nation broke free politically from the legacies of foreign domination that had shackled it until the nineteenth century, one could have expected the development of a more optimistic current within the major art form by the twentieth century. In fact the Italian film industry, like much other economic activity, flourished "in" the decades immediately after World War II, and by 1960 the Italian film industry enjoyed a period in which it was second only to Hollywood in terms of activity. During this same period in the late 1950s, Italian gross national product soared, and the Italian people experienced a millennial change in their basic way of life from a mainly agricultural existence to an economy based on industry and service. Yet the narrative conventions forged out of centuries of cultural collective memory did not change. The commonplaces established among the Italian public in the early sound period through a period of cultural centralization remained in place.

Perhaps the best proof of the seeming circularity in Italian film is the manner in which the Italian film industry has dealt with biopics. Italian history is so deep that there are numerous opportunities for films depicting the lives of heroic or exceptional Italians. However, apart from some films in the silent period and a current of films about Italy's operatic composers within the early sound period perhaps pivoting off of Mussolini's description of the Italian nation as one of great saints, artists, and navigators, the Italian film industry has produced relatively few biopics. To this day there are no films on major figures in Italian culture like Dante or Machiavelli and few Italian films about Italy's renowned artists like Michelangelo or Da Vinci. Political figures like Mussolini or Garibaldi have received somewhat more attention. Perhaps films depicting exceptional individuals able to leave a mark on history simply go against the grain of a national narrative that is fatalistic in nature.

If we accept the idea that there is a stubborn narrative circularity in the Italian cinematic tradition, there is no reason patterns should not exist in other established or newly affirming cinematic traditions or even why a

national cinematic tradition should be limited to a single narrative pattern. After all modern nations, including Italy, house numerous regional identities that in some cases have been expressed in literature and film. If a plausible narrative pattern is defined for a cinematic tradition, then the films in that tradition could be studied in terms of their tendency to follow, reject, or modify expected narrative patterns due to cultural borrowing resulting from colonial or hegemonic relationships. In the present period of increasingly global culture, the traditional boundaries between national identities have become less rigid, raising the specter of increasing uniformity in cultural production. The recognition of national narrative patterns could actually discourage the penchant for cultural monotony through a theoretical validation of the numerous potential national narratives available for study of which the Italian cinema offers but one example.

7

Death in Mexico

One of the more unique events in Mexican culture is the celebration of the *Día de los Muertos* (Day of the Dead). Most world cultures have some form of ancestor worship or remembrance ceremonies. But Mexico's *Día de los Muertos* celebrations enjoy massive, cult-like, popular participation. The idea of the importance of death imagery in Mexican art, literature, and history is a given in Mexican culture. However, the persistence of death themes has not been noted as the definitive running current within the Mexican national cinema. Perhaps because of the heroic period of the Mexican cinema in its golden age of the early sound period, interpretation has focused on the challenge of establishing a separate sense of Mexican identity in the face of the legacy of Spanish rule until independence in 1821 and successive foreign interventions and wars from the Mexican-American War 1846–48, the French intervention of 1862–67 or the Revolution of 1910–20 when class and ethnic divisions exploded into an extended and debilitating civil war.

The resonance of the *Día de los Muertos* celebrations indicates how deeply the underpinnings of the pre-Columbian cultures still influence Mexican identity. The legacy of the country's last pre-Columbian rulers is central to Mexican nationalist ideology for the promotion of the cohabitation of the nation's indigenous and Hispanic heritage for the establishment of a uniquely Mexican identity.[1] In reality numerous indigenous groups continue to reside within the confines of the modern Mexican state where the official language is Castilian. As many as 56 separate linguistic identities remain within the territory to the present day as some indigenous peoples have managed to retain their linguistic heritage rather than completely submitting to the Castilian tongue of their Spanish conquerors.[2]

One method of investigation into Mexican culture would be to concentrate on the contrast between the cultural and economic pull of the capital city, Mexico City, versus the outlying regions with correlations to the conflict between indigenous and European influences in both ethnicity

and language. Mexico City, the ancient Aztec Tenochtitlán, has been an important cultural and political center from pre-Columbian times to the present with tensions between the hinterland dating to the Aztec period and before. Ancient Mexico was an imperial country well before the Aztec period with the dominance of the capital city over the cultural and linguistic minorities of the outlying areas. The centrality of the capital city in Mexican culture reveals a depressing continuity between the regimes that have dominated the country from the pre-Columbian period to the present. According to Octavio Paz in works such as *El labirinto de la soledad* (*Labyrith of Solitude*; 1950), there is arguably a line of political continuity running from the Aztec nobility to the Castilian viceroyalty and the contemporary Mexican plutocracy.[3] All these societal models feature a pyramidical structure with the concentration of power in the hands of an aggressive, corrupt, and arrogant oligarchy. This economic and social reality has never been adequately addressed despite attempts at federalist, republican, and capitalist reforms for the creation of the basic economic and legal climate necessary to foster the creation of economic prosperity and social mobility.[4] Due to long-term economic stagnation, unlike almost every country in Latin and South America, Mexico has never been blessed with the influx of vitality from large-scale, extraregional immigration, as immigrants have chosen other destinations that offered greater possibility for the creation of individual wealth. The establishment of corrupt, single-party rule in the decades following the Mexican Revolution saw the rise of the paradoxically named *Partido Revolucionario Istitucional* (PRI or the Revolutionary Institutional Party), tied to oligarchical interests, which did not establish the sort of economic climate necessary for individuals to overcome the large gaps in class status and wealth that persist from pre-Columbian times.[5] Just as revolts against Aztec rule were a feature of pre-Columbian Mexico, so too are rebellions against the plutocratic power of contemporary Mexico as revolts in hinterland regions (most recently in Chiapas) demonstrate.

Another consistent aspect of Mexican history from pre-Columbian days to the present is the conflict between liberal ideas of individual property rights and ancient indigenous concepts of the communitarian economic structures in feudal societies. There is an economic legacy from the pre-Columbian oligarchies to the colonial encomienda plantation system and the contemporary concentration of wealth among Mexico's plutocratic elite, extending to the nationalization of natural resources. At the composition of this study, one of the world's richest men is a Mexican, Carlos Slim, whose monopolistic businesses have controlled up to an estimated one-third of the Mexican stock exchange and up to 5 percent of the country's gross domestic product.

What emerges from a summary consideration of Mexican history is the culture as expressed in novels like *La muerte de Artemio Cruz* (*The Death of Artemio Cruz*; 1962) where time and progress are uncertain and almost nebulous concepts subordinate to a fatalistic acceptance of the repetition of a reality marked by economic and ethnic determinism.[6] The historical and cultural constant in this milieu has been the cheapness of life where only death exists as an equalizing factor against the inequities of the present. Death themes and imagery hover over the atavistic memory of the country as a central aspect of pre-Columbian Mexico, although estimates of percentages or raw numbers of human sacrifices can be controversial due to reliance on colonial sources arguably inclined toward emphasizing the barbarity of such practices. It is, however, not a matter of controversy to state that the pre-Columbian cultures that dominated Mexico practiced some form of ritual human sacrifice and that the basic economics of human sacrifice point to a debasement and devaluation of human life. Nor is it a matter of controversy to state that pre-Columbian regimes had as a constant political characteristic a plutocratic, pyramidical feudal system in which human sacrifice, whether on a grand or private scale, served as demonstration of oligarchic power.[7]

In the Spanish colonial period, estimates have arrived at figures of decline in the indigenous population as high as 95 percent following the conquest of 1521, mainly due to horrific pandemics in 1545–48 and 1571–81.[8] During the colonial period Mexican Catholicism much like its medieval Mediterranean forbearers incorporated pre-existing pagan cults into Christian practice, often consolidated around death imagery. The prevalence of death imagery in auto-da-fé spectacles during the Counter-Reformation period adds another element of death fascination in a culture where such imagery is in no short supply. The practice of human sacrifice in pre-Columbian times and the population declines due to pandemics, violence, and slavery following the Hispanic conquest point to an atavistic collective burden of death memory in Mexican culture. A possible explanation for the fatalistic fascination with death imagery may lie in Mexican political history since Spanish conquest. After the catastrophic mass death events of the sixteenth century, Mexico has seen a gradual regaining of indigenous populations.

Such dramatic figures must be considered in light of the continuing popularity of the Mexican celebration of the Day of the Dead whose pre-Columbian roots are depicted in documentaries such as *La Ofrenda* (*The Days of the Dead*; 2002) by Lourdes Portillo and Susana Muñoz or in *La Santa Muerte* (*Saint Death*; 2007) by Eva Aridjis, which details the persistence of a morbid Saint Death (*Santa Muerte*) cult in contemporary times. Even the establishment of the Virgin of Guadalupe cult gained popularity after the miraculous halting of a typhus epidemic in 1737, although the

roots of the Virgin cult have been identified in the preexisting cults of the moon goddess Tonantzin or the Earth goddess Coatlicue.[9]

As a popular art form, the cinema is able to reach above particulars for universal themes and imagery in an atavistic manner reaching to the very depths of national identity. Since the cinema has the capacity to be a unifying cultural force even for a populace as diverse as that in Mexico, the morbid undercurrents from the pre-Columbian and Hispanic colonial period that appear thematically in Mexican cinema provide keys to understanding Mexican cultural identity. Within the Mexican cinema the themes of Mexican identity are expressed in the Castilian tongue of the Spanish conquistadors, but the master themes developed rose from deeper elements within the country's history. The prevalence of death themes and imagery regarding an individual's status and treatment at death is a potential master theme in the classic and contemporary Mexican cinema.

Mexican nationalism, perhaps due to the sense of opposition to its more economically successful neighbor to the north, has an element of stubborn vitality and tenaciousness even in the face of defeat. A certain fatalism is also an element of the Mexican historical experience in which outlying regions of the country have a millennial experience in being subjugated to the political will of the central capital, which in turn has historically felt the weight of the interests of an exterior power like Spain or the United States. Thus the raw material for the sort of nationalist mythmaking exists in Mexico for a romantic vision of Mexican identity fighting against the injustices of a history of colonialism. This has been a centerpiece of the culture of Mexican nationalism that grew out of the independence movement in the nineteenth century and was subsequently enlarged to include elements of the mestizo experience. Mexico has a pantheon of figures representing the stubborn vitality of Mexican identity such as the revolutionary leaders from the revolutionary war period like Emiliano Zapata or Pancho Villa whose stories are essentially tragic and fatalistic narratives of men who sought to violently overthrow the yoke of class and ethnic subjugation. When Mexico attempted the sort of national educational reform needed for the creation of a modern economy, the spirit of such figures was an important element in the conveyance of a sense of Mexican identity. There were also efforts to standardize language and instruction, although these efforts are still under way, and the solidity of the hold of the central Mexican state over the interests of its outlying provinces is still far from secure with the latest threat to a Mexican polity coming from interests tied to the contraband drug economy.

As part of the push toward the creation of a national cultural identity like other nations examined herein, Mexico developed a vibrant national cinema in its capital city during the early sound period (1929 to the early

1950s) known as the golden period of Mexican cinema. Sound gave Mexicans a chance to develop a film industry on a large scale and become the leading producer of Castilian language films for markets in Central and South America. The Mexican cinema was aided by the proximity of Hollywood as a training ground for Mexican technicians who brought a high level of expertise upon their return home. The sound period spawned a generation of talented directors and actors like Pedro Armendáriz, Dolores del Río, María Félix, Emilio 'El Indio' Fernández, and Fernando de Fuentes, many of whom enjoyed international careers for a truly golden period of the Mexican cinema.[10]

Often credited as Mexico's first sound film, *Santa* (1932) by Antonio Moreno is a melodramatic tale about a fallen woman similar to the tragic narrative of operatic melodramas like *La traviata*. The fallen woman genre has long been a subject of fascination for Mexican cinéastes with stories of disenfranchised and defenseless women struggling to survive in a world of cruel male exploitation, often set in a port city. The theme of a fallen woman with an optional revenge subcurrent was repeated often in Mexican cinema in seminal films such as *La mujer del porto* (*The Woman of the Port*; 1934) by Arcady Boytler and Raphael J. Sevilla, *La mujer sin alma* (*Woman without a Soul*; 1944) by Fernando de Fuentes, *Doña Barbera* by Fernando de Fuentes (1943), *Maria Candelaria* (1944) by Emilio Fernández, *Enamorada* by Emilio Fernández (1946), *La otra* (*The Other One*; 1946) by Roberto Gavaldón, and *La escondida* (*The Hidden One*; 1956) by Roberto Gavaldón. Critics have written of a current of misogyny in Mexican culture as related to Mexican machismo culture perhaps even dating from resentment regarding the role of the defeat of the final Aztec regime by La Malinche, the woman who spoke the Aztec language Nahuatl and aided Hernán Cortés (1485–1547) in his conquest. Mexican machismo could also be identified in psychological terms as the transference of aggression due to an inferiority complex regarding subservience first to Hispanic conquerors and then to American economic and cultural dominance.

A melodramatic story line about a fallen woman, who either accepts her fate or is rescued by a love interest with an eye toward revenge, is by no means specific to the Mexican cinema. However, the death imagery that appears in such films is an identifier of deeper roots in Mexican culture. *Maria Candelaria* (1944) by Emilio Fernández is ripe with themes of the subjugation of mestizo or indigenous peoples, particularly in scenes in which a wealthy urban artist asks the Indian heroine, Maria, to pose nude. The artist is only interested in painting her supple body, and not her face, which betrays indigenous traits. The scene actually brings up one of the ironies in golden age Mexican cinema when starlets like María Félix who had European physiognomies played virtuous and victimized Indians.

After posing Maria is shunned by her village and dies in misery. Yet the film ends with a glorious funereal procession, with wreaths of garlands accompanying Maria's corpse in a canoe, perhaps a nod to the ancient lakebed of the Aztec capital Tenochtitlán. The value of the heroine while alive was negligible. Her community made little effort to save her. She is rehabilitated only in death through the imagery connected with burial. It is as if the injustices of the society that abused her are negated, echoing deep roots in Mexican culture, due to the respect she is afforded in her burial procession. There is a deep fatalism expressed in this scene, communicating the cynical idea that the amount of time one spends in death is infinitely longer than in life and one's treatment in death, and thus at least according to the ancient codes of Mexican culture, treatment in death is a determining aspect of worth.

In *Aventurera* (*The Adventuress*; 1950) by Alberto Gout, Cuban-born actress Ninón Sevilla stars in a film that on the surface seems to have a fallen woman story line. An innocent girl, Elena, finds herself on the street after her father commits suicide following his discovery of the infidelity of the girl's mother, who absconds with the family patrimony. The film is interesting for the manner in which the heroine performs dance routines, which are not Mexican but international with a Cuban, Brazilian, and even a Middle-Eastern belly dance number. The actress Ninón Sevilla had Cuban heritage, and part of her box office appeal was her ability to bring a world of exotic dance numbers to the Mexican cinema. The film has other foreign influences in the characters of two brothers who vie for the girl's attentions. Both look for inspiration to the United States where they have attended university. There is also a ne'er-do-well boyfriend whose zoot-suited style and behavior mimics 1940s American gangster imagery. The film thus has a myriad of foreign influences: the song-and-dance routines, the characters interested in America, and especially the fact that the bulk of the cast have European rather than Mesoamerican physiognomies, a common characteristic of golden age Mexican cinema.

Yet even with these seemingly imported elements, the fallen woman story line and the worldly dancing ability of the heroine, the film still is able to display a stubborn core of Mexican themes. After she is unable to support herself, the girl falls into prostitution. Through her charms she is able to marry an upper-class, innocent lad and regain her lost class status. Secure once again with her social position, she visits the mother who had abandoned her, now terminally ill and eager for reconciliation. But the girl coldly refuses to grant forgiveness, turning the mother's impending death into an undignified event. Even though the mother was valued in life according to her elevated class status, in death she is scorned and her funeral will be undignified. The mother's death is an abject event, and thus

she receives the worst possible condemnation according to the atavistic codes of Mexican culture.

The themes of death fascination creep into the film again most determinately through Rengo, one of the few characters with an arguably indigenous physiognomy. Rengo appears in the film as a sort of Mexican grim reaper who murderously eliminates all the obstacles in Elena's life in recognition for an act of kindness she selflessly bestowed upon him early in the film. Rengo displays an almost childish loyalty to the heroine. He is not depicted as a sociopathic serial killer but rather as an expression of the great equalizing capacity of death as a constant foil to the presumptions of the secondary characters in the film to harm the protagonist. The film's happy ending has a murderous undertone with Rengo lurking in the shadows ready to strike anyone who may cross Elena's path.

Death imagery also appears in foundational films depicting the Mexican Revolution, another event that left a shadow of morbidity over the country for the amount of death it imparted. *El compadre Mendoza* (*My Buddy Mendoza*; 1934) by de Fuentes depicts the fleeting and unpredictable nature of political power during the years of the Mexican Revolution. The film's rotund protagonist Don Rosalio is the owner of a hacienda who cleverly changes the portraits of generals hanging in his dining room according to whichever faction has troops in the vicinity. An appropriate display of loyalty is a key to survival within the chaotic and deadly course of revolutionary politics. As the film opens Mendoza removes a portrait of the federalist general from his dining room and replaces it with a portrait of the rebel leader, Zapata. After the Zapatista soldiers leave and a detachment of government troops arrives, a portrait of General Huerta takes the place of the portrait of Zapata. After the changing of each portrait, there are scenes of the hacienda retainers and soldiers drinking the adult beverages associated with their faction. Mescal, a beverage of indigenous origin, is the favorite of the revolutionaries. The federal soldiers are treated to rations of cognac, a beverage of European origin. Mendoza must survive within the precarious and capricious confines of a rapidly shifting political and military reality where the racial makeup of the political factions between the Europeante government troops and the rebel forces are also an indication of their political loyalty. Mendoza has no control over larger political and military realities. In order to survive he must curry favor with whichever faction is in the proximity. The tentative nature of life during the Revolution reveals itself when some returning Zapatistas decide to kill Mendoza for no other reason than that he is the owner of a hacienda, and therefore according to their class-based morality, he must be guilty of something. Mendoza is rescued by a Zapatista officer, Nieto, who calms his troops but then impregnates Mendoza's new bride, another indication

of the appeasements the landowner must make to the powers that be. The film concludes when Mendoza in turn betrays Nieto and allows him to be assassinated by government forces to the consternation of his wife holding his bastard son. There is much symbolism in the betrayal of Nieto by Mendoza who finally decides to side with government forces although his own child will retain mestizo identity as Nieto's progeny. Mendoza chooses economic wealth, class status, and survival, yet his posterity will be the heir of the indigenous populations. The film offers a vision of the conflicting identities at work within the Mexican Revolution and the sense of insecurity about identity and future existence and compromises between indigenous and postcolonial influences that the upheavals spawned. The ultimate message of the film is clear, however, from the manner in which Nieto's corpse is displayed. As Mendoza and his wife escape their hacienda, they must pass under Nieto's dripping corpse. The film began with the hanging of portraits of generals and revolutionary leaders. The last hanging icon in the film and a reference to the changing of generals' portraits that opened the film is Nieto, a figure who is identified with the indigenous, Zapatista currents in the Revolution. He is shamed because he suffers an undignified post mortem, without respectful burial or ritual mourning. The manner of Nieto's death through Mendoza's betrayal is important due to the ill treatment of his corpse after death. In a larger context the betrayal of Nieto and the indignity afforded to his corpse impart a lesson about the results of the Revolution. The land-owning status quo saved its skin but would increasingly identify itself not with European but indigenous currents.

Vámonos con Pancho Villa (*Let's Join Pancho Villa*; 1936) by de Fuentes is another film depicting the revolutionary period impregnated with death imagery. The film combines themes of machismo with the pessimistic lessons of the Revolution. The main character, Tiburcio, optimistically leads his comrades to join the army of Pancho Villa after scenes that emphasize the cultural separation of indigenous populations from the more European style of commanders of federal troops. In the film each of the comrades performs an act of extreme heroism to prove machismo under fire. But eventually death itself becomes the real destination of the comrades and arguably of the war. In a key scene, despite numerous heroic acts in which comrades have fallen to prove their mettle, the remaining companions find themselves challenged to prove their virility once again at an absurd card and pistol game that ends in death and suicide. Rather than the noble and heroic aura of sacrifice under fire to steal an enemy machine gun in battle or save their comrades, death comes as a result of ridiculous, drunken causality. The ignominy of an accidental and absurd death reveals a telling aspect about the essence of death fascination within the Mexican cinema. For despite the heroic and optimistic title inviting the spectator to

participate in the revolutionary spirit, the film is really much more about death than about the Revolution. In the final sequences Tiburcio reveals to his superiors that his last remaining comrade has come down with a highly contagious disease that could spell disaster for the entire army. Tiburcio receives and carries out the order to burn his feverish and suffering comrade alive as the only way to eliminate the threat of contagion. The horror of the immolation recalls themes of human sacrifice in pre-Columbian Mexico. However, this final act of sacrifice and cruelty is not received in a celebratory manner by the army leaders. The general sheepishly tells the protagonist, Tiburcio, to go home as if embarrassed by the stain of the undignified deaths of his last comrades. Death initially appears in the film as an expression of machismo culture where it is arguably the result of voluntary impetus among the comrades eager to redress the injustices of Mexican society and finally have a chance to correct centuries of exploitation through heroism on the battlefield. However in the concluding sequences, death arrives after absurdity and extreme cruelty lending an aura of waste, horror, and fatalism to the entire revolutionary experience. The essence of the Mexican experience is the persistence of a fatalistic and unyielding morbidity, which nullifies the sense of optimism about armed struggle that began the film. The film's protagonists merely become pawns in a parade of suffering. This lesson is driven home through the waste of their lives and the lack of dignity they are afforded once dead.

El indio (*The Indian*; 1939) by Armando Vargas de la Maza is drama within the backdrop of themes about the struggle of indigenous populations to make a place for themselves in their own country. In the film nefarious landowners of Hispanic descent try to coerce members of the virtuous, long-suffering indigenous peasantry to lead them to the site of valuable ancient artifacts. At one point in the film, Felipe, the protagonist, speaks with his grandfather who takes out a worn cloth map of the country and points out the various tribes within the territory of the Mexican state whose lack of unity has allowed a minority of descendants of Hispanic conquerors to rule. The film tries to establish a paradoxical *mexicanidad* (sense of Mexican identity) with an actress with marked European physiognomy playing a Mesoamerican heroine who after a series of travails is paired with Felipe, the virtuous hero. Despite the racial and class themes in the film, death imagery makes an appearance through the secondary character Julian, initially betrothed to the heroine against her will. Julian is forced to lead the landowners and his comrades to the secret site of a pre-Columbian treasure. When he refuses, the film expresses the cheapness of life as the Hispanic landowner has another servant hang Juilan unless he reveals the secret location of the ancient burial ground. When Julian

refuses he is let down and falls down a cliff, left to die by the landowner and his party.

Other films treat themes of indigenous oppression more directly. *Río Escondido* (1948) by Emilio Fernández is a message film about Mexican national reclamation and nation building starring María Félix as Rosaura, a teacher with a terminal heart condition who is sent by the Mexican president to reopen a rural school. The film opens with a nationalistic montage recounting the centuries of struggles of Mexican history depicted on the murals at the presidential palace in Mexico City as an explanation for the centuries of moral, economic, and social ills in the country. Hope for Rosaura is represented by the example of nationalist President Benito Juárez (1806–72), who had indigenous origins and yet rose to be Mexican president. The film is able to concisely depict the planks of nineteenth-century, Mexican nation building through a centralized effort to bring an unruly province into the national fold, symbolized by the efforts of the teacher Rosaura to reopen a school. A key element in this national strategy was of course homogeneity in education and language. In effect the film presents a national icon, María Félix, as a purveyor of national cultural identity as evident in the opening sequences of the film as she passes in awed reverence though the halls of the presidential palace. Within the almost propagandistic tones in support of a narrative of nineteenth-century romantic nationalism, the film retains a more ancient cultural essence through its death imagery. Rosaura departs heroically, yet the shadow of death hangs over her as she is terminally ill due to a heart condition. Elements providing clues to her previous life and decision to embark on a self-sacrificial crusade for the propagation of Mexican national culture are absent from the film. She is simply an iconic figure for the policies of cultural centralization emanating from the capital. The other heroic character in the film, a well-educated doctor, also sent on a mission of self-sacrifice and travail in the provinces, is the other prong of the traditional attempts of central governments to extend their power through education and medical care.

At the village Rosaura meets Don Regino, whose violent demeanor is emblematic of the challenges faced by the central government to civilize the country. Don Regino runs the small hamlet like a tyrant with every aspect of life subject to his personal whims, including access to water, schools, or to the itinerant doctor. Regino declares himself an admirer of Pancho Villa, which equates the idea of the taming of the Mexican provinces with the taming of the unpredictable and puerile nature of Villa's faction in the Revolution. Regino rules due to his charismatic ability to control his bloodthirsty seconds who eagerly carry out his cruel orders. The fatalistic acceptance of such brutal and irrational distribution of power seems to be accepted by the townsfolk as a centuries-old characteristic of life.

Death themes appear when a destitute, pox-stricken mother dies, leaving her orphaned children in the care of Rosaura and the doctor. Don Regino refuses to allow the doctor to properly dispose of the corpse and burn the contaminated house to stop the contagion. Making such an effort to properly assure a decent burial would afford the poor woman a higher status, potentially threatening Regino's control over town life. However once Regino himself falls ill, he temporarily abandons his macho code and agrees to reopen the school and vaccinate the populace. There is death imagery even in these sequences as Don Regino's seconds shoot at people to encourage them to get vaccinated.

When Regino orders his seconds to kill his girlfriend with the idea of installing Rosaura in her well-watered apartment, the girlfriend is resolved to accept her fate and gives her belongings to her would-be murderers, inspiring their pity. After they let her go, she kills herself anyway, an irrational and futile gesture as the specter of death dominates the story. When Rosaura refuses Regino's advances, he shuts off the village's water. When the brightest child in Rosaura's school takes water from Don Regino's well, he shoots him. It is at this point in the film where the weight of Mexican death imagery becomes more preponderant. When Regino insists that the nighttime vigil over the body end and that the body be buried immediately, the villagers finally revolt. The unifying call to action comes not from the threat of the spread of a deadly disease, the closing of the school, or even Regino's irrational refusal of water. What unifies the villagers is Regino's affront to post-mortem protocol.

After Rosaura shoots and kills Don Regino, he is marked with an undignified death. As she hovers over Regino's corpse with a gun, his seconds attempt to flee and the mob beats them to death. When Rosaura's heart gives out from the stress, the doctor returns, and she dies a respectful even heroic death accompanied by a voice-over of the president's answer to her letter with news that the state has approved a waterworks project for the town. The film ends not with her burial, as might be expected, but with a cameo of a plaque describing her mission to revitalize Mexico, an honorable and dignified post mortem.

La perla (*The Pearl*; 1947) by Emilio Fernández depicts economic subjugation in dire terms with overwhelming death imagery. In the film a poor fisherman finds a magnificent pearl, but due to his lower-class status he cannot take advantage of his good fortune and must flee with his wife and child. When he attempts to bring the pearl to town and sell it for an honest price, the merchants and middlemen he encounters, who are arguably dressed and coiffed in a more European style, try to swindle him. When he refuses their paltry offers, they send thugs to steal the pearl and kill him. The fisherman realizes that he does not have any rights in the society

he inhabits and resorts to the only option available for him—flight. Equilibrium is not restored until death enters the story in tragic terms. The couple's child dies during their desperate attempt to escape the seconds of the town merchants. The fatalism in the film is not limited to society, for the film has an extremely fatalistic undertow as if the very idea of class mobility requires the retribution not only of the entire society that conspires against the fisherman but also of the very landscape of an indifferent nature that claims their son. Equilibrium is only restored when the fisherman rids himself of the pearl as if the desire for wealth and a reward for his achievement are simply not part of societal makeup. The son's death and the inability of the indigenous fisherman to participate legally in the economy of his town impart an extremely pessimistic and fatalistic message regarding class mobility.

Like *La perla*, *Macario* (1960) by Roberto Gavaldón is also a film about extreme class divergences where death is the only certainty. The plot depicts the death reverie of a starving peasant, Macario, who after stealing a turkey dreams that Death confers upon him the miraculous ability to heal the sick and resuscitate the dying. Macario travels to the capital to ply his trade as a miracle healer aided by Death who provides him with the means to recognize the course of his patients' illnesses. When Death dissolves their partnership, Macario returns home and the entire escapade is revealed as a death reverie. In the end it is Death who rules as Macario's corpse is found by his family in an undignified rigor mortis clinging to the remains of a half-eaten turkey. In the beginning of the tale, Macario's desires were for mere sustenance for himself and his family members. After Death confers magical powers upon him, Macario becomes susceptible to the sort of material desires of which he had been previously oblivious. The ultimate lesson of the film is the true power that Death exerts over Mexican culture. Macario's initial desire to avoid malnutrition or even starvation by stealing a turkey seems to be punishable according to codes whereby the extreme fatalism and stacity of Mexican society are so strong that any attempt to break them are doomed to failure.

Ahi está el detalle (*There's the Rub*; 1940) by Juan Bustillo Oro is a seemingly innocent comedy starring Mexican icon Cantinflas, known for his improvisational comedic skills.[11] Cantinflas enjoys a following in Mexican popular culture as the country's greatest comedic talent. Due to more humorous themes in Cantinflas films one might not expect severe death imagery in a Cantinflas comedy. However, even this film is filled with images of death. Hoping to get a free meal, Cantinflas comes to an upperclass house where his girlfriend works as a maid. He woos the maid, and she awards his attentions with food. However, when she asks him to kill her matron's dog, he mistakenly thinks she has asked him to kill her matron's

lover. When faced with the threat of losing his source of food, Cantinflas readily carries out the task but mistakenly believes he has killed the boyfriend. The film features skits in which Cantinflas must impersonate the maid's boss. Themes of hunger and scarcity of resources are the fodder for comedy. When Cantinflas is finally arrested, he is acquitted because he had actually not killed the boyfriend, although he believed he had done so. Cantinflas's defense before the judge reveals how little difference he feels between the value of the dog and the matron's boyfriend. Thus death makes an entrance into the film through jokes about the cheapness of life where again, death is the only factor able to resolve the huge inequities in Mexican society and economy.

Besides the fallen women films, another genre of film that is stereotypically Mexican is the ranchero film, often set on a rural hacienda with melodramatic themes and celebratory music-and-dance sequences. A seminal film in this genre is *Allà en el rancho grande* (*Over at the Big Ranch*; 1936) by Fernando de Fuentes, starring Jorge Negrete. The plot of the film, as with many ranchero films, centers on class divisions between the landowners and workers with tensions between characters who seek to elevate their class status. On the surface these films would not seem to provide opportunities for death imagery. However in this seminal film of the genre, there is a sequence that indicates the cheapness of life in Mexican society when the two main characters, former childhood playmates, find themselves in a cockfight where their machismo is at stake. The lower-class worker takes a bullet for his boss but survives, and the film ends in a matrimonial procession.

Pedro Infante, (see Figure 7.1) an actor who perhaps due to his premature death in 1957 at age 39 continues to have a mythical hold over the Mexican popular culture, came out of the ranchero genre to appear in the major box office hit, *Nosotros los pobres* (*We the Poor*; 1948) directed by Ismael Rodríguez. The film combines several currents popular in Mexican cinema. Musical numbers by Infante as *Pepe el Toro* hearken to the essence of the ranchero film where good-hearted commoners behave virtuously despite the nefarious influences of their wealthy overlords. Yet the film is set in the city and has a fallen woman current with the character of Yolanda, Pepe el Toro's sister, whose affair with a rich man caused a rift in her family. Yolanda seeks to regain her family's affection as she lies dying from tuberculosis. The key sequence in the film regards the demise of the family matriarch, estranged from the wayward daughter. The film ends with a family reconciliation that is celebrated not as a marriage but with a Day of the Dead ceremony at the matriarch's grave. The family pins its hopes on an ability not necessarily to change their class status but to be able to celebrate a respectable burial ritual capable of reuniting the family. Despite

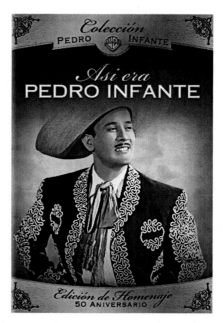

Figure 7.1 *Así era Pedro Infante* (1963, Mexico). Credit: Warner Home Video/ Photofest © Warner Home Video.

the inequities of their experiences and the extreme tragedies that they suffer, the film concludes on a victorious note. The communal celebration at the feast of the dead imparts a lesson of the enduring spirit of the Mexican people who may not have the ability to collectively organize their society into a motor for economic and class mobility but who value family ties and adapt to the fatalistic lessons of their history and culture.

The ending of *Nosotros los pobres* is echoed in *Los Olvidados* (*The Forgotten Ones*; 1950) by Luis Buñuel, a film made in gritty neorealist style about the Mexican underclass. The film recalls the Bowery Boys films of the Hollywood tradition and the more stark and heroic period of Italian neorealism in films like Vittorio De Sica's *Sciuscià* (*Shoeshine*; 1948). The film recounts the experiences of a group of street urchins whose daily struggle to survive in the big city imparts a dire and unforgiving view of Mexican society. Adolescent status contests decide the power hierarchy between the boys. When the main character Pedro is caught and sent to a reform school he briefly experiences false hope for a better life. At the reformatory he receives humane treatment and is even entrusted by the headmaster with a small sum of money, a manner of teaching the boy to think beyond his

immediate physical concerns, for his future within the school and perhaps within society. However, the headmaster's experiment goes tragically awry when Pedro meets up with the film's antagonist, Jaibo, who kills Pedro and dumps his body on a garbage heap in one of the most undignified burials in film history. The headmaster had tried to impart the lesson that Pedro's worth exceeded the small sum entrusted to him. The encounter with the ruthless reality of the Mexican street and the homicidal antagonist Jaibo teaches otherwise. In a key exchange in the film, a character explains the essence of Mexican death culture whereby one's status during death is more important than that during life, since death lasts much longer. Pedro's true value to society, despite the efforts of the reform school director, remains at the level expressed at his horrific burial.

The Mexican cinema, like most of its counterparts around the world, underwent a decline into the 1980s when the introduction of affordable television sets changed the economics of the entertainment industry. Subsequent efforts to recapture the glories of the golden age have been attentive to continuing the themes of classical Mexican cinema. The Mexican cinema has experienced a rebirth since the 1990s but rather than a studio-based, standardized cinema, Mexico has been able to tap into the current of independently produced films that have received international distribution and recognition.

A film indicative of the manner in which death themes can pervade more recent Mexican cinema is *Y tu mamá también* (*And Your Mother Too*; 2001) by Alfonso Cuarón. The film was a domestic box office hit in Mexico and also gained international critical praise. Despite outward appearances as merely a sexually charged road and buddy movie, the film has clear references to issues of Mexican historical identity and expresses key themes of the Mexican cinema. The story is an update of the fallen woman genre so important in early Mexican cinema. An unhappily married Spanish woman, Luisa Cortés, a name with obvious reference to Mexico's Extremaduran conquistador, meets a pair of callow and untalented students, one tied to the ruling oligarchy and the other the son of a secretary who has been able to forge a middle-class identity working for the same ruling oligarchy. Both boys are parasitic figures who rely on the corruption and graft of the ruling Mexican oligarchy to afford them a leisurely and hedonistic existence as well as a sense of superiority over their humble compatriots. The names of the two boys refer to key figures in Mexican history. One is named Julio Zapata, the surname of the famed revolutionary leader. The other is Tenoch Iturbide. Tenoch was the name of a fourteenth-century Aztec ruler. Agustín Cosme Damián de Iturbide y Aramburu (1783–1824) was a Mexican general who ruled briefly as emperor after independence in 1821. The boys symbolize the arrogance and immaturity of the Mexican

ruling elite as if the lessons and results of the Mexican Revolution were the ability of the oligarchy to incorporate the trappings of indigenous culture in order to maintain power.

The Spanish woman, Luisa, an orphan, came to Mexico as the bride of a member of an oligarchic family. But she leaves her unfaithful husband for a road trip as the sexual divertissement for the two boys after learning that she is dying of cancer, an oblique reference to the tuberculosis themes in the fallen women, *mujer del puerto*, genre from the golden period of Mexican cinema. The privileged life of the two boys contrasts markedly with the subsistence struggles of the rural Mexicans the trio pass on the road. Despite an outwardly hedonistic and celebratory initial presentation, the director fills the film with death imagery, from the crosses on the sides of the road indicating fatal car accidents, to a passing funeral procession, to the tales of the Spanish woman who recounts the death of all the members of her family and her first lover, an event that led her to accept transfer to Mexico, the country where the dead are held in such respect. The film follows key themes in Mexican cinematic film tradition with expositions of the cheapness of life and the fatalistic voice-over of an omniscient narrator recounting events post facto so that the individual impulses of the characters seem irrelevant when considered in relation to the inevitability of a triumph for death, in this case of the terminally ill Spanish woman.

One of the most acclaimed directors of the contemporary current in the new Mexican cinema is Guillermo del Toro. His breakthrough film *El labirinto del fauno* (*Pan's Labyrinth*; 2006) reached international audiences, yet it retains the essence of death fascination that is a key theme in Mexican cinema. The film is set in northern Spain in 1944, after the definitive victory of Francisco Franco's Falangists in the Spanish Civil War. In the film's opening sequence, the protagonist, Ofelia, a name pregnant with death imagery, lies dying after she is shot by her evil stepfather, an officer in the Spanish army in charge of rooting out rebels in what appears to be Basque country. The plot develops around Ofelia's death reverie/ flashback revolving around fantastic encounters with a spiritual netherworld that concludes in a celebratory reunification with her dead parents in a glowing afterlife in accordance with the basic concept of Mexican death culture—one's placement in death trumps status in life, as death lasts much, much longer.

8

Ukrainian Dualism

Ukraine has long been contested by neighboring states that promoted and rewarded those who chose to abandon their Ukrainian identity. Political, military, and cultural pressures from Russia encouraged Ukrainians to become Orthodox Russophiles. Political, military, and cultural pressures from Poland or Austria encouraged Ukrainians to become Catholics and look west rather than east. The main geographic characteristics of Ukraine are fertile plains bordered by the Black Sea to the south and the Carpathian mountains and the Danube River to the west. A number of rivers traverse the country such as the Dnieper River that flows through the capital city Kiev to the Black Sea. The three main cities of the country—Lviv in the western most region, Kiev in the center, and Donbas in the east—have differing ethnographic, cultural, and historical backgrounds. The meandering Dnieper River does effectively split the country in twain with one side closer to western influences from Poland or Germany and Austria versus the opposite, eastern bank more in step with Russia. Although Ukrainian was defined as the state language under the country's 1996 constitution, the differences in languages used in the territory are clear from 1989 surveys of the languages used in primary education in the country. In western Ukraine (Galicia) a clear majority of schools teach in Ukrainian whereas in eastern Ukraine of Dunbas and in southern Ukraine (Crimea), the percentage is lower.[1] The conclusion to be drawn is that Ukrainian has remained as the language of the countryside whereas the capital city Kiev and regions close to Russia have more linguistic mixture and fluxuation. It must also be stated that even with the idea of a fixed east-west geographic divide and its cultural correlations, Ukraine features a patchwork of cultural influences throughout its territory.

Ukrainian historians have developed a culture of self-examination where the multiplicity of possible influences in the country has almost become an identifying factor in its own right. However, the east-west duality was in clear evidence in elections held as a consequence of the implosion

of Russia's Soviet Empire in 1991 after which pro-Russian and pro-Western factions faced off in fierce campaigning that continues to the present day. After hotly contested elections and the subsequent Orange Revolution (2004–2005), pro-Western factions were able to attempt a transition to republican, constitutional rule for an independent Ukraine. Ukrainian independence is a truly remarkable event in world history, a unique opportunity for a nation subjugated for so long to enjoy and develop its own national culture and identity.

One source for Ukrainian identity is from the historically remote Rus period (ninth–thirteenth centuries), which apparently existed in Ukrainian territory and extended to Belarus and western Russia as described in the foundational epic the *Tale of Ihor*.[2] Unfortunately the authorship of the work, now lost and reconstructed according to the work of scholars, is controversial and has not provided the sort of unifying epic as has been the case for other nations. This sense of uncertainty and doubt about the very essence and legitimacy of what should be a foundational tale cannot but increase the sense of instability about Ukrainian identity.

One area in which the cultural identity of Ukraine has been characterized is religion, which would find Ukraine caught between Catholic Poland and Orthodox Russia. The legacy of this division is that some regions have remained largely under the control of the Orthodox Church whereas others have accepted the precepts of faith as prescribed by the Ukrainian Uniate Church, officially part of the Roman Catholic Church, with the interesting caveat that Ukrainian Uniate priests to this day are allowed to marry and raise a family. Thus religious influences have mirrored the political and linguistic divisions in Ukrainian history.

The greatest challenge for Ukrainian identity has been the continuity of external threats—from the recent history of Russian imperialism to more remote cataclysms like the 1240 Mongol sack of Kiev. Other invasions include incursions from Polish forces and the Austria Hungarian Empire, which brought Catholic influence, reinforcing the religious identity of western provinces of Galicia and the city of Lviv in contrast to areas more heavily influenced by Russian colonialism, autocracy and the Orthodox faith. Subsequent events such as the creation of the Uniate Church, the restoration of the Kievian Orthodox Church, or the establishment of a Cossack Orthodox State have served to reinforce the legacy of religious division in the country.

Despite all these competing influences, there is consensus that Ukrainian identity developed in the seventeenth century in conjunction with the rise of a Cossack State. Western Ukraine, Galicia, was subsequently annexed by Austria's Hapsburg Empire, establishing a Hapsburg model for Ukraine dominated by Catholic influences, just as eastern Ukraine is influenced by

what may be considered a Russian Orthodox model. The dualism between these two models has been expressed by figures like Nikolai Gogol (1809–52) who was apparently somewhat confused about Russian and Ukrainian identity. Ultimately Ukrainian nationalism coalesced around figures like Taras Shevchenko (1814–61) whose concept of "Cossack nativism" emphasizes peasant identity as the essence of Ukrainian nationalism.[3] If Ukrainian dualism is identifiable in religious terms between the Uniate and Orthodox churches, then the legacy of Cossack/Ukrainian identity plays out under Russian, Polish, or Germanic incursions. What may be concluded from a cursory look at Ukrainian history is an overwhelming sense of dualism with themes of the city versus countryside, proletarian versus peasant, Russian versus Ukrainian, Orthodox versus Catholic or Uniate, and of course, East versus West.[4]

The events that defined contemporary ideas of Ukrainian identity hearken back to World War I and the defeat of the Russian Empire. The subsequent October 1917 Bolshevik Revolution led to attempts by German forces to gain a foothold in the region and access to grain sources in Ukraine. The ensuing civil war spread to Ukraine with devastating consequences for the population with the Russian/Soviet victors reclaiming the oppressive legacy of their tsarist predecessors. What followed was one of the darkest episodes in world history with the virulence of a state-sponsored farm collectivization program against Ukraine in the 1930s. In Nikita Khrushchev's "secret" speech in 1956, the Soviet premier apparently commented that the only reason the entirety of Ukrainians were not deported is that there were too many of them to deport, a horrific comment on the forced state collectivization push that provoked famine in Soviet Ukraine during 1932–33, leaving up to five million or more dead.[5] The Nazi German invasions of the 1940s brought short-lived attempts by groups favoring Ukrainian independence, until the realization that Hitler considered the Ukrainians inferior beings suitable for slave labor and their territory destined for German colonization.[6] Following World War II another Ukrainian independence movement fielded an army against Soviet forces and was only completely defeated after isolation during the ensuing Cold War.

As one of the newest nations on the planet after independence in 1991, Ukraine offers a case of a national cinema with master themes and plots not as evident in film production as those of most of the other nations examined herein, for the simple reason that film production in most of the twentieth century was under the heavy boot of the Soviet system and the cultural hegemony of Ukraine's neighbor to the east, Russia. Following the 1917 October revolution and the ensuing civil war, the Soviet regime nationalized the cinema in 1922 to form the All Ukrainian Photo Cinema Administration (VUFKU). Existing studio "factories" in Yalta and Odessa

were placed under Soviet control. The silent period saw limited indigenous film production with 4 films in 1923, 16 films in 1924, 20 films in 1927, 36 films in 1928, and 31 films in 1929.[7] The paradox of the Ukrainian cinema is that for most national cinemas the advent of sound allowed the development of a mini-Hollywood, based in the capital city that competed with extranational products because of the ability to offer audiences films in a national tongue. However, in Ukraine the introduction of sound cinema coincided with severe Russian/Soviet oppression. Films depicting Ukrainian themes independent of Russian/Soviet dictates apparently deeply threatened the imperial aims of Russia's Soviet Union. At the moment when most national cinemas were able to gain an audience by offering films in a national language, Ukraine was not, perhaps also due to the prevalence of non-Ukrainian languages and elements in other regions of the country as well as in the capital city Kiev. Thus the sound cinema did not provide Ukraine with the sort of nation-building cultural opportunities as in other countries. In fact the key films displaying a sense of Ukrainian cultural identity were actually made during the silent period.

Despite the disadvantages of Soviet/Russian oppression, the Ukrainian cinema did develop though the early work of its most renowned director, Alexandr Dovzhenko (1894–1956), who made a number of silent films with plots and themes of Ukrainian cultural identity. Dovzhenko's origins in Ukrainian peasant culture were fundamental for his subsequent work, a background well in line with Shevchenko's identification of the rural and peasant roots of Ukrainian culture. Of 14 siblings only Alexandr and a sister would survive into adulthood. His mother was an Orthodox Christian, and his Cossack origins point to an identity steeped in the sort of makeup dear to Ukrainian nationalists. This background would form the core of a basic sense of identity that would fortify Dovzhenko during his turbulent career.

Dovzhenko worked as a teacher in tsarist schools where Russian was the language of instruction. With the arrival of the 1917 revolution, like his entire generation, Dovzhenko would be marked by the political events that followed. Some factions in Ukraine declared independence seeking protection from German and Austrian troops eager to claim a share of Ukrainian grain. Dovzhenko joined Ukrainian nationalist forces that briefly enjoyed success against the Bolsheviks.[8] However, he suffered capture and imprisonment until the end of the war. His role in nationalist factions would be a mark against him in the eyes of Soviet authorities. He was purged from the Communist party in 1923 and was subsequently imprisoned for his efforts by the victorious Bolsheviks. Given his Ukrainian nationalist background,

Dovzhenko would endure a precarious political position for the rest of his life.

Dovzhenko was part of a generation of Slavic filmmakers who imparted a cinematic style with heavy reliance on montage and formalism. This style of filmmaking was favored in the cultural and political climate of the Soviet Union, which had high levels of illiteracy and also lacked a common tongue throughout its vast territorial possessions. The montage film style is able to communicate mainly through visual rather than verbal techniques allowing for the distribution of films across the Soviet Empire. Examples of this Soviet montage style include some films of seminal importance in cinema history such as Vsevolod Pudovkin's *Mother* (1924), Sergei Eisenstein's *Strike* (1925) and *The Battleship Potemkin* (1925), Lev Kuleshov's *The Extraordinary Adventures of Mr. West in the Land of the Bolsheviks* (1924), and Dziga Vertov's *Cinema-eye* (1924).[9] It was a cinema that made a virtue of the illiteracy of its audience by developing a montage-based style that could communicate themes, often of socialist realism, without relying on intertexts.[10] As in much of the world, in the Ukrainian market foreign films challenged indigenous production at the domestic box office and Dovzhenko's first efforts were influenced by the Hollywood model such as his first political film *The Diplomatic Pouch* (1927) in which a Soviet diplomatic courier is assassinated by émigrés in the United Kingdom. Dovzhenko followed this effort with major contributions to Ukrainian and world cinema: *Zvenigora* (1928), *Arsenal* (1929), and *Earth* (1930).

In *Zvenigora*, originally entitled *The Enchanted Place*, Dovzhenko "attempts to unite legends of the Ukrainian past into one film," making use of a nonlinear narrative that relies heavily on the Soviet montage film style.[11] The importance of the film for this study is the manner in which it depicts Ukrainian identity as an independent and enduring reality. This was in complete contrast to centuries of Russian policy, whether tsarist or Bolshevik, which defined Ukraine as a part of Russia, without the rights of autonomy granted to Finland or Armenia, nations that had been part of the Russian Empire in the nineteenth century. In *Zvenigora* Ukraine is identified with a hidden treasure, which reappears over the course of Ukrainian history under the eye of a grandfather figure who also symbolizes Ukraine. These two symbols, the treasure and the grandfather, persist throughout the film over events enduring more than a thousand years. The film communicates a sense of Ukrainian identity separate from Russia in a manner that could be understood by an illiterate public, although the film was apparently not popular as it apparently confused audiences with its vivid imagery. Since the mass of Ukrainian peasants was illiterate, the film was a potentially very powerful tool if interpreted according to nationalist ideals, a fact that would cause political difficulty for Dovzhenko. Despite

the nods to Bolshevik absolutism, the film identified Ukrainian history as separate from Russian history with settings key to Ukrainian identity in accordance with narratives favored by Ukrainian nationalists. As George O. Liber points out, the film concentrates on those bits of Ukrainian history that have been singled out as having elements of a hidden but stubbornly resistant Ukrainian nation through the definition of a symbolic core to Ukrainian identity in a mythical treasure contested by forces from the east and west.[12]

The film shifts back and forth in historical time. The first story is the Roksana myth with references to the Varangian invasions near the turn of the first millennium during the Rus period, which historians have identified as a moment of possible Ukrainian national formation. The grandfather recounts how invaders captured Princess Roksana who fell in love with the invader leader and betrayed her people. Eventually she turns against the invader and incites the people to rebel. After the rebellion is crushed by the invaders, the invader leader curses Roksana. The gold the invaders demanded in tribute (the source of the treasure of Zvenigora) remains hidden in the mountain in accordance with this curse.

The second story is set during the Cossack invasions of the sixteenth and seventeenth centuries, another period often identified as a moment of the conception of the modern Ukrainian nation. The grandfather leads the Cossacks to a mountain forest where he says there is a treasure, a Ukrainian treasure. In the array of images that follow, Dovzhenko depicts the Cossacks defeating the Poles and finding a magic grail (a possible Christian symbol) that breaks, perhaps an indication of the division between religious professions in the regions. A monk then puts a curse on the mountain that will make it impossible to find the buried treasure. Thus the essence of Ukrainian identity, symbolized by this mysterious treasure, is once more hidden away and unreachable following the Cossack period. The Cossack leader then orders the grandfather to guard the treasure in their absence.

The grandfather guards the treasure until the twentieth century when he reappears with two grandsons. Timoshka is identified with the Russians, no matter whether tsarist or Bolshevik. The other grandson, Pavlo, remains with the grandfather to find the treasure and only flees once the Russians are victorious. According to Liber the two grandsons are cast according to competing influences on Ukrainian identity. Timoshka is svelt and is depicted as industrious and related to elements of industrial progress. Pavlo is more of a peasant-like figure identified with folklore and past traditions. He is portrayed as an idealist and a Ukrainian nationalist.

During the war, tsarist forces dig a mine into the mountain trying to get at the treasure. When the tsarists lose, Timoshka joins the Bolsheviks, while Pavlo joins Ukrainian nationalists. Once the Bolsheviks win, Pavlo

goes to Europe to raise funds by performing as the Duke of Ukraine. He lectures on the Bolshevik destruction of Ukraine. As a finale to his show, he tells audience that he will kill himself, although the show is actually a scam since he is in cahoots with the local police who break up the performance. The audience, feeling cheated out of the spectacle of Pavlo's death, protest virulently, a wry comment on the true level of Western solidarity for Ukraine. Upon his return Pavlo tries to convince the grandfather to blow up a Bolshevik train. But the grandfather refuses, at which point Pavlo does kill himself. The train then stops and picks up the grandfather who is celebrated by the Bolsheviks for having resisted counter revolutionary forces. Thus in the film's finale, Dovzhenko seems to favor the Bolshevik Timoshka, the winner of the civil war, with whom the grandfather boards the train in the final sequence.[13] The film could be considered somewhat autobiographical since Dovzhenko, like the grandfather in the film, was active in the Ukrainian nationalist movement having enrolled in nationalist armies but spent the rest of his career kowtowing to the ultimate representative of Soviet and Russian imperialism, the Georgian-born dictator Josif Stalin (1879–1953). However as Liber has noted, despite the pro-Bolshevik conclusion, the film's Ukrainian elements, such as the telling of the Roksana or Cossack stories and the idea of a hidden wealth and essence to the Ukrainian identity, are more resoundingly communicated than the pro-Russian conclusion that seems almost out of step with the rest of the film.

The second seminal film by Dovzhenko, *Arsenal* (1929), was made in response to calls for films marking the tenth anniversary of the Bolshevik coups that founded Russia's Soviet Empire. The film is almost a sequel of *Zvenigora* and takes up the story of Timoshka, the pro-Russian character from *Zvenigora*. Timoshka exposes his chest to the bullets of Ukrainian nationalists, but they cannot kill him. In one scene a portrait of the Ukrainian national poet Shevchenko comes to life and blows out the candle of Ukrainian nationalism, for in accordance with Marxist dogma the film emphasizes class identity rather than national divisions. The film offers highly symbolic imagery of the civil war period with references to Ukrainian nationalist conferences and charges by a Ukrainian solider who accuses the Bolsheviks of only wanting to perpetuate the subjugation of Ukraine. The interesting aspect is that with *Arsenal*, Dovzhenko thought he had made a pro-Soviet film that would serve to quell suspicions about his sense of loyalty to the Soviet cause, particularly in light of his service in Ukrainian nationalist units during the civil war. However, during the paranoid period of purges following the civil war, any reference to Ukrainian identity should have made Dovzhenko fear for his physical survival. The film climaxes when the protagonist must answer the question, "Are

you a Ukrainian?" at the barrel of a Russian gun. The reply, "Yes, a worker," is a clear attempt by Dovzhenko to express the essence of Soviet ideology, which sought to replace national consciousness with class consciousness, but again even posing such questions was risky during the period of purges by the Stalin regime.

With his third silent film of note, *Earth* (1930), in Figure 8.1, Dovzhenko had to conform to the change in the Bolshevik regime's previously favorable attitudes regarding Ukrainian political and cultural autonomy. The film presages the forced collectivization of 1932–33 that led to the mass murder-forced starvation of up to an estimated five million or more, beginning with the relatively autonomous subsistence farmers known as Kulaks, who became the scapegoats of a state agricultural centralization scheme that brought the horror of mass starvation to the Ukrainian people. During the mass collectivization and ensuing starvation, the Soviet regime targeted Ukraine as a source of revenue from grain in order to pay for machinery brought from abroad for the development of the coal and steel industry. By 1933 65 percent of all farmland and 70 percent of livestock in Ukraine had been stolen by the Soviet State with cataclysmic costs

Figure 8.1 *Earth* (1930, Soviet Union) a.k.a. *Zemlya*. © Wufku/Mosfilm.

in terms of human suffering and starvation.[14] The class war against the Kulaks turned into a collective war against the Ukrainian peasantry who were robbed of land, possessions, and livelihood and herded into collective farms where they starved to death. There is an immense and tragic irony that Dovzhenko would make a film depicting Soviet collectivization plans that would cause horrific suffering for his people, including his own parents who were caught in the maelstrom. In a sense Dovzhenko's silent film trilogy seems to chronicle the defeats of his nation. First *Zvenigora* and *Arsenal* treat the topic of the defeat of the Ukrainian nationalists during the civil war. Then *Earth* presages the murderous state-run programs of the Bolsheviks that destroyed the lives of millions through forced starvations and deportations as a direct consequence of state theft of private property.

Earth is the story of a family during the collectivization of 1929. The film opens with the grandfather's death, perhaps an echo from *Zvenigora* where the grandfather was the essence of Ukrainian identity. Opanas, the father, opposes the state communal farm scheme while his son Vasili, a fanatical Communist, is in favor and brings a tractor to the public debate and presentation of the collectivist plan. Apparently the first promotions of collectivization by the Soviets were held at such open village forums where socialist authorities attempted to convince the peasants of the merits of handing over their land and livelihood to the state. Thus the film has elements of chilling historical veracity especially if considered in terms of the horrific suffering these policies caused. The film has a sinister, propagandistic undertone as it depicts one of the tactics used by authorities to coax peasants into collective farms before the cataclysmic consequences of state-run farms actually hatched out. When the pro-Communist son Vasili plows a tractor across fenced land, it is meant to symbolize the end of personal property rights in favor of submission to the will of the state. Vasili represents the new Soviet socialist man able to subordinate his own personal talents for the alleged good of the collective. In retaliation Khoma, the Kulak, is the film's villain, seeking to retain his natural rights to property and create prosperity in accordance with his talents. Khoma murders Vasili after the latter celebrates the eventual arrival of collectivization in a beautifully filmed dance sequence. Eventually Opanas changes his mind about collectivization, and the film progresses toward a happy ending.

In a repeat of the difficulties that Dovzhenko faced after making *Arsenal*, *Earth* also brought trouble as critics charged that its Ukrainian cultural elements, such as the dance and folklore imagery, were so visually powerful and evocative that they detracted from the canned pro-Communist themes in the plot.[15] The film's depiction of Ukrainian elements in dress and dance were an indication of a national identity separate from Russian/Soviet

dominance. Even if these elements were presented in the context of a plot that slavishly adhered to party dogma, their mere appearance was anathema under the climate of political paranoia of the period.[16] The film was censored in 1930 on charges of obscenity for the two scenes that depicted simple physical acts that are actually evocative of nature and the essence of agricultural living. In one scene Vasili urinates in the tractor's radiator so that the engine may cool, arguably making a connection between the industrial progress brought by the tractor and the naïve idealism of his participation in the collectivization scheme. In another scene Vasili's fiancé Natalia displays herself in a nude flourish, although the scene has limited sexual connotations, and Natalia is more a figure of vitality and fecundity than pornography.

Dovzhenko's next film *Ivan* (1932) was one of the first feature length sound films made in the Ukrainian language. This meant that no matter how eloquent Dovzhenko's attempts at pro-Communist propaganda themes, the film was destined to cause trouble according to the imperialist and nationalist paranoia of the Russocentrist Soviet Union. As with his previous films, Dovzhenko's film slavishly follows the Communist Party line in terms of political content. The film depicts the building of a public works project to dam the Dnieper River. Actual construction took place during the horror years of collectivization, 1932–33. Many Ukrainians indentured to work on the project were ironically able to avoid the "starvation, collectivization, deportation, death" of the collectivization massacres because they were needed to work on the dam.[17] As with *Earth* the subject matter of Dovzhenko's film is pregnant with the tragic fate of his countrymen under the tyranny of the Soviet state. The damming of the Dnieper River also has a historical resonance, for it was the turn of the meandering Dnieper that provided Cossacks a natural haven during an important period of formation of Ukrainian identity. The damming of the Dnieper was thus a cause for celebration in terms of a Soviet ideology that favored the elimination of factors that could be seen as fomenting regional identity.

The film features two opposing characters: the ideologically committed protagonist, Ivan, and the lazy ne'er-do-well co-worker, Haba. The film ascribes to the master plot of socialist realism in which a protagonist confronts a problem and realizes that it may only be overcome though an increased awareness of his responsibility to the collectivity. The hero of the socialist narrative "strengthens his communist consciousness by overcoming a serious socio-political-economic challenge,"[18] in a story where the dilemma may only be resolved through a socialist crusade. As with Dovzhenko's previous films, elements that emphasize Ukrainian identity such as the use of the Ukrainian language and subthemes of apparent conflict between peasant traditions and the dictates of Communist industrialization

would cause the filmmaker political trouble to the point of having to fear for his survival in the Stalinist purges of the period. In fact, like *Earth*, *Ivan* also received a cool official reception. Soviet culture commissars were more pleased with films like Georgi and Sergei Vasilyev's *Chapaev* (1934), a film that left little room for themes of national identity in the story of a Red Army soldier during the civil war who was guided to socialistic identification by his political commissar. Again, despite the openly propagandistic plot in *Ivan*, Dovzhenko was criticized as a Ukrainian nationalist to the point that he had to fear for his life. Paradoxically Dovzhenko sought refuge in Moscow where he was able to save his skin by successfully currying favor at the court of Stalin, who was apparently a fan.

As mentioned *Ivan* is one of the first sound films in the Ukrainian language and here again ironies abound. For given the similarities between Russian and Ukrainian, Russians apparently found the film difficult to understand as the similarity of the languages, and confusion resulting thereby, posed more of a problem than if the film had been accompanied by intertexts. The film still presents the duality seen in Dovzhenko's film *Zvenigora* although the nationalist character Haba is not represented as a committed partisan like Pavlo. Ivan, the everyman name for Slavs, on the other hand takes up the mantle of Timoshka in *Arsenal* and Vasili in *Earth* through his complete digestion of Communist Party dogma. The Soviet bureaucracy is however not flatteringly portrayed, another point that did not aid Dovzhenko during the years of the Stalinist terror. In one sequence a woman whose son dies on the job must pass through numerous doors of a bureaucratic inferno before being able to file a complaint to a commissar.[19] Dovzhenko hoped the film would emphasize the manner in which the Ukrainian peasantry was being transformed by the industrialization plans of the Soviet Union into the ideal workforce for Communist society, but again the mere fact that his characters were portrayed as Ukrainians by Ukrainian-speaking actors made the film suspect according to the nationalist criteria of Soviet critics. Dovzhenko actually claimed that he could not find enough Russian actors for the film to be made entirely in Russian despite the 1926 census of Kiev that shows that a majority of residents considered Russian to be their native tongue.[20]

After his troubles making films with Ukrainian themes, Dovzhenko made *Aerograd* (1935), a film set in the Soviet Far East with a plot more in tune with the master plots of socialist realism. In the film a veteran of the civil war kills his former friend who is collaborating with the Japanese during the period of Japanese expansion. The protagonist puts national loyalty over personal feelings and comradery. The film was another attempt by Dovzhenko to save his skin and led him to accept an invitation from Stalin to direct *Shchors* (1939), a faithful regurgitation of the propaganda of the

Soviet regime. The film is about a Ukrainian officer who fought in the Bolshevik army, Nikolay Shchors, a subject strongly encouraged by Stalin as part of his subsequent involvement in the production. In this period it was not unusual for European tyrants to take an active interest in the cinema. Mussolini, who considered himself a playwright, collaborated on Alessandrini's *Scipione l'africano* (*Scipio the African*; 1937), and Leni Riefenstahl's direction of the Nazi documentary *Triumph of the Will* became an important step in her career during Hitler's regime. Dovzhenko was prodded by Stalin to portray the Bolshevik victory in Ukraine as a result of the voluntary participation of Ukrainians,[21] a tricky assignment following the mass murder and starvation of Ukrainians during the forced collectivization of the early 1930s. By making *Shchors* Dovzhenko not only saved his skin after millions of his countrymen had been killed as a result of the collectivist schemes of the socialist regime but he also produced a film under the bloodthirsty, watchful eye of Stalin himself. The film became a key tool for the Stalinist revision of history once the immediate shock of the horrors of the mass starvations of the early 1930s had attenuated. *Shchors* is about willing Ukrainian adhesion to Soviet imperialism when in fact a significant portion of the population, including Dovzhenko himself, had actively promoted and even fought against the Russian/Soviets during the civil war. The story of the making of the film during the height of the Great Purge (1936-38) is incredible in itself. In the atmosphere of state terror, some of Dovzhenko's collaborators apparently did not see the completion of the film. Nevertheless, in Dovzhenko's defense, the film does feature some Ukrainian elements that again left the film open to the sort of criticism that had nearly cost Dovzhenko his life after *Earth* and *Ivan*. More important for Dovzhenko's personal survival is that the film, whose language is Russian, was apparently quite popular. Dovzhenko's submission to the powers in Moscow is reminiscent of the ending of *Zvenigora*, a film ripe with Ukrainian nationalist themes that ends with a sequence of acquiescence and submission to Russian imperialism. Despite the success of *Shchors*, Dovzhenko would live in internal exile for the remainder of his days on suspicion that he was a Ukrainian nationalist, although arguably anyone living under the Soviet system could be classified as living in internal exile. While unable to complete many feature films, Dovzhenko did complete some films and documentaries and wrote a number of treatments, stories, and novels. His wife made films from some of his scripts following his death.

During the successive period in which Ukraine was part of Russia's Soviet Empire, the Ukrainian film industry languished under bureaucratic control with ebbs and flows over the decades allowing for film production according to the level of Russian nationalist paranoia regarding Ukrainian

self-expression. The Soviet regime subsequently dubbed the studios in Kiev as the Dovzhenko Film Studios, an ironic homage for the director whose personal survival was ensured by his acquiescence to Soviet power. One film, *Shadows of Forgotten Ancestors* (1966) by Sergei Parajanov, received international recognition with a style that recalled Dovzhenko's ability to communicate with imagery and montage in the tradition of cinematic formalism.

When Russia's Soviet Empire finally collapsed and Ukraine gained independence in 1991, the Ukrainian film industry produced some interesting films. Among them, is *A Friend of the Deceased* (1997) by Leonid Boyko and Vyacheslav Krishtofovitch. The film is based on a script by novelist Andrey Kurkov, a resident of Ukraine who although born in Leningrad, considers himself a Ukrainian, perhaps in an echo of the cultural confusion felt by Gogol. The film takes up the master theme of the Ukrainian cinema of the tension between Ukrainian identity and the external influences from the East and West that recall the narratives in Dovzhenko's silent trilogy. The film is set in Kiev, the new capital of the Ukrainian republic and the nascent center of a reviving film industry where the main language is Russian. In the film the indigenous Russian and western influences on Ukrainian identity remain in conflict. For the protagonist, Anatoli, the change from Russian/Soviet domination to Western-style living has not brought benefits as he must submit to the mafia-like, corrupt essence of the new Ukrainian economy. Anatoli had aspired to Western influences by becoming an English teacher and translator. But in the post-Soviet world, such skills are not valued. Anatoli's only contact for work is an ex coconscript from the Soviet Army who runs a bar and is well-connected in the corrupt netherworld of the new Ukrainian economy. The film expresses an ironic nostalgia for the days in which the moral virtues of heroic communism were promoted under the Soviet system in contrast to the mendacity of the new Ukraine. Anatoli gets paid handsomely ($1,000) for false testimony at a divorce trial but earns only $10 for work as a translator. Anatoli cannot keep his ideal blonde wife, Katia, who leaves him for a successful, seemingly foreign businessman who picks her up in a red sports car. The film has several cameos of richly dressed men parading ideal Ukrainian blondes as a symbol of wealth and success. The implication is that Anatoli's wife, like the quirky prostitute who lives in their condominium, is a commodity.

Desperate, Anatoli decides to take out a contract on himself, arranging for his own murder. But when he has second thoughts he must find someone to kill his own hired killer. In the new Ukraine business arrangements and economic relationships are the only factors of life that retain meaning. If there is any legacy of the hidden treasure of Ukrainian identity from Dovzhenko's films like *Zvenigora*, it is in the search of the protagonist

for the sullen ex-soldier he hires as a bodyguard and hit man. To find the ex-soldier Anatoli must take a train to the countryside, leaving the cosmopolitan influences of Kiev. At the conclusion of *Zvenigora*, the grandfather gets on the train accepting Bolshevik domination. At the conclusion of *A Friend of the Deceased*, Anatoli visits the widow of the hit man he had killed, in effect taking his place in a curious plot twist indicating the continuity of life. Anatoli adapts to a new reality that is not necessarily an idealized vision of independence but a stark and unpredictable future where Soviet state oppression has been replaced by mafia-style corruption. The film adheres to the basic narrative forged by directors like Dovzhenko in the early days of Ukrainian silent cinema with a plot in which Ukrainian identity is pressed between influences from the East and West. The shaky equilibrium that Anatoli establishes by bringing the Ukrainian ex-soldier out of retirement from the countryside to be a hit man in the city in effect reveals the replacement of the Eastern model of Soviet-style communism with a mafia model. However, the new model is not based on the higher precepts of republican constitutionalism and culture to which Anatoli as a student of the English language was perhaps attracted. Rather, the new Ukraine is subject to the basest aspects of a mafia economy in which all commodities, even human lives, are for sale. The film's message seems to be that the essence of Ukrainian identity is to be perpetually divided between competing and conflicting influences from the East and West where the fate of Ukrainians is to be decided by these models.

9

America's Civil War and Hollywood's Pragmatism

The world's most economically successful cinema industry, known as Hollywood, is loosely based in the greater boomtown of the Los Angeles basin. The Hollywood cinema also has an international scope since its products figure prominently in box office histories worldwide. Hollywood producers may have made films with a predominantly American national audience in mind in its early periods, but in later years and particularly with the fall of most barriers to American cultural content following the end of the Cold War (1947–91), Hollywood producers have made an increasing percentage of their profits abroad. Thus more recent Hollywood films may feature American actors and even have American settings, but they are also international films with themes at times critical of the traditions of the American experience.

Hollywood may have a reputation for profligacy in terms of the lifestyles of its personnel, but it also has an established industrial culture based on effective market research.[1] The Hollywood happy-ending narrative has been, above all, the result of rational business decisions by studio executives.[2] The Hollywood cinema stereotypical three-act happy-ending film (boy gets girl, boy loses girl, chase, boy gets girl) was a production response to audience demand. It is a narrative whose economic core recalls the philosophical school of American pragmatism. Hollywood producers were economically motivated to capitalize on returns from films that offer evasion and suspension of belief for a spectatorship that was linguistically and culturally diverse.[3]

Historically the Hollywood film industry has reacted ably to changes in demographics and audience composition with a pragmatism that has continued to characterize production. For example Hollywood has recognized that its target spectator has changed from the young adult female in the 1930s and 1940s to the adolescent male in the 1970s and 1980s. In France

the most profitable films of all time have been comedies, yet as we have seen herein, the French film canon is decidedly tragic in narrative composition, perhaps a vestige of the cultural tradition emanating from the Romantic period. This is not the case with Hollywood where the industry accurately identified target spectators and then made films to appeal to specific target audiences. Despite the cultural and political changes in the United States over the course of the twentieth century, the basic content of Hollywood film did not significantly change from the 1930s to the 1970s and beyond.[4] The happy-ending narrative in Hollywood film has remained as a constant despite changes in mores, demographics, and political outlook, and it has remained strong within the international scope of Hollywood products. The result of effective market research and industrial planning has been the affirmation of the expected happy-ending narrative.

In terms of critical histories of film, Hollywood has actually suffered from its ability to be economically profitable. Somehow the idealism that many critics associate with artistic endeavor is seen as being absent from a powerful industrial machine able to distribute its product to the ends of the Earth. Thus a critical disdain regarding Hollywood films has developed to the point that American films that do not follow the three-act happy-ending template may be tagged as "art" films with a "goal bereft protagonist."[5] The critical assumption is that Hollywood films are interested in closure and thematic certainty, while art films are concerned with ambiguity and relativism.[6] Such division of world cinema into Hollywood versus non-Hollywood camps could benefit from examination of the varying narrative tendencies of different national traditions, of which the United States is arguably a part. There is also no reason to limit a nation to a single narrative, since most nations house regional identities, some of which have been represented in the cinema. For example when the Hollywood cinema examines Californian life, it often presents tales that are not stereotypical of the Hollywood classic narrative. Billy Wilder's *Double Indemnity* (1944), John Ford's *Grapes of Wrath* (1940), Mike Nichols's *The Graduate* (1967), and Roman Polanski and Robert Towne's *Chinatown* (1974) could be seen as films that place themselves within an historical resonance of the regional identity of the boomtown culture of the California republic. Thus the happy-ending reputation of the Hollywood cinema is but one aspect of a more complex reality in which a vast and historically successful industry has outgrown its national confines and become not only a national cinema but also a world cinema.

The master plots and master themes examined in this study have identified how the relevance of national cultural heritages can be confirmed at the domestic box office. Despite the reach of Hollywood cinema, this interpretation should be applicable to American cinema as well. For when it

comes to examining or defining a cinematic narrative for the United States, the international relevance of Hollywood cinema is clear from a look at the films that have topped the domestic box office. Thus it is necessary to distinguish between the international pull of Hollywood cinema in comparison to an American cinema more reflective of the themes of indigenous American culture and history. In the top-25 domestic box office as of 2005 (inflation adjusted) films, only 7 are actually set in the United States or deal with themes relating directly to American culture and history.[7]

1. *Gone With the Wind* (1939)
7. *Jaws* (1975)
15. *The Sting* (1973)
18. *The Graduate* (1967)
21. *The Godfather* (1972)
22. *Forrest Gump* (1994)
25. *Grease* (1978)

Other Hollywood films in the top 25 feature extranational influences whether biblical like

5. *The Ten Commandments* (1956) and
13. *Ben-Hur* (1959),

infernal like

9. *The Exorcist* (1973),

or extraterrestrial like

2. *Star Wars: Episode IV—A New Hope* (1977)
4. *E. T. The Extra-Terrestrial* (1982)
12. *Star Wars: Episode V—The Empire Strikes Back* (1980)
14. *Star Wars: Episode VI—Return of the Jedi* (1983)
19. *Star Wars: Episode I—The Phantom Menace* (1999).

Other top-earning Hollywood films are set outside the United States.

3. *The Sound of Music* (1965) in Austria
6. *Titanic* (1997) on an English ship in the North Atlantic
8. *Doctor Zhivago* (1965) in Russia
11. *101 Dalmatians* (1961) and 23. *Mary Poppins* (1964) in London
10. *Snow White and the Seven Dwarfs* (1937) a German fairy tale

16. *Raiders of the Lost Ark* (1981) around the planet
17. *Jurassic Park* (1993) a fictional island in the Pacific
20. *Fantasia* (1940) numerous imaginary settings
21. *The Godfather* (1972) half set in Sicily
24. *The Lion King* (1994) based on Shakespeare's play about a Danish prince (*Hamlet*) but set in Africa

The narrative pattern of the happy ending is actually so imbedded into Hollywood production culture that Hollywood has developed a genre of time warp films where protagonists who fail for one reason or another to achieve a happy ending in their time allotted on Earth are allowed a chance to changed reality. This current is evident in films such as Robert Milton's *Outward Bound* (1930), remade by Edward Blatt as *Between Two Worlds* (1944), Frank Capra's *It's a Wonderful Life* (1946), *Heaven can Wait* (1943, 1978), the *Back to the Future* (1985, 1989, 1990) series, *Defending Your Life* (1991), *Groundhog Day* (1993), *Jumanji* (1995), and *The Family Man* (2001). Since none of these films found its way into the all-time box office top 25, the wishful-thinking optimism they espouse must not be central to an American cinematic narrative. Yet they are an obvious part of the culture of Hollywood films whereby happy endings create happy customers and the sort of return business and brand loyalty that profit-making ventures seek. A search for direct correlation and mimesis between films with resounding popularity at the box office and a nation's history and culture would expect at least some of the top-earning Hollywood films to treat domestic American themes. If cinemas imitate national culture, then the world's most commercially successful and stylistically influential cinema, Hollywood, should provide examples of films that reflect American national identity.

Perhaps there has been a critical tendency to dismiss the American cinema due to its commercial success as a cultural artifact with a short-term historical memory. With the creation of immigrant businessmen for a nation of immigrants, there is the prejudice that the United States cinema does not have enough of a historical patrimony for more deeply seated historical and cultural factors to be an important consideration.[8] However as an enduring political entity, the United States Constitution signed in 1787 has determined the cultural essence of the United States of America for over two centuries, a period longer than enjoyed by most regimes in Europe or around the world. Thus despite the claims of countries, including those examined in this book, for superiority with regards to the United States in terms of cultural existence, in fact the United States has a longer history of political continuity than any other country examined herein. To cite one example Italy has only been a unified nation with a national

government promoting a national culture and language since 1870 with a constitution enforced in 1948.

If we return to those seven top-grossing films set in the United States, *Gone With the Wind* (1939), *Jaws* (1975), *The Sting* (1973), *The Graduate* (1967), *The Godfather* (1972), *Forrest Gump* (1994), and *Grease* (1978), what immediately comes to the eye is the absence of westerns, the genre most often identified with American national formation. Westerns were a mainstay of Hollywood production until the 1960s and 1970s. Explanations for the identification of the western as a master narrative of classical Hollywood cinema could derive from Frederick Jackson Turner's frontier explanation for the development of an American world view.[9] According to this interpretation the essence of American culture may be explained by the need of pioneers to cooperate in an underpopulated continent where the major obstacle was the shortage of labor. This fostered an environment encouraging technical invention and boosterism. As the country has increased its population and economic wealth, wilderness taming and labor shortages faded into memory, and the resonance of the western in the collective memory of Americans has lapsed. Another interpretive tract is the tradition of Horatio Alger rags-to-riches tales, common in a country where class boundaries were historically more easily broken than in Europe.[10]

Robert B. Ray has written of the narrative tendencies in American film in terms of an antiheroic theme common in the western genre. The moment in which the antihero ascribes to collective values becomes a moment of healing and the American cinema becomes a cinema of compromise, of acceptance of all points of views, an embrace of all peoples and traditions into an optimistic synthesis.[11] According to Ray the American antihero provides a vehicle for resolution between incompatible values for a synthesis of opposites, the perfect expression for a country comprised of everything and everyone the world over in a narrative of inclusion and optimism whose origins are in the action needed to tame a wilderness in the civilizing process.[12] The original model for the antihero is from the descriptions of the classical historian Livy (Titus Livius) of Cincinnatus, the Roman general, farmer, and reluctant hero who returned to his farm after serving his country. Cincinnatus was a model for George Washington (1732–1799)—to cite only one example of important and heroic figures in American history inspired by the ideal behavior of the ancient Roman general. This reluctant hero model is arguably a source for the self-effacing attitude of male leads that has carried over from Hollywood's studio era to the present day in the cinematic personas of actors like Gary Cooper, Humphrey Bogart, Steve McQueen, or Clint Eastwood.

That Hollywood cinema is truly international is borne out by the extra American settings for its top 25; and the increasing reliance of Hollywood

producers on profits from outside the United States. However, if we look closely at the list of the seven domestically set films within the top 25, we may discern two films that specifically treat themes of American history: *Gone with the Wind* (1939) and *Forrest Gump* (1994). The common thread between these films is a setting in the American South with repercussions emanating from the American Civil War (1861–1865). No other American war, the Revolutionary War, the War of 1812, the Mexican-American War, the Spanish-American War, World War I, World War II, the Korean War, the Vietnam War, or the Iraq and Afghanistan Wars, is depicted in a film in the top-25 box domestic office films of all time. The aftermath of the Civil War is often a starting point for westerns, especially the films of John Ford whose protagonists and antagonists are often Civil War veterans who have traveled west in films such as *Fort Apache* (1948), *She Wore a Yellow Ribbon* (1949), or *The Searchers* (1956). The importance of Civil War themes and the manner in which the western exists as a genre that is framed around the historical experience and the cultural assumptions of the Civil War should come as no surprise. Western expansion of the United States took place during the years preceding and following the Civil War.

Thus the lack of a stereotypical western in the top-25 top grossing films in the United States should be adjusted for the presence of films that have the American Civil War as their backdrop. The importance of these two films, *Forrest Gump* and *Gone with the Wind*, also hearkens back to the silent period whose uncontested box office champion, D. W. Griffith's *The Birth of a Nation* (1915), is also set during the Civil War period. The plot of *The Birth of a Nation* revolves around a northern family, the Stonemans, and a Southern family, the Camerons. The sons of the families meet at a northern university and then find themselves on opposite sides of the conflict. After the war the two families collaborate in an openly racist message that northern and southern whites should unite against the threat of miscegenation and republican reconstruction. In the film's finale the Ku Klux Klan "rescues" white females and works to deny ex-slave suffrage. There is direct continuity from *The Birth of a Nation*, *Gone with the Wind*, and *Forrest Gump* (Figure 9.1) in a plot line that revolves around the saving of a Southern damsel in distress. The connection between *Forrest Gump* and *The Birth of a Nation* is explicit from the opening sequences of *Forrest Gump* with a cameo from Griffith's silent film depicting Tom Hank's protagonist as a direct descendent of Nathan Bedford Forrest (1821–77), the decorated Confederate Army officer and founding member of the Ku Klux Klan.

With themes relating to the Civil War and the defeat of the Confederacy, these films, *Gone with the Wind* and *Forrest Gump*, touch upon deep themes in American history. The resonance that these films evoked among

Figure 9.1 *Forrest Gump* (1994, United States). Credit: Paramount Pictures/
Photofest © Paramount Pictures.

the American public is evidence of a popular awareness of how the essence of American national identity was forged out of the Civil War and the two very different political and societal models that faced off in that conflict. The two opposing factions, the proslavery Confederacy and the antislavery Union, actually were the retainers of economic and political models from England that colonized different parts of the Atlantic Seaboard in the seventeenth century. The northern colonies, with their merchant culture and Calvinist religious ideology, were colonized by companies closely aligned with the victorious Roundhead faction of the English Civil War (1642–51). The Roundheads brought their own version of parliamentary governance to the New World based on corporative collaboration, capitalist profit, individual initiative, and religious freedom. However, they also had a maximalist and statist streak, as evidenced by Oliver Cromwell's (1599–1658) assumption of the title of Lord Protector in 1653, a de facto dictatorship embodying state power as the ultimate arbiter for a societal commonwealth. The anti-Roundhead and losing side of the English Civil War were the Royalists, known as the Cavaliers whose leader, King Charles I, was beheaded in 1649. The Cavaliers were eventually able to restore the British monarchy and establish an aristocratic model of governance and society in the colonies of the southeastern Atlantic Seaboard, which would later form the Confederacy. The mascot of the University of Virginia established

in 1819 by Thomas Jefferson (1743–1826), for example, is a Cavalier, the champion of an agricultural, slave-holding aristocracy. Cavalier culture took considerable influences from ancient Greece and Rome, also societies with large percentages of the population bound in slavery to paradoxically champion the ideals of individual freedom based on Lockean concepts of the natural right to own property.

The split between these two factions (Roundheads and Cavaliers) has stubbornly persisted in American history and culture to the present day. After the American Civil War, there was a long-standing boycott by former Confederate states of the Republican party of the Great Emancipator Abraham Lincoln (1809–65). The recent red state/blue state mass media definition of the split has persisted in contemporary American politics into the twenty-first century between the statist policies championed in northern, former Roundhead territory in contrast to more laissez-faire policies favored in the South, the region colonized by the losing Royalist, Cavalier side in the English Civil War.

This brief excursion into the depths of American history leads to a look at *Gone with the Wind* and *Forrest Gump* for the manner in which these two films present master themes within American national identity. First, the two protagonists of *Gone with the Wind*, the adventurer Rhett Butler and the Southern belle Scarlett O'Hara, present two completely different world views. Despite his casting as a Southerner, Clark Gable's Rhett Butler has an obvious Midwestern cadence to his English. He comes across as a Northerner with his self-serving outlook openly derisive of antebellum Southern culture. A key to the manner in which the film develops Rhett Butler's persona is through his cynicism about the Confederate *cause*. He presents himself as a hedonist who refuses to take part in the Confederate Army and instead occupies himself during the war as a gun-running profiteer, an entrepreneurial attitude that provokes the disdain of antebellum society. Butler is out of sync with the agrarian, slave-based economy of the Cavalier South and its gentlemanly honor culture. When Butler tries to conquer the epitome of the southern belle, Scarlett O'Hara, she rejects him preferring the well-mannered and inoffensive Ashley Wilkes, whose retiring and stoic demeanor is presented as the epitome of Southern gentlemanliness. Aside from melodramatic trappings in which Scarlett, impoverished by the defeat of the Confederacy, tries to reacquire the elevated class status she enjoyed before the war, *Gone with the Wind* is about how the aristocratic tenets of the Cavalier model would accede to the capitalist entrepreneurism of the Roundhead North. This process was not actually completed until the introduction of air conditioning in the South in the second half of the twentieth century.

Throughout *Gone with the Wind*, Butler is portrayed as someone who is able to make money, from his associations with gun running and prostitution to his appearances on the river boats, the commercial nexus of nineteenth-century America. For other national cinemas this study has noted how geographical makeup can be a determining factor in cultural development. In the United States massive, navigable continental rivers allowed the transportation and agricultural surplus necessary for economic development. The importance of rivers and the opportunities afforded to Americans in terms of personal mobility resonates in Mark Twain's novel *The Adventures of Huckleberry Finn* (1885). One of the defining characteristics of the American experience is how social mobility and economic vitality confer the possibility to reinvent oneself and to rise out of the rigidity of Old World class constrictions. In *Gone with the Wind*, Butler is identified with the mobility of commerce and the role of the Mississippi River in the economic development of the nation. Similarly in *Forrest Gump*, when the protagonist jogs across the continental United States, his journey is framed by the country's rivers. The first boundary that Forrest encounters is the river demarcating the boundary of his native Greenbough County in Alabama.

After the Civil War Butler's love interest Scarlett O'Hara, the perfect incarnation of antebellum femininity, again rejects Butler. Despite yearning for Ashley Wilkes, she decides to marry a local businessman who seems faithful to the ideals of ante bellum aristocracy. After her husband's death Scarlett is able to establish her class status by making money according to the commercial and industrial model represented by Butler, whom she eventually marries. Yet Scarlett's success is not within the codes of the aristocratic, agrarian, ante bellum model that disdained honest labor or commerce as ungentlemanly. Despite the victory of the financial and economic model represented by Butler; Scarlett still longs for Ashley Wilkes, the perfect Cavalier gentleman, vestige of the ante bellum, aristocratic South. When Butler accepts that Scarlett's connection to ante bellum ideals is stronger than any feeling she may have for him, their relationship ends. Other vestiges of aristocratic society such as the caste system, which relegated ex-slaves to secondary social and economic status, are not challenged in the film. The Hollywood of the late 1930s was not interested in social activism as much as box office success, and the film retains the racial attitudes of its day. However, the basic lessons of the American Civil War and the English Civil War remain. The Southern, aristocratic Cavalier model was defeated by the Roundhead, merchant model both on the battlefield and in the narrative of America's all-time box office champion *Gone with the Wind*.

If *Gone with the Wind* is about the legacy of the American and English Civil Wars, then *Forrest Gump* continues the narrative in post–World War

II America. In effect *Forrest Gump* takes up where *The Birth of a Nation* and *Gone with the Wind* leave off. *Forrest Gump* continues the historical trajectory with a protagonist who is the heir to Southern aristocratic culture. As mentioned Gump, played by Tom Hanks, is identified early in the film as the heir of Nathan Bedford Forrest, noted Confederate war hero and founding member of the Ku Klux Klan. Griffith's film receives a cameo in an opening sequence in which Tom Hank's image is superimposed onto the final sequences of the final Ku Klux Klan charge from *The Birth of a Nation*. Thus the contemporary character of Forrest Gump is directly connected not only to his ancestor Nation Bedford Forrest but also to the narrative of *The Birth of a Nation*. The plot of *Forrest Gump* follows the main narrative currents of both *Gone with the Wind* and *The Birth of a Nation* where the goal of the protagonist is to defend a Southern woman. In *Forrest Gump* Gump's childhood playmate and friend Jenny suffers an unhappy journey from child abuse to counterculture promiscuity that eventually results in her untimely death from AIDS. Gump attempts to defend her throughout the course of the film while passing through the main events of American history from the 1950s to the 1990s. He tries to dissuade her promiscuity during college. He defends her from a hypocritical and abusive anti–Vietnam War demonstrator. Gump tries to rescue Jenny from the degradation of the strip club where she performs counterculture pop songs while naked.

Gump takes his disenfranchised identity as an heir of the fallen Southern aristocracy and its charismatic leader, Nathan Bedford Forrest, into the dynamism of the American post–World War II consumer economy. He gains a football scholarship due to his excellence in sprinting. He serves honorably in the Vietnam War, saving the lives of his company and winning the medal of honor. Gump even makes a trip to New York City, the mecca of Roundhead, merchant culture, during the depths of the city's cultural and economic decline in the 1970s. He thwarts the suicide attempt of his commanding officer from Vietnam, Lieutenant Dan, whose ancestors had fought in all the American wars, including the Union side in the Civil War, thus reclaiming the tarnished honor of America's military after its defeat in Vietnam. He sells his image as a ping-pong diplomat during Richard Nixon's diplomatic policy refurbishing relations with Communist China. When Gump becomes rich by keeping a promise to his fallen black comrade Bubba to become a shrimp fisherman, he provides personal de facto reparation for slavery by presenting the defunct Bubba's share of the enterprise to his fainting mother. Gump inspires and cashes in on fads in consumer culture like t-shirts and jogging. Despite his success throughout the film Gump is characterized as "stupid," and his successes are ascribed to dumb luck. He acts and speaks with the mannerisms of a losing cultural

model. The Hollywood film industry with its centers of finance and pro-
duction in New York and Los Angeles marked Southern-tilted American
English as a sign of stupidity, a probable vestige of Union victory in the
Civil War and subsequent Northern economic hegemony. Gump's code of
behavior (loyalty, honesty, a certain misanthropic stoicism and diligence in
effort, and chivalric defense of Southern womanhood) echoes the codes of
the aristocratic culture to which he is an heir.

Once this heir of the fallen Southern aristocracy has reclaimed his station
in the world, he returns to his ancestral home in Alabama, which thanks to
his abilities in the modern economy, must no longer be rented out to trav-
eling salesmen. The attitude of Tom Hank's protagonist in *Forrest Gump* is
reflective of the antihero model. Gump eventually returns to his farm after
success like the Roman model for the reluctant hero, Cincinnatus. In a dif-
ferent vein in *Gone with the Wind* the cool indifference displayed by Clark
Gable's Rhett Butler also recalls the reluctant antihero archetype. Butler
only joins Confederate forces during the desperate siege of Atlanta when
he fights for the personal goal of saving his friends from sack and pillage
rather than defending slavery, an institution for which he expresses little
sympathy during the course of the film. *Forrest Gump* takes up the narra-
tives of the defense of Southern womanhood and the legacy of cultural and
political conflict from the English and American Civil Wars from *The Birth
of a Nation*, subsequently updated in *Gone with the Wind*, as master themes
that resonated at the domestic box office. *The Birth of a Nation, Gone with
the Wind*, and *Forrest Gump* all share a narrative based on the rescue of a
Southern woman in the context of the competition between the two origi-
nal societal and economic models from British colonialization.

The ultimate importance of *Gone with the Wind* and *Forrest Gump* is the
manner in which these domestic box office champions provide clues about
the essential narrative and cultural identity of America and its separation
from the internationalist current within Hollywood cinema. For neither
film completely follows the Hollywood happy-ending paradigm. *Gone with
the Wind* has a particularly enigmatic conclusion in which the heroine suf-
fers the death of her only child and is abandoned by the film's protagonist.
The film ends as Scarlett O'Hara strolls out to an idealized Southern land-
scape and expresses a vague hope for a better future. Forrest Gump suffers
continuous rejection by the woman he loves until one day she turns up to
tell him that she is dying of AIDS and that he will be charged with raising
their son, the fruit of a single night of passion. The film ends with a nod
to Old World narrative circularity with the image of a feather blowing in
the wind, which also began the film. The bittersweet endings of both *For-
rest Gump* and *Gone with the Wind* deny the audience the sort of happy-
ending closure for which Hollywood cinema is stereotypically renowned.

However, both films eloquently present narratives about the essential conflicts within American economic, cultural, and political life dating back to the English and American Civil Wars that persist to the present day.

Crossing Master Narratives

Hollywood cinema has numerous examples of the cross pollination that occurs when directors work in the industry of one national cinema but express the national narrative of their country of origin or educational and cultural background. Also because of the contributions of expatriate directors, Hollywood cinema may claim directors trained in the narrative commonplaces of other nations such as Fritz Lang, Ernst Lubitsch, Billy Wilder, Jean Renoir, Roman Polanski, and Milos Forman, to name only a few.[13]

When cultural material is shared between Italy and Hollywood, the results often conform to narrative expectations. Vittorio De Sica and Cesare Zavattini were inspired by King Vidor's silent film *The Crowd* (1928) for their neorealist masterpiece *Ladri di biciclette* (*The Bicycle Thief*; 1948).[14] Vidor's film has the happy ending and closure typical of three-act Hollywood dramas. The previously distraught family man returns home accompanied by his son after having overcome a period of unemployment and alcoholism provoked by the tragic death of his daughter. De Sica's film ends on a more somber and fatalistic note in accordance with Italian narrative circularity. As in Vidor's film the intervention of the son saves the father. However, rather than the optimistic outlook one may expect of Hollywood cinema in the final scene of *The Bicycle Thief*, an anonymous crowd envelops father and son. The assumption is that the father will return to the unemployment lineup that began the film, his class and economic status unchanged, a fitting example of the sort of fatalism and narrative circularity that is an identifying characteristic of the Italian cinema.

Alessandro Blasetti's *Quattro passi fra le nuvole* (*Four Steps in the Clouds*; 1942) is a drama from a Cesare Zavattini script about a traveling salesman who briefly masquerades as a pregnant girl's absent husband in order to convince her family that the child will be legitimate. The original film has the circular narrative expected of mainstream Italian film. The candy salesman takes temporary delight at the pastoral life of the girl's family but eventually returns to his drab class and family obligations in the city. His life remains what it was at the outset of the film, a perfect expression of Italian narrative circularity. Zavattini's script has themes of class conflict and moral impropriety that were not well-viewed by Mussolini's Fascist regime and the film is often cited as an example of the manner in which

the Italian film industry of the late 1930s and early 1940s moved toward the social outlook of the neorealist period.

Hollywood remade *Four Steps in the Clouds* as a Keanu Reeves vehicle, *A Walk in the Clouds* (1995) directed by Mexican born Alfonso Arau, and the script is credited to the Writers Guild of America (WGA) as a multiwriter effort. For the remake Zavattini's narrative was changed to meet producer expectations of the desires of an American audience. *A Walk in the Clouds* has a happy ending in which the candy salesman, now an orphaned and emotionally scarred World War II veteran, marries the pregnant girl after a dramatic fire in the vineyards of her family farm. The circularity of the Italian original is replaced by the definite closure of a stereotypical Hollywood film. The candy salesman's family problems alluded to in the original are solved in the Hollywood remake. In the Italian original Gino Cervi's wife is only present off-camera. In the Hollywood remake the wife's promiscuity and disinterest in the traditional values championed by Reeves's World War II veteran hero allow the annulment of their marriage and the opportunity for Reeves's protagonist to marry the farm girl.

National film narratives can cross genre boundaries. Sam Peckinpah's *The Wild Bunch* (1969) was made when America's foundational myths were being challenged during the youth revolts known as the counterculture period of the late 1960s. Counterculturalists sought to overturn the traditional reading of American history as a "manifest destiny" whereby civilization was brought to a savage land by emphasizing the nobility of North American indigenous peoples. Peckinpah was also heavily influenced by the style of Sergio Leone's Italian westerns with realistic portrayals of violence and a certain cynicism about the efforts to imprint any one ideology on history. *The Wild Bunch* also retains the circular narrative structure of an Italian film.

Despite the seeming Italian or Sicilian context, *The Godfather* (1972) and its prequel/sequel *The Godfather Part II* (1974) display elements typical of mainstream Hollywood narrative. The protagonist, Vito Corleone, must overcome the obstacles of a hostile environment in order to establish a family dynasty and take revenge on the mafia boss in Sicily who murdered his family. The film has a humorous epilogue in which the hero convinces a hostile landlord to allow a little old lady to keep her dog in her apartment. In *The Godfather* the mafia boss Don Corleone defends the weak in the tradition of the cinematic persona of Gary Cooper. Italian depictions of the mafia concentrate on economic stagnation and the futility of attempting to change Sicilian social reality, elements absent from Coppola's films. Italian mafia dramas such as Giuseppe Ferrara's *Cento giorni a Palermo* (*One Hundred Days in Palermo*; 1984), Marco Tullio Giordana's *I cento passi* (*One Hundred Steps*; 2000), Damiano Damiani's television serial *La piovra* (*The*

Beast; 1984), or Alessandro Di Robilant's *Il giudice ragazzino* (1994) feature an idealistic protagonist whose futile sacrifice and has no ultimate effect on Sicilian reality. In Italian mafia films the cultural and political reality of Sicily is impervious to attempts at reform while in the United States the mafia boss's story is inscribed in the Horatio Alger rags-to-riches story line.

Hollywood remakes of the French film *Pépé le Moko* (1937) tend to abandon the suicidal narrative of the French original. In *Pépé le Moko* Jean Gabin disembowels himself when his girlfriend leaves on a ferry, and he is about to be arrested. In the first American remake, John Cromwell's *Algiers* (1938), the protagonist still dies but is shot by the police. In Michael Curtiz's *Casablanca* (1942), a film that owes much to *Pépé le Moko* in terms of narrative setup, instead of killing himself, the lead played by Humphrey Bogart shoots a Nazi officer and joins an idealized French resistance. In *Sorcerer* (1977), William Friedkin's undervalued remake of *La salaire de la peur* (*Wages of Fear*; 1953), there is an allusion to the death of the protagonist played by Roy Scheider, which is far less explicit than the ending of Clouzot's original in which Yves Montand drives off a cliff in an exploding truck.[15] Jon Amiel's *Sommersby* (1993) is a surprising remake of Daniel Vigne's *The Return of Martin Guerre* (1982) because Richard Gere is actually hung at the end of the film like Gérard Depardieu in the French original. But the national narratives are preserved in another Richard Gere remake of a French film, Jim McBride's *Breathless* (1982) remake of Jean Luc Godard's *A bout de souffle* (1960). At the film's concluding sequence, instead of having the police shoot the drifter as in Godard's original, in McBride's remake, he simply dances.

There is only one significant Hollywood remake of a Finnish film. H. C. Potter's *The Farmer's Daughter* (1947) is based on the same play by Wuolijoki that inspired Vaala's comedy *Juurakon Hulda* (1937). Since the Finnish country-city narrative adheres to Hollywood narrative patterns' expectations for pair bonding and a happy ending, one might expect that there would not be significant changes to the narrative structure of the original. However, this is not the case. The tale of urban and pastoral conflict in the Vaala original is still present in the Hollywood remake, *The Farmer's Daughter*. But as might be expected, the Hollywood film achieves complete closure and victory for the female protagonist, Katie, now a Swedish farm girl played by Loretta Young. Both films retain the message of women's rights. In the Finnish version Hulda gains increased social status via marriage, but her personal and professional goals are thwarted. The result of Katie's trip to the city in *The Farmer's Daughter* is not only a good husband but also a career as a politician. The Hollywood remake ends with a montage rush depicting Katie's political campaign and the attempts by her adversaries to smear her reputation. Her marriage to Joseph Cotton's

congressman is postponed until she can clear her name and win the election after an extended chase sequence. In *The Farmer's Daughter* the Horatio Alger tale hinted at in the Finnish original *Juurakon Hulda* is completed in its Hollywood transfiguration. In the final sequence Katie is carried over the threshold of the Congress building in Washington, DC by her husband, a happy power couple of newlywed legislators.

An interesting aspect of Mexican cinema is shown in how its exponents have reached into neighboring Hollywood cinema in films that maintain the current of death imagery from classic Mexican cinema. *21 Grams* (2003) by Alejandro González Inarritu has a title referring to the body weight lost by a human being after the moment of death. A particularly interesting example of Mexican themes in Hollywood cinema is *The Three Burials of Melquiades Estrada* (2006) directed by Tommy Lee Jones with writer Guillermo Arriaga whose other efforts include *Amores perros* (*Life's a Bitch*; 2000) and *21 Grams* (2003). In *The Three Burials of Melquiades Estrada*, all the Mexican characters are presented as kind and loving souls in stark contrast to the demeaning representation of a masturbating border patrolman from Ohio and his vapid, adulterous wife. In the film a self-loathing Texas rancher obsessively ingests the idea of the importance of an honorable burial in Mexican culture. With a curiously self-important sense of paternalistic vigilantism, he resolves to provide the body of his deceased Mexican friend, Melquiades Estrada, a burial according to Estrada's final wishes. In his gruesome quest the American rancher abuses and beats the border guard who accidentally shot Estrada only to discover that the Mexican hometown described by Estrada was imaginary. Had such a Mexican idyll existed there would, of course, have been little reason for Estrada to emigrate to the United States in the first place. The film expresses the Mexican fascination with death and burial, in which treatment after life trumps one's position before death.

Another film with a Mexican subtext is Mel Gibson's *Apocalypto* (2006), one of the few films ever produced that attempts a reenactment of pre-Columbian culture. In the film a family man is captured with his fellow villagers by the marauding soldiers who seek captives as victims for horrific mass human sacrifice ceremonies. The graphic depiction of the barbaric practices of this pre-Columbian culture, with its incessant death imagery, places the film firmly in the morbid narrative tradition of Mexican cinema. The plight of the poor villagers slated for sacrifice before the imposing sacrificial machine of the theocratic pre-Columbian state evokes the pity of the spectator, but the subtext of their predicament is the lack of dignity which they are afforded. The corpses of the sacrificial victims, painted blue, recalling Julius Caesar's descriptions in his *Commentarii de Bello Gallico* (*Commentaries on the Gallic War*) of the rites of the Gallic tribes he conquered,

are rendered a status separate and beneath the heaving crowd lusting for their blood. Once removed from their community, the villagers lose all status. Their deaths are abject and public with their mutilated corpses tossed down the temple stairs after their hearts are ripped from their bodies to be barbecued as snacks for the attending priests. The film ends, interestingly enough, when the hero avenges the destruction of his village by killing the marauding soldiers and rescuing his family that had taken refuge in a well. The film could be seen to have a stereotypical Hollywood ending were it not for the final sequences in which the hero and his family observe the arrival of Spanish conquistadors who will enact the same sort of mass scale destruction and killing, through war and disease, on the powerful city that had captured the villagers in the first place. The conclusion to be drawn from the film is that it is faithful to the basic tenets of Mexican cinema where death and status at death are determining factors.

Perhaps the most interesting application of the idea of crossing master narratives is *Citizen Kane* (1941). Upon close examination Orson Welles's masterpiece actually has the narrative structure of an Italian film. In fact the tale of the newspaper magnate is recounted within a Boccaccio-style cornice (framework) where the story is related as a series of flashbacks unified around the efforts of a reporter trying to find the meaning of Kane's life and last words. The film's original treatments and screenplays included an orgy sequence in a Roman palazzo. In these unused scenes Kane's business associate Thatcher visits on Kane's twenty-fifth birthday to discuss the future management of Kane's affairs.[16] Kane dismisses Thatcher with the *sprezzatura* (cool) expected of a Renaissance prince living in the cynical cultural climate of Italianate *trasformismo* (cultural and economic immobility) rather than American optimism. Kane's final utterance, "rosebud," is an indication of narrative circularity. Despite Kane's life as a tycoon and his accumulation of the expensive trinkets stored in the basement of his Xanadu mansion, in his last moments he retained his original identity as a boy sledding in the woods at his mother's home. The narrative structure of the film therefore has an element of Italianate circularity and fatalism.

Jim Jarmusch's *Night on Earth* (1991)

The American cinema has also developed an oppositional, underground, or independent narrative strain heavily influenced by art cinema that challenges the limits of the happy-ending paradigm. The paradox is that the national cinema with the reputation for being most grounded in traditional narrative, even inspiring the use of the term "classical" to a medium as new as film, is actually among the most experimental. Films such as *Citi-*

zen Kane (1941), psychologically laced noirs, Leone influenced westerns, Kubrick's dramas such as *The Killing* (1956) or *Full Metal Jacket* (1987), rebelliously themed films such as *Bonny and Clyde* (1967) or *The Trial of Billy Jack* (1974), or *Thelma and Louise* (1991) all offer an indication of currents consciously working against the classical Hollywood narrative.

Jim Jarmusch's *Night on Earth* (1991) is a unique example of a film in the American art or oppositional tradition that provides a case study for many of the assertions proposed herein. With the film's five episodes depicting taxi drivers in Los Angeles, New York, Paris, Rome, and Helsinki, Jarmusch confronts the narrative commonplaces and expectations of Hollywood, French, Italian, and Finnish national cinemas. The Ohio-born Jarmusch was educated in New York City and spent a period studying in France. Jarmusch claims to have a working knowledge of French and to be able to follow Italian, although he has made no such claims of Finnish. For *Night on Earth* Jarmusch allowed the native-speaking actors he cast to freely translate the material he had written so that film has a linguistic authenticity, evident not only in the Finnish and Roman segments but also in the vernacular tone of the American episodes set in Los Angeles and New York.[17] This linguistic authenticity carries over into the narratives of each episode.

The opening segment presents a view of the planet Earth from outer space and a slow roll on a map to indicate the location of each segment within a global context. Jarmusch's film strives for human universality through the common experiences of cab drivers at the same moment in time in five large cities: Los Angeles, New York, Rome, Paris, and the Finnish capital Helsinki. The film is proof that national narrative patterns are so imbedded into cultural production that even when an outsider like Jarmusch attempts to enter into the territory of a national cinema, he inevitably works within the narrative patterns of the countries he depicts. This is particularly the case of the Rome and Helsinki episodes since the actors in Jarmusch's film, Roberto Benigni and Matti Pellonpää, may have had status as art cinema figures in the United States, but in Italy and Finland they are universally recognizable, popular performers.

The two opening segments are set in America in the two cities that have been the entertainment and cultural hubs of the nation over the last century. In the opening Los Angeles episode, Jarmusch pays homage to John Cassavetes through the casting of Gena Rowlands in a maternal role that recalls *A Woman Under the Influence* (1974) or *Love Streams* (1984). The episode has a quixotic happy ending because the young cabby played by Winona Ryder has the courage to retain her identity and steadfastly refuses offers of movie stardom. She dreams of becoming a mechanic and does not succumb to temptation when the casting agent played by Rowlands

offers to turn her into a movie star. The setting of Los Angeles and the casting agent's promise of stardom plays to the rags-to-riches story line, historically a staple of mainstream Hollywood film. Yet Jarmusch ultimately denies the spectator the Hollywood-ending set up in the story. However, the fact that the film makes an implicit reference to the possibility of a Hollywood ending in the Los Angeles episode proves the underlying relevance and influence of Hollywood narrative. Even in a film by an independent filmmaker like Jarmusch, Hollywood is a boomtown of endless possibilities from the drunken rock stars who are the cab driver's first fares, to the remarkable offer of stardom she receives from a chance encounter with a casting agent.

The seemingly open narrative of the Hollywood episode where a chance encounter can lead to wealth and fame contrasts with the next episode set in New York City. The casting of Giancarlo Esposito and Rosy Perez from *Mo Better Blues* (1990), *Do the Right Thing* (1989), and *School Daze* (1988) seems to be a homage to Spike Lee. As the segment opens, a black man is unable to hail a cab on a New York City street. He is picked up by a recent immigrant, a former East German clown on his first day of work as a cabby. The clown/cabbie is played by Armin Mueller-Stahl who had appeared as a Russian patriarch in Barry Levinson's *Avalon* (1990). The casting connection between an actor who played a role about twentieth-century immigration and the references to Lee's themes of racism in the United States underline very different aspects of the American experience. The somber ending of the New York episode opens up possibilities for the identification of a difference between a Hollywood– and New York–influenced narrative. But the undercurrent of the film in its first episodes deals directly with the American obsession with race as an identifier of class status. The indolent white taxi driver in Los Angeles is offered stardom and is uninterested whereas in contrast the belligerent black passenger and his obnoxious girlfriend find themselves in a world that is more static in terms of the possibilities for social mobility. The moral of the New York episode lies in the contrast between the good-natured incompetence of a member of the world's underclass, the East German clown, with the fatalism of the unhappy member of the American underclass, the black passenger who cannot hail a cab.

The Paris episode continues the examination of racial issues and also features an immigrant protagonist, a cab driver from the Ivory Coast. Yet just as in the Hollywood segment, the essence of French narrative creeps into the film. In French the term to describe a resident of the Ivory Coast, an Ivorian, is a homophone for "cannot see" (*n'y voit rien*). On the surface it may not seem that Jarmusch's story about an Ivorian cab driver in Paris could reflect French cultural identity. Yet the Ivorian is as marginalized

and seemingly doomed as any protagonist in classic French narrative. Two passengers from Cameroon tease the Ivorian cab driver about his national identity and blindness. Then the cab driver picks up a white blind passenger who despite her handicap is quite aware of the physical and sensory world. The Ivorian taxi driver's symbolic castration and blindness as an *n'y voit rien* begun by the African fares continues in the treatment he receives from the blind woman. She verbally abuses him and rebuts his meager attempts at flirtation. The fact that the cab driver is black is meaningless to a blind woman, yet she can read his own sense of uncertainty about his own abilities in the world in part due to conditioning about race. The cab driver is in fact ridiculed both by the fares from Cameroon, and by the white blind woman. After the Ivorian cab driver drops her off, he causes a car accident. The other driver, angry that the Ivorian smashed his car, also accuses the Ivorian of being blind. The accusation is not a racial reference to the homophone of Ivorian nationality or a sexual/castration reference to his awkward manner with women. Instead, the cabbie's blindness is due to his incompetence, the core of his identity as a professional driver. With the accident the episode ends on a note of self-inflicted tragedy that recalls the tendencies about French narrative mentioned herein.

The Rome episode was cowritten by Roberto Benigni who appears as Gino, a Tuscan cab driver in the Roman night. Gino's confession to his passenger, a priest, is an updated version of Benigni's theatrical monologue *Cioni Mario di Gaspare fu Giulia* (*Mario Cioni Son of Gaspare and the Late Giulia*; 1975) with its often obscene stories of Benigni's memories growing up in rural Tuscany. Like Benigni's theatrical monologue the episode is replete with lower-bodily, peasant humor. Benigni improvises stories of copulations with a pumpkin, a lamb named Lola, and his sister-in-law. As may be expected of an Italian film, the episode is circular. After the priest dies of a heart attack, Gino leaves the body on the side of the road and continues on his way. Gino's class and social position are unchanged. The Roman segment of *Night on Earth* actually seems inspired by an episode from *I nuovi mostri* (*Viva Italia!*; 1977) directed by Mario Monicelli and starring Alberto Sordi as a Roman driver who cannot find a hospital willing to admit his injured passenger, so he brings him back to the point where of departure. Like the Benigni character in *Night on Earth*, the Sordi episode in *I nuovi mostri* (*Viva Italia!*) has a circular structure. The Roman cab driver deposits the deceased passenger on a bench before going on his way.

The final episode of the film set in Helsinki is a homage to the Kaurismäki brothers, Aki and Mika, who helped Jarmusch with the casting and production of the segment. The protagonist is played by Matti Pellonpää who reprises his role as a stoic, Finnish everyman from Kaurismäki films. Mika, the cab driver, is alienated, alone, and connected to the world only through

the rough crackle of his dispatcher's radio. His cab route runs through the Eira, ex-working class district of Helsinki often featured in Kaurismäki films to the statue of Alexander I, the Russian Czar who granted autonomy to Finland, in Helsinki Cathedral square. When Mika picks up three drunken passengers, the impersonal city veneer of Helsinki temporarily fades. The sad tales told by the drunken fares in the cab recall the traditional obstacles faced by males in Finnish cinema; in particular, the confrontation between the primitive urge of alcoholism against the dictates of family and societal duty. Mika tells of the death of his prematurely born daughter, a story with a naturalistic undercurrent. Mika had determined to "kill his love" for the infant girl after the hospital doctor's warning that she was not strong enough to survive more than a week. But when the child did not die according to the doctor's predictions, Mika decides to love the child with all of his might. Her death at the moment of Mika's decision has a bucolic essence as if the city doctor's advice to deny the gift of nature was an affront to Mika's natural impulses. When dropping off the last groggy passenger, Mika asks if he recognizes his surroundings. The man yawns and answers, "Helsinki," the eternal urban antagonist to Finnish rural identity. The setting of the film in Helsinki and Mika's rough paternal instincts place the episode within the tradition of Finnish cinema where characters yearn to express their authentic impulses despite the impositions of urban life.

Conclusion

E very medium enjoys a golden age when its very newness inspires the creation of seminal works. With the cinema there is general recognition that the early sound period, and in particular the apex of the Hollywood studio system of the late 1930s, marked a period of achievement for the medium. During the early sound period, film was the unquestioned standard of choice of mass public entertainment. The development of mini-Hollywoods around the world also made this period pivotal in the formation of mass media cultures. As countries developed television broadcasting, the primary role of the cinema as the dominant form of public entertainment declined. The crisis that beset the American film industry in the 1950s occurred subsequently in other countries as cinema patrons realized they could stay at home to watch television rather than pay for a trip to the theater. This process of the decline of cinema as a mass entertainment event is presently occurring in developing countries where the dominance of the theatrical cinema is destined to decline as nations' economies progress. Television is not the only threat to theatrically released films. As the cinema was challenged by other media like television, it is now being further challenged by other forms of media available via the personal computer or portable media devices. In fact the primary form of entertainment for the youth in the developed world is not necessarily the cinema or even television but the myriad of possibilities offered by games and personal electronic devices that have a technical capacity far beyond the wildest dreams of the cinéastes of the golden age of studio cinema in the 1930s.

The cinema gained its maximum popularity and cultural relevance during a period in which individual nation-states were able to confine their culture within national boundaries. Even the importation of foreign films succumbed to dubbing in local language so that the cultural homogeneity of cinematic products was able to foster a sense of cultural identity and belonging within domestic entertainment markets. With the technological progress first from cinema to television and subsequently to the Internet and handheld media, this situation no longer exists. Entertainment is more of an international flow than ever before, and the ability to share and

discover the cultures of other countries has expanded beyond the wildest dreams of even the most fervent internationalists of decades past. Filmmaking is also no longer a centralized, industrial process. The diffusion of digital filmmaking technology has significantly reduced the economies of scale needed to make a film. Despite these epochal changes the cultural commonplaces established by the cinema still have relevance and the time has come to codify the manner in which the seminal period of filmmaking in the early sound period imitated cultural and historical traditions within national cultures. For the sense of identity that the early cinema was able to promote in individual national cultures has remained, even though the commonplaces that one may stereotypically associate with national cultures are in flux. The internationalization of culture has meant that peoples, and especially the youth of the world, dress in an almost identical fashion and consume much of the same entertainment materials. They may even eat similar types of food as indigenous cultural identity has been diluted to a greater extent than ever before in human history. If most inhabitants of the planet spoke mainly in dialect one hundred or two hundred years ago and identified themselves according to millennial regional cultural traditions, the cinema with its consolidation of language, culture, and identity through popular imagery and narrative helped to fuse separate identities into national ones. This process is occurring again as national cultural identities are fusing into international ones. This book has attempted to define the commonplaces of some national cultures and perhaps even help preserve them for posterity. For the future of the cinema lies not within a heavily restricted industrial process as was the case in the studio period but rather within the diffusion of the technology needed to make a film to the individual level.

This study pointed out how the political centralization that occurred with the consolidation of nation-states particularly in the late nineteenth century coincided with the appearance of the cinema as the dominant form of mass public entertainment. The cinema had a definitive consolidating effect on national cultures as it allowed citizens of a nation to have common cultural points of reference, which were transmitted in a voluntary forum, where the spectators themselves chose to participate in what could be considered a form of voluntary mass cultural indoctrination. Thus the commonplaces of cultural identity whose roots come from millennial influences derivative of geography and religious traditions were promoted in the early cinema in conjunction with the programs of national governments for the formation of national identities. The fascinating aspect of the cinema is that, even in cases where there was direct government interference in the operating of a free cinema, such as in the Soviet Union for the case of Ukraine examined herein, the cultural history

of the nation and its collective memory and expectations in terms of story and plot were stronger than the political designs of even the most repressive, authoritarian governments. Thus even if Stalin wished to promote a narrative regarding Ukraine that saw it as an entirely willing participant in the Russo-centrist imperialist policies of Soviet Communist ideology, the essence of Ukrainian identity still was able to shine through in the work of directors like Dovzhenko. Similarly the desire to present a heroic and manly narrative regarding Italian identity on the part of Mussolini's Fascist regime was subverted in story lines reflecting the more fatalistic experience according to the Catholic culture and historical experiences of the Italian people. Hollywood's stereotypical interest in pleasing audiences with happy endings has brought not only huge economic rewards but also a dearth of films directly relating to the American historical experience in the top-grossing films of the United States. The response of American audiences to *Gone with the Wind* and *Forrest Gump* reveals the ability of the popular cinema to demonstrate the underlying historical and cultural essence of the United States with particular reference to themes regarding the Civil War and the legacy of British colonialism. Similar generalizations, and conflations, are possible regarding the other cinemas examined herein. The essence of indigenous culture and history and its rich backdrop in religious mythology and static social relationships is an identifying aspect of the Bollywood cinema just as the deep civic philosophical traditions are an undeniable aspect of Chinese cinema. The tendency for opposition with the Iranian national character, reflective not only of geography but also of millennial indigenous religious traditions, has also appeared in its popular cinema. The tragic morbidity of the Mexican historical experience is similarly an underlying characteristic of that country's cinema. The deep rural essence of Finnish culture is an identifying characteristic of their cinema. The lesson to be drawn from the presentations of national cinemas in this book is that it is possible to conflate elements of historical and religious traditions in the study of a contemporary art form like the cinema. The one exception in this book has been in the study of French cinema. Instead of being reflective of the desires of the French people as expressed in their preferences at the domestic box office, French film culture has promoted a vision of the country and its culture favored by the nation's elite in a reflection of the defeats of French nationalism. The French film canon and its most renowned directors are almost uniformly absent from any listing of the most popular films with the French public. The cultural tradition of France as a world cultural force and oppositional pole to Anglo-American cultural and linguistic hegemony is reflected in its cinema.

The other aspect of the cinema that this study has tried to emphasize is the connection between culture and language by which the political

centralization that made possible the rise of separate national cinemas also provided an opportunity for the promotion of national standardized tongues. This process would be initialized by educational reform movements in newly united or independent countries and then propagated through the diffusion of radio broadcasts and made definitive through the reach of national television broadcasts. But the cinema also had a role in the development of national linguistic cultures as many of the standards for communication that would eventually be continued on television were first established in the cinema through film and newsreels.

The flip side of this promotion of linguistic homogeneity is that the true sources of cultural vitality, which are regional and local, became peripheral to the sense of national culture fostered by the mass distribution of film. The dialect that enjoyed proximity to economic power and political power, usually in the nation's political or financial capital, relegated regional expressions in language and culture to the periphery. The standardized languages promoted by education ministries whether in Rome, Helsinki, Paris, Tehran, or Mexico City gained in prestige and diffusion to the detriment of other linguistic identities. An interesting case in this stead is in the United States where the linguistic norms of Hollywood cinema, which were unarguably dominated by producers and actors with origins in New York, the country's financial center, gradually moved westward. The New Yorker–tinged English of Humphrey Bogart or Bugs Bunny that dominated Hollywood cinema into the 1940s gave way to cultural influences and linguistic tones dominant in the American Midwest and then in the Los Angeles area. The dialects of the American South, the losing faction in the development of American nationhood, have been equated with economic backwardness and imbecility.

One of the main conclusions of this study is that the key to understanding national identity in the cinema is in narrative, in the plot conventions that formed through audience box office response to the products offered in different national cinemas. The manner in which different national cinemas resolve a story can be a culturally specific reflection of deep historical, literary, and theatrical traditions. Canonical films in different national cinemas have narrative patterns and rely on plot conventions that reflect their culture and history. The unexpected aspect of the narrative commonplaces established during the early sound period and proposed herein is that they have stubbornly remained as identifying characteristics of some national cinemas into the twenty-first century. Just as assumptions about classical Hollywood narrative continue to define public expectations about Hollywood cinema, the narratives in the mini-Hollywoods around the world have continued to define the essence of these national cinemas. These narrative patterns may be manifestations of cultural identities that are deep

reflections of cultural essences more profound than any economic or ideo-
logical apparatus. Or the narrative pattern could be the result of the influ-
ence of a critical elite that influences funding of the cinema in opposition
to domestic tastes. The idea of national narratives within cinema studies
could allow scholars of previously undervalued cultural traditions a means
to assert their own unique cultural identity by determining how their cin-
emas rely on narrative patterns and conventions or achieve plot closure in
a manner reflective of sources important to the country's cultural heritage.
Such examinations should not be limited to the developed world or just to
the countries in this study. In a world where media culture is increasingly
global, the validation of cinematic traditions through the recognition of
the cultural and historical commonplaces expressed through the narrative
patterns repeated in canonical works can only enrich wider culture in gen-
eral and the study of film in particular.

One of the major impulses for this study was to renew an interest in cul-
tural heritage and other identifying aspects of national identity that have
not been adequately examined under the current paradigms of cultural
theory that emphasize diversity and multiculturalism, gender, sex, or class-
based readings on Marxist lines. These paradigms search out universality
based on elements that are basically physical and materialistic. A person's
gender and race are predetermined and are not necessarily reflective of
their own individuality in terms of their mind, their spirit, and ultimately,
their personal culture. Definitions of class can be similarly deterministic,
as if a person's background were an absolute indication of their station in
the world. A study of the identifying characteristics of national cinemas
as performed in this study has therefore been contrary to the current of
cultural studies, which predicates identity on physical characteristics like
gender or race, especially as it is increasingly anachronistic to equate eth-
nic physiognomy with national origin. To reduce an individual to physical
characteristics is a devaluation of their basic humanity and is reflective of
a materialistic philosophical bent. The richness of the human experience
lies in the almost infinite myriad of different cultures in the historical and
cultural heritages in which they function. To reduce the study of culture to
questions of physicality is to devalue cultural richness and promote homo-
geneity of artistic expression. The identification and celebration of culture
has a larger and richer trajectory than mere physical characteristics.

One of the costs of national cinemas is that they developed, both cultur-
ally and linguistically, at the expense of local, regional cultures. The cultural
and linguistic homogenization that has occurred in countries with mature
cinema industries and established national television broadcasting has dev-
astated local regional cultures. There has been a political reaction against
this process of cultural homogenization with recognition of just what has

been lost as a result. Presently Catalans in Barcelona or Scots in Edinburgh are attempting to reclaim their local cultural identity at the expense of the power structures built by the nation-states in which they reside. When federal authorities in Mexico City or Tehran trouble themselves with a revolt in Chiapas or in Kurdistan, they are fighting an ancient battle between central hegemony and the aspirations of regional minorities trying to defend their cultural identity. The national cinematic cultures examined in this book reduced the influence of regional cultural voices within their countries. When films are produced with an eye toward national distribution, they communicate in a language that tends to conform to the basic tenets of a national koine. Similarly the plot lines and conventions in such films made concessions, even if subconsciously, to the expectations of a national culture rather than to regional ones. As the Italian film industry has been increasingly set in Rome, the amount of content and narratives set in Rome and spoken in the Roman dialect increased. One may say the same of other national cinemas. Finnish cinema is also set largely in Helsinki, French cinema in Paris, Mexican cinema in Mexico City, and so on. The sound cinema is a child of the 1930s, and its subtexts reflect the push for hegemony, centralization, and homogenization, which were a definite characteristic of the political climate of that period, particularly in the West.

The irony is that this process of subjugation of regional themes to national ones performed with the aid of the cinema has now taken another step toward further cultural assimilation. The theoretical paradigms in vogue in cultural studies are in their essence an intellectualization of physical characteristics, which has reduced the multiplicity of human artistic endeavor to physical categories. Such a reduction of questions of study to physical characteristics occurs to the detriment of not only expressions of national culture but also regional culture. Just as nationalist culture reduced the importance of regional identity, the adhesion to cultural studies paradigms that emphasize materialistic and physical attributes are reducing the importance of themes that express national identity. This book has attempted to rescue national cinematic cultures from the oblivion of being reduced to mere purveyors of physical, materialist attributes and renew interest in cultural heritage.

The hope for the survival of the legacy of national cultural heritage is that the increasing power of technological innovation will not further reduce the role of national cultural expression in a manner similar to the fate of regional culture. If radio, film, and television have reduced the scope and importance of regional cultural expression in most nations on the planet, one may logically expect a similar fate for national culture under the influence of the technological media innovations of the twenty-first century. If the cultural precepts derivative of contemporary theory that

emphasize elements of physical identity rather than cultural heritage are victorious, the result will be a reduction in interest of questions of both national and regional identity. The idea of cultural diversity should not be limited to the recognition of physical differences but extend to the contributions of regional and national identities to the human experience.

Notes

Introduction

1. See Jean-Michel Frodon, *La projection nationale cinéma et nation* (Paris: Editions Odile Jacob, 1998); Erich Auerbach, *Mimesis: The Representation of Reality in Western Literature* (Garden City, NY: Doubleday, 1957).
2. See Peter von Bagh, *Drifting Shadows: A Guide to the Finnish Cinema* (Helsinki: Otava, 2000).
3. Renzo Renzi, *Il cinema dei dittatori* (Bologna, Italy: Grafis, 1992); Gregory Black, *The Catholic Crusade Against the Movies, 1940–1975* (New York: Cambridge University Press, 1998).
4. Peter Wollen, "An Alphabet of Cinema," in *Paris Hollywood: Writings on Film*, by Peter Wollen (London: Verso, 2002), 11.
5. David Bordwell, Janet Staiger, Kristin Thompson, *The Classical Hollywood Cinema: Film Style and Mode of Production to 1960* (New York: Columbia University Press, 1985), 111.
6. Benedict Anderson, *Imagined Communities Reflections on the Origin and Spread of Nationalism* (New York: Verso, 1991); Ernest Gellner, *Nations and Nationalism* (Oxford: Blackwell, 1983); Bego de la Serna-Lopez, "Europe: The Creation of a Nation? A Comparative Analysis of Nation-Building," in *Why Europe? Problems of Culture and Identity*, ed. J. Andrew, M. Crook, and M. Waller (New York: MacMillan, 2000), 132.
7. See Alan Williams, *Film and Nationalism* (New Brunswick, NJ: Rutgers University Press, 2002).
8. Stuart Hall, "The Question of Cultural Identity," in *Modernity and Its Future* (Cambridge: Polity Press in association with the Open University, 1992), 596–632; Stuart Hall, *Questions of Cultural Identity* (London: Sage, 1997); Madan Sarup, *Identity Culture and the Postmodern World* (Athens: University of Georgia Press, 1996); M. E. Price, *Television: The Public Sphere and National Identity* (Oxford: Clarendon, 1995); Edward Buscombe "National Culture and Media Boundaries: Britain," *Quarterly Review of Film and Video* 14, no. 3: 25–34.
9. See for example David Bordwell and Noel Carroll, *Post-Theory: Reconstructing Film Studies* (Madison: University of Wisconsin Press, 1996).
10. Ismail Xavier, "Historical Allegory," in *A Companion to Film Theory*, ed. Roby Miller and Robert Stam (Malden, MA: Blackwell Publishers, 1999), 361.
11. Frodon, *La projection nationale cinéma et nation*.
12. See Alan Williams, *Film and Nationalism*.

13. See Valentina Vitali and Paul Willemen, *Theorizing National Cinema* (London: BFI, 2005) 1–16.

Chapter 1

1. J. A. G. Roberts, *A Concise History of China* (Cambridge, MA: Harvard University Press, 1999), 8.
2. Ibid., 19.
3. Ibid., 113.
4. Ibid., 10.
5. George O. Liber, *Alexander Dovzhenko: A Life in Soviet Film* (London: BFI, 2002), 129.
6. Chris Berry and Mary Farquhar, *China on Screen: Cinema and Nation,* (New York: Columbia University Press, 2006), 12.
7. Ibid., 12–13.
8. J. A. G. Roberts, *A Concise History of China*, 29.
9. Ibid., 38.
10. Ibid., 57.
11. Ibid., 130.
12. Jubin Hu, *Projecting a Nation: Chinese National Cinema Before 1949* (Hong Kong: Hong Kong University Press, 2003), 62.
13. Gary G. Xu, *Sinascape: Contemporary Chinese Cinema* (Lanham, MD: Rowman & Littlefield, 2007), 90.
14. Ibid., 25.

Chapter 2

1. Tarmo Malmberg, "Traditional Finnish Cinema: An Historical Overview," in *Cinema in Finland*, ed. Jim Hiller (London: BFI, 1975), 9.
2. Peter von Bagh, *Drifting Shadows: A Guide to the Finnish Cinema* (Helsinki: Ottava, 1999), 5. See also Peter Cowie, *Finnish Cinema* (Helsinki: VAPK, 1990), 57–76.
3. von Bagh, *Drifting Shadows.*
4. Ibid.
5. I would like to thank Kimmo Laine for generously and patiently providing these unpublished figures and the Finnish Film Archive for providing access to Finnish films. See also Kimmo Laine, *Pääosassa Suomen kansa* (Jyvaskyla, Finland: Gummarus Kirjapaino, 1999).
6. Peter Wollen, *Signs and Meaning in the Cinema,* (London: BFI, 1998).
7. Veijo Heitala, Ari Honka-Hallila, Hanna Kangasniemi, Martti Lahti, Kimmo Laine, and Jukka Sihvonen, "The Finn-Between Uuno Turhapuro, Finland's Greatest Star" in *Popular European Cinema*, eds. Richard Dyer, Ginette Vincendeau (London: Routledge, 1992), 126–40.
8. Ibid.
9. Ibid.

Chapter 3

1. Dudley Andrew has noted the Tristan narrative tendency in French cinema in "Fade in/Fade out: Aspiration of National Cinema," accessed April 15, 2010, http://sdrc.lib.uiowa.edu/preslectures/andrew97/andrew.html.

2. See Jean-Michel Frodon, *La projection nationale cinéma et nation* (Paris: Editions Odile Jacob, 1998).

3. A. G. Macdonell, *Napoleon and His Marshals* (London: MacMillan, 1934).

4. Gabrielle Cahn, *Suicide in French Thought from Montesquieu to Cioran* (New York: Lang, 1998); Bernard Debré and Jacques Vergès, *Le suicide de la France* (Paris: Olbia, 2002).

5. Victor Brombert, *The Intellectual Hero: Studies in the French Novel, 1880–1955* (Chicago: University of Chicago Press, 1960).

6. Bego de la Serna-Lopez. "Europe, the Creation of a Nation? A Comparative Analysis of Nation-Building," in *Why Europe? Problems of Culture and Identity*, ed J. Andrew, M. Crook, and M. Waller (New York: MacMillan, 2000), 132.

7. Hagan Schultze, *Nations and Nationalism*, trans. William E. Yuill (New York: Blackwell, 1996), 160.

8. Harry Waldman, *Paramount in Paris: 300 Films Produced at the Joinville Studios, 1930–1933, with Credits and Biographies* (Lanham, MD: Scarecrow Press, 1998).

9. Rick Altman, *Film/Genre* (London: BFI, 1999), 61.

10. Jean-Michel Frodon, *La projection nationale cinéma*, 93.

11. Phil Powrie and Keith Reader, *French Cinema: A Students' Guide* (London: Arnold, 2002), 9.

12. Genette Vincendeau, *Pépé le Moko* (London: BFI, 1998).

13. Ewelyn Ehrlich, *Cinema of Paradox: French Filmmaking Under the German Occupation* (New York: Columbia University Press, 1985).

14. See Wheeler Winston Dixon, *The Early Criticism of François Truffaut*, trans. Ruth Cassel Hoffman, Sonja Kropp, and Brigitte Formentine-Humbert (Bloomington: Indiana University Press, 1993).

15. This is also fertile ground for feminist interpretations of French cinema along the lines established by Mary Ann Doane, *The Desire to Desire: The Woman's Film of the 1940s* (Bloomington: Indiana University Press, 1987).

16. Michael Kelly, *French Cultural Studies* (Oxford: Oxford University Press, 1996), 6.

17. Phil Powrie and Keith Reader, *French Cinema: A Student's Guide*, 183–84.

18. Harry Waldman, *Paramount in Paris: 300 Films Produced at the Joinville Studios*.

19. Louis Giannetti, *Understanding Movies* (Englewood Cliffs, NJ: Prentice Hall, 1996), 409.

20. See Victor Brombert, *The Intellectual Hero: Studies in the French Novel, 1880–1955*.

21. See Dennis D. Hughes, *Human Sacrifice in Ancient Greece* (New York: Routledge, 1999).

Chapter 4

1. K. Moti Gokulsing and Wimal Dissanayake, *Indian Popular Cinema: A Narrative of Cultural Change* (Stoke on Trent,: Trentham Books, 2003), 130.
2. Barbara D. Metcalf and Thomas R. Metcalf, *A Concise History of India* (Cambridge: Cambridge University Press, 2002), 233.
3. Ibid., 270.
4. Vijay Mishra, *Bollywood Cinema: Temples of Desire* (New York: Routledge, 2002), 41.
5. Rasipuram Krishnaswami, Narayan, *The Mahabharata* (New York: Vision Books, 1987).
6. Raimondo Bultrini, "La rivolta dei fuori casta," *La Repubblica*, December 30, 2007, 30.
7. Gayatri Chatterjee, *Mother India* (London: BFI, 2002).
8. See Mishra, *Bollywood Cinema.*

Chapter 5

1. Elton L. Daniel, *The History of Iran* (Westport, CT: Greenwood Press, 2001).
2. Ibid., 13.
3. Shahla Mirbakhtyar, *Iranian Cinema and the Islamic Revolution* (Jefferson, NC: McFarland, 2006), 37.
4. Ibid., 60.
5. Daniel, *History of Iran*, 17–21.
6. Hamid Reza Sadr, *Iranian Cinema: A Political History* (London: I. B. Tauris, 2006), 52.
7. Shahla Mirbakhtyar, *Iranian Cinema*, 38.
8. M. Ali Issari, *Cinema in Iran, 1900–1979* (London: Scarecrow Press, 1989), 105.
9. Sadr, *Iranian Cinema*, 59.
10. Mirbakhtyar, *Iranian Cinema*, 46.
11. Ibid., 60.
12. Ibid., 125.
13. Sadr, *Iranian Cinema*, 165–69.
14. Mirbakhtyar, *Iranian Cinema*, 103.
15. Sadr, *Iranian Cinema*, 175.
16. Ibid., 206–9.
17. Edward Said, *Orientalism* (New York: Vintage Books, 2003).

Chapter 6

1. Carlo Celli, "A Master Narrative in Italian Cinema?" *Italica* 81, no. 1 (2004): 73–83; André Bazin, *Qu'est-ce que le cinema?* (Paris: Editions du Cref, 1990), 264.

2. Carlo Celli, "The Legacy of the films of Mario Camerini in Vittorio De Sica's *Ladri di biciclette/The Bicycle Thief* (1948)." *Cinema Journal* 40, no. 4 (2001): 3.
3. Vincenzo Mollica, *Fellini Words and Drawings*, trans. Nina Marino (Turin: Soleil, 2001), 114.

Chapter 7

1. Charles Ramirez Berg, *Cinema of Solitude: A Critical Study of Mexican Film 1967–1983* (Austin: University of Texas Press, 1992); Anne T. Doremus, *Culture, Politics, and National Identity in Mexican Literature and Film, 1929–1952* (New York: Peter Lang, 2001).
2. Brian R. Hamnett, *A Concise History of Mexico* (Cambridge: Cambridge University Press, 2006), 17.
3. Ibid., 55.
4. Ibid., 56.
5. Fernando Arce Gaxiola and Víctor Manuel Muñoz Patraca, *Partido Revolucionario Institucional, 1946–2000: Ascenso y caída del partido hegemónico* (México: Siglo Veintuno Editores; Universidad Nacional Autónoma de México, Facultad de Ciencias Políticas Sociales, 2006).
6. Fernando Moreno and Carlos Fuentes, *La mort d'Artemio Cruz, entre le mythe et l'histoire* (Paris: Editions caribéennes, 1989).
7. Hamnett, *Concise History of Mexico*, 53.
8. Ibid., 63.
9. Ibid., 67.
10. François Maspero and Paulo Antonio Paranagua, *Le Cinéma mexicain*, trans. Claude Bleton (Paris: Centre Georges Pompidou, 1992).
11. Jeffrey M. Pilcher, *Cantinflas and the Chaos of Mexican Modernity* (Wilmington, DE: Scholarly Resources, 2001).

Chapter 8

1. Andrew Wilson, *The Ukranians Unexpected Nation* (New Haven: Yale University Press, 2000), 1.
2. Ibid.
3. Ibid., 95.
4. Ibid., 145.
5. Ibid., 149.
6. Ibid., 133.
7. Volodymyr Kukijovic, "Film," in *Encyclopedia of Ukraine* (Toronto: University of Toronto Press, 1984), 1:884–86.
8. George O. Liber, *Alexander Dovzhenko: A Life in Soviet Film* (London: BFI, 2002).
9. Ibid., 69.
10. Ibid., 71.

11. Ibid., 88.
12. Ibid., 90.
13. Ibid., 88–93.
14. Ibid., 106.
15. Ibid., 108.
16. Ibid., 107.
17. Ibid., 126.
18. Ibid., 129.
19. Ibid., 127.
20. Ibid., 128.
21. Ibid., 158.

Chapter 9

1. James Beniger, *The Cultural Revolution* (Cambridge, MA: Harvard University Press, 1986); Melvyn Stokes and Richard Maltby, *Identifying Hollywood's Audiences: Cultural Identity and the Movies* (London: BFI, 1999).
2. John Sedgwick and Michael Pokorny, "The Risk Environment of Film Making: Warner Bros in the Inter-War Years," *Explorations in Economic History* 35, 1998; Sandra B. Rosenthal and Carl R. Anderson, eds., *Classical American Pragmatism: Its Contemporary Vitality* (Urbana: University of Illinois Press, 1999).
3. Timothy Brennan, "The National Longing for Form," in *Nation and Narration*, ed. Homi K. Bhabha (New York: Routledge, 1990), 53.
4. Robert B. Ray, *A Certain Tendency of the Hollywood Cinema, 1930–1980* (Princeton, NJ: Princeton University Press, 1985); Robert Sklar and Charles Musser, eds., *Resisting Images: Essays on Cinema and History* (Philadelphia: Temple University Press, 1990).
5. David Bordwell, *Narration in the Fiction Film* (Madison: University of Wisconsin Press, 1985), 205–9.
6. Ibid., 207.
7. "All-Time Top 100 Box Office Films," AMC Filmsite, accessed April 15, 2010, http://www.filmsite.org/boxoffice.html.
8. See Neal Gabler, *An Empire of Their Own: How the Jews Invented Hollywood* (New York: Doubleday, 1989).
9. Frederick Jackson Turner, *The Frontier in American History* (New York: Dover Publications, 1996).
10. Richard Weiss, *The American Myth of Success: From Horatio Alger to Norman Vincent Peale* (Urbana: University of Illinois Press, 1988).
11. Ray, *Certain Tendency*.
12. Peter Wollen, *Signs and Meaning in the Cinema* (London: BFI, 1998).
13. Harry Waldman, *Hollywood and the Foreign Touch: A Dictionary of Foreign Filmmakers and Their Films from America, 1910–1995* (Lanham, MD: Scarecrow Press, 1996).

14. Francesco Savio, *Cinecittà anni Trenta: Parlano 116 protagonisti del secondo cinema italiano (1930–1943)*, ed. Tullio Kezich (Rome: Bulzoni, 1979), 490.
15. See Carolyn A. Durham, *Double Takes: Culture and Gender in French Films and Their American Remakes* (Hanover, NH: University Press of New England, 1998).
16. Robert L. Carringer, *The Making of "Citizen Kane"* (London: University of California Press, 1985).
17. Mark Peranson, "The Rise and Fall of Jim Jarmusch," in *Fifty Contemporary Filmmakers*, ed. Yvonne Tasker (London: Routledge, 2001), 177–85.

Bibliography

Aitken, Ian. *European Film Theory and Cinema: A Critical Introduction*. Bloomington: Indiana University Press, 2002.

"All-Time Top 100 Box Office Films." AMC Filmsite. http://www.filmsite.org/boxoffice.html (accessed April 1, 2010).

Altman, Rick. *Film/Genre*. London: BFI, 1999.

Anderson, Benedict. *Imagined Communities: Reflections on the Origin and Spread of Nationalism*. New York: Verso, 1991.

Andrew, Dudley. "Fade in/Fade out: Aspiration of National Cinema." Presidential lecture given by the University of Iowa Communication Studies Professor, 1997. http://sdrc.lib.uiowa.edu/preslectures/andrew97/andrew.html (accessed April 15, 2010).

Aristarco, Guido. "Zavattini e l'itinerario di Vittorio De Sica." *Cinema nuovo* 23, no. 232 (1974): 443–45.

———. "*Ladri di biciclette* (*The Bicycle Thief*)." *Cinema nuovo* 7 (1949): 220–22.

———. *Cinema italiano romanzo e antiromanzo*. Milan: Il Seggiatore, 1961.

Auerbach, Erich. *Mimesis: The Representation of Reality in Western Literature*. Garden City, NY: Doubleday, 1957.

Bammer, Angelika, ed. *Displacements: Cultural Identities in Question*. Bloomington: Indiana University Press, 1994.

Bazin, André. *Qu'est-ce que le cinema?* Paris: Editions du Cerf, 1990.

Beniger, James. *The Control Revolution: Technological and Economic Origins of the Information Society*. Cambridge, MA: Harvard University Press, 1986.

Benigni, Roberto, and Giuseppe Bertolucci. *Berlinguer ti voglio bene*. Rome: Theoria, 1992.

Benjamin, Walter. *Selected Writings*. Edited by Marcus Bullock and Michael W. Jennings. Cambridge, MA: Belknap Press of Harvard University, 1996.

Bennett, James C. "The Coming Info-National Order." *The National Interest* 74 (2003): 17–30.

Berg, Charles Ramírez. *Cinema of Solitude: A Critical Study of Mexican Film, 1967–1987*. Austin: University of Texas Press, 1992.

Berger, Stefan, Mark Donovan, and Kevin Passmore, eds. *Writing National Histories: Western Europe Since 1800*. New York: Routledge, 1999.

Bernardelli, Aldo. *Il cinema sonoro 1930–1969*. Rome: Anica Edizioni, 1992.

Berry, Chris, and Mary Farquhar. *China on Screen: Cinema and Nation*. New York: Columbia University Press, 2006.

Bhabha, Homi, ed. *Nation and Narration*. New York: Routledge, 1990.

Black, Gregory. *The Catholic Crusade Against the Movies, 1940–1975.* New York: Cambridge University Press, 1998.

Bollati, Giulio. *Gli italiani e il carattere nazionale come storia e come invenzione.* Turin, Italy: Einaudi, 1996.

Bondanella, Peter. *Italian Cinema: From Neorealism to the Present.* New York: Continuum, 1995.

———. "Three Neorealist Classics by Vittorio De Sica." *Cineaste* 23, no. 1 (1997): 52–53.

Bondebjerg, Ib. *Moving Images, Culture and the Mind.* Bloomington: University of Indiana Press, 2000.

Bordwell, David. *Narration in the Fiction Film.* Madison: University of Wisconsin Press, 1985.

Bordwell, David, David J. Staiger, and Kristen Thompson. *The Classical Hollywood Cinema: Film Style and Mode of Production to 1960.* New York: Columbia University Press, 1985.

———. *Post Theory: Reconstructing Film Studies.* Edited by David Bordwell and Noel Carroll. Madison: University of Wisconsin Press, 1996.

Borgello, Giampaolo. *Letteratura e marxismo.* Bologna, Italy: Zanichelli, 1975.

Brennan, Timothy, "The National Longing for Form." In *Nation and Narration,* edited by Homi K. Bhabha, 44–71. New York: Routledge, 1990.

Brombert, Victor. *The Intellectual Hero: Studies in the French Novel, 1880–1955.* Chicago: University of Chicago Press, 1960.

Brunetta, Gian Piero. *Intellettuali cinema e propaganda tra le due guerre.* Bologna, Italy: Riccardo Pàtron, 1972.

———. *Spari nel buio.* Milan: Marsilio Press, 1991.

———. *Storia del cinema italiano.* Rome: Editori Riuniti, 1993.

Brunette, Peter. *Roberto Rossellini.* New York: Oxford University Press, 1987.

Bultrini, Raimondo. "La rivolta dei fuori casta." *La Repubblica* (December 30, 2007): 30.

Buscombe, Edward. "National Culture and Media Boundaries: Britain." *Quarterly Review of Film and Video* 14, no. 3 (1993): 25–34.

Cahn, Gabrielle. *Suicide in French Thought from Montesquieu to Cioran.* New York: Lang, 1998.

Camerini, Mario. "Come fare un film." *Il dramma,* 9, 170, Sept. 9 1933.

———. "Comment realise-t-on un film." In *Mario Camerini,* edited by Alberto Farassino. Locarno, Switzerland: Editions Yellow Now, 1992.

Camus, Albert. *The Myth of Sisyphus.* New York: Oxford University Press, 1994.

Cánovas, Agustín Cué. *Liberalismo y federalismo en México.* Mexico: Instituto Nacional de Estudios Históricos de la Revolución Mexicana, 2004.

Carringer, Robert L. *The Making of Citizen Kane.* London: University of California Press, 1985.

Carrol, Noël. *Theorizing the Moving Image.* New York: Cambridge University Press, 1996.

Carter, Everett. "Cultural History Written with Lightning: The Significance of *The Birth of a Nation*." In *Focus on Birth of a Nation*, edited by Fred Silva, 9–19. Englewood, NJ: Prentice Hall, 1971.

Casadio, Gianfranco. *Adultere, Fedifraghe, innocenti La donna del 'neorealismo poplare' nel cinema italiano degli anni cinquanta.* Ravenna, Italy: Longo, 1990.

———. *Il grigio e il nero. Spettacolo e propaganda nel cinema italiano degli anni trenta* (1931–1943). Ravenna, Italy: Longo, 1989.

Cawelti, John. *The Six-Gun Mystique.* Bowling Green, OH: Bowling Green University Popular Press, 1971.

Cecchi, Emilio. *America amara.* Florence: Sansoni, 1946.

Celli, Carlo. "A Master Narrative in Italian Cinema?" *Italica* 81, no. 1 (2004): 73–83.

———. "Italian Neorealism's Wartime Legacy: Roberto Rossellini's *Roma città aperta/Rome Open City* (1945) and *L'uomo dalla croce/Man of the Cross* (1943)." *Romance Languages Annual* 10 (1999): 225–28.

———. "The Legacy of the Films of Mario Camerini in Vittorio De Sica's *Ladri di biciclette/The Bicycle Thief* (1948)." *Cinema Journal* 40, no. 4 (2001): 3–17.

Chakravarty, Smita S. *National Identity in Indian Popular Cinema.* Austin: Texas University Press, 1993.

Chiarini, Luigi. *Arte e tecnica del film.* Bari, Italy: Laterza, 1962.

Cohan, Steven, and Ina Rae Hark, ed. *Screening the Male: Exploring Masculinities in Hollywood Cinema.* New York: Routledge, 1993.

Cook, Pam, and Mieke Bernink. *The Cinema Book.* London: BFI, 1999.

Cowie, Peter. *Finnish Cinema.* Helsinki: VAPK, 1990.

Cripp, Thomas. *Making Movies Black: The Hollywood Message Movie from World War II to the Civil Rights Era.* New York: Oxford University Press, 1993.

Crofts, Stephen, "Reconceptualizing National Cinema/s." In *Film and Nationalism*, edited by Alan Williams, 25–51. New Brunswick, NJ: Rutgers University Press, 2002.

Cumbow, Robert C. *Once Upon a Time: The Films of Sergio Leone.* Metuchen, NJ: Scarecrow Press, 1987.

Daniel, Elton L. *The History of Iran.* Westport, CT: Greenwood Press, 2001.

Dau Novelli, Cecilia. "La famiglia come soggetto della ricostruzione sociale (1942–1949)." In *Cattolici, chiesa, resistenza*, edited by G. De Rosa, 469–90. Bologna, Italy: Il Mulino, 1997.

Debré, Bernard Jacques Vergès. *Le suicide del la France.* Paris: Olbia, 2002.

Del Sorbo, Paola Agostini. "1948–1998 I cinquant'anni di un eroe senza tempo." *Storia e dossier* 21, no. 127 (1998): 65.

De Paoli, Enzo. *Il cinema e la prima repubblica.* Como, Italy: Marna, 1995.

Derrell, William Davis. *Picturing Japaneseness: Monumental Style, National Identity, Japanese Film.* New York: Columbia University Press 1996.

Di Giammateo, Fernaldo. *Dizionario del cinema italiano.* Rome: Editori Riuniti, 1995.

Dixon, Wheeler Winston. *The Early Criticism of François Truffaut*. Translated by Ruth Cassel Hoffman, Sonja Kropp, and Brigitte Formentine-Humbert. Bloomington: Indiana University Press, 1993.

Doane, Mary Ann. *The Desire to Desire: The Woman's Film of the 1940s*. Bloomington: Indiana University Press, 1987.

Doremus, Anne T. *Culture, Politics and National Identity in Mexican Literature and Film, 1929–1952*. New York: Peter Lang, 2001.

Duggan, Christopher. *A Concise History of Italy*. Cambridge: Cambridge University Press, 1994.

Durham, Carolyn A. *Double Takes: Culture and Gender in French Films and Their American Remakes*. Hanover: University Press of New England, 1998.

Easthope, Anthony. *Contemporary Film Theory*. New York: Longman, 1993.

Ehrlich, Ewelyn. *Cinema of Paradox: French Filmmaking Under the German Occupation*. New York: Columbia University Press, 1985.

Elsaesser, Thomas. "Putting on a Show: The European Art Movie." *Sight and Sound* 4, no. 4 (1994): 24.

Fellini, Federico. *Fellini on Fellini*. Translated by Isabel Quigley. New York: Delacorte Press, 1976.

———. *Fare un film*. Turin, Italy: Einaudi, 1980.

Ferrara, Giuseppe. *Il nuovo cinema italiano*. Florence: Le Monnier, 1957.

Forsyth, Douglas J. "The Peculiarities of Italo-American Relations in Historical Perspective." *Journal of Modern Italian Studies* 3, no. 1, 1998.

Fortini, Franco. "*Ladri di biciclette* (1949)." In *Dieci inverni, 1947–1959: Contributi a un discorso socialista*, 128–31. Milan: Feltrinelli, 1958.

Frayling, Christopher. *Spaghetti Westerns Cowboys and Europeans from Karl May to Sergio Leone*. London: Routledge, 1981.

———. "The Wretched of the Earth." *Sight and Sound* 3, no. 6 (1993): 26.

French, Warren. *The South and Film*. Jackson: University Press of Mississippi, 1981.

Frodon, Jean-Michel. *La projection nationale cinéma et nation*. Paris: Editions Odile Jacob, 1998.

Gabler, Neal. *An Empire of Their Own: How the Jews Invented Hollywood*. New York: Doubleday, 1989.

Gaxiola, Fernando Arce, and Víctor Manuel Muñoz Patraca. *Partido Revolucionario Institucional, 1946–2000: Ascenso y caída del partido hegemónico*. México: Siglo Veintiuno Editores; Universidad Nacional Autónoma de México, Facultad de Ciencias Políticas Sociales, 2006.

Gayatri, Chatterjee. *Mother India*. London: BFI, 2002.

Gellner, Ernest. *Nations and Nationalism*. Oxford: Blackwell, 1983

Giannetti, Louis. *Understanding Movies*. Englewood Cliffs, NJ: Prentice Hall, 1996.

Gieri, Manuela. *Contemporary Italian Filmmaking: Strategies of Subversion: Pirandello Fellini, Scola, and the Directors of the New Generation*. Toronto: University of Toronto Press, 1995.

Gledhill, Christine, and Linda Williams, eds. *Reinventing Film Studies*. New York: Oxford University Press, 2000.

Gokulsing, K. Moti, and Wimal Dissanayake. *Indian Popular Cinema: A Narrative of Cultural Change.* Stoke-on-Trent, UK: Trentham Books, 2003.

Gramsci, Antonio. *Lettere dal carcere.* Turin, Italy: Einaudi, 1971.

Hall, Stuart. *Questions of Cultural Identity.* London: Sage 1997.

———. "The Question of Cultural Identity." In *Modernity and Its Futures.* Edited by Stuart Hall and Tony McGrew, 596–632. Cambridge: Polity Press, 1992.

Hamnett, Brian R. *A Concise History of Mexico.* Cambridge: Cambridge University Press, 2006.

Heider, Karl. G. *Images of the South: Constructing a Regional Culture on Film and Video.* Athens: University of Georgia Press, 1993.

Heitala, Veijo, Ari Honka-Hallila, Hanna Kangasniemi, Martti Lahti, Kimmo Laine, and Jukka Sihvonen. "The Finn-Between: Uuno Turhapuro, Finland's Greatest Star." In *Popular European Cinema,* edited by Richard Dyer and Ginette Vincendeau, 126–40. London: Routledge, 1992.

Higson, Andrew. "The Concept of National Cinema." In *The European Cinema Reader,* edited by Catherine Fowler, 133–42. London: Routledge, 2002.

———. "The Limiting of National Cinema." In *Cinema and Nation,* edited by Mette Hjort and Scott MacKenzie, 63–74. New York: Routledge, 2000.

———. *Waving the Flag: Constructing a National Cinema in Britain.* Oxford: Oxford University Press, 1995.

Hosejko, Lubomir. *Histoire du cinema ukrainien (1896–1995).* Paris: Éditions à Dié, 2001.

Hu, Jubin. *Projecting a Nation: Chinese National Cinema Before 1949.* Hong Kong: Hong Kong University Press, 2003.

Hughes, Dennis D. *Human Sacrifice in Ancient Greece.* New York: Routledge, 1999.

Issari, M. Ali. *Cinema in Iran, 1900–1979.* London: Scarecrow Press, 1989.

Jameson, Fredric. "Postmodernism, or, The Cultural Logic of Late Capitalism." *The New Left Review* 146 (1984): 53–92.

Kellner, D. *Media Culture: Cultural Studies, Identity, and Politics between the Modern and the Postmodern.* London: Routledge, 1995.

Kelly, Michael. *French Cultural Studies.* Oxford: Oxford University Press, 1996.

Kezich, Tulio. *Fellini.* Milan: Camunia, 1987.

Koivonen, Anu. *Performance Histories, Foundational Fictions. Gender and Sexuality in Niskavuori Films.* Helsinki: Finnish Literature Society, 2003.

Kolker, Robert. *Film, Form, and Culture.* Boston: McGraw-Hill, 1999.

Kracauer, Siegfried. *From Caligari to Hitler: A Psychological History of the German Film.* Princeton, NJ: Princeton University Press, 1947.

Krawschenko, Bohan. *Social Change and National Consciousness in Twentieth-Century Ukraine.* New York: St. Martin's Press, 1985.

Kukijovic, Volodymyr, ed. *Encyclopedia of Ukraine.* Vol. 1. Toronto: University of Toronto Press, 1984.

Laine, Kimmo. *Pääosassa Suomen kansa.* Jyväskylä, Finland: Gummarus Kirjapaino, 1999.

Landy, Marcia. *Cinematic Uses of the Past.* Minneapolis: University of Minnesota Press, 1996.

Liber, George O. *Alexander Dovzhenko: A Life in Soviet Film*. London: BFI, 2002.

Lo Bello, Nino. *Vaticanerie anedotti e curiosità di una storia millenaria*. Rome: Ancora, 2000.

Lopez, Bego de la Serna-. "Europe . . . the Creation of a Nation? A Comparative Analysis of Nation-Building." In *Why Europe? Problems of Culture and Identity*, 131–54. Edited by Joe Andrew, Malcolm Crook, and Michael Waller. New York: MacMillan, 2000.

Macdonnel, A. G. *Napoleon and His Marshals*. London: MacMillan, 1934.

Malmberg, Tarmo. "Traditional Finnish Cinema: An Historical Overview." In *Cinema in Finland*, edited by Jim Hiller, 1-14. London: BFI, 1975.

Marcus, Millicent. *Italian Film in the Light of Neorealism*. Princeton, NJ: Princeton University Press, 1986.

Martinelli, Massimo. *Benigni Roberto di Luigi fu Remigio*. Milan: Leonardo Arte, 1997.

Martini, Giulio, and Guglielmina Morelli, eds. *Patchwork due geografia del nuovo cinema italiano*. Milan: Il Castoro, 1997.

Maspero, François, and Paulo Antonio Paranagua. *Le Cinéma mexicain*. Translated by Claude Bleton. Paris: Centre Georges Pompidou, 1992.

Metcalf, Barbara D., and Thomas R. Metcalf. *A Concise History of India*. Cambridge: Cambridge University Press, 2002.

Mereghetti, Paolo. *Dizionario dei film 1996*. Milan: Baldini & Castoldi, 1996.

Micciché, Lino. *Il nuovo cinema deglli anni '60*. Turin, Italy: ERI, 1972.

Mininni, Francesco. *Sergio Leone*. Rome: Castoro, 1994.

Mirbakhtyar, Shahla. *Iranian Cinema and the Islamic Revolution*. Jefferson, NC: McFarland, 2006.

Misheer E. "Models of Narrative Analysis: A Topology." *Journal of Narrative Life and History* 5, no. 2 (1995): 87–123.

Mishra, Vijay. *Bollywood Cinema: Temples of Desire*. New York: Routledge, 2002.

Mitchel, Lee Clark. *Westerns: Making the Man in Fiction and Film*. Chicago: Chicago University Press, 1996.

Mollica, Vincenzo. *Fellini: Words and Drawings*. Translated by Nina Marino. Turin, Italy: Soleil, 2001.

Moreno, Fernando, and Carlos Fuentes. *La mort d'Artemio Cruz, entre le mythe et l'histoire*. Paris: Éditions caribéennes, 1989.

Moseley, Philip. *Split Screen: Belgian Cinema and Cultural Identity*. Albany: SUNY Press, 2001.

Narayan, Rasipuram Krishnaswami. *The Ramayana*. New York: Penguin Books, 1972.

Neale, Steve. "Masculinity as Spectacle: Reflections on Men and Mainstream Cinema." In *Screening the Male: Exploring Masculinities in Hollywood Cinema*, edited by S. Cohan and I. R. Hark, 9–20. New York: Routledge, 1993.

Noble, Andrea. *Mexican National Cinema*. New York: Routeledge, 2005.

Nuzzi, Paolo, and O. Iemma. *De Sica & Zavattini Parliamo tanto di noi*. Rome: Editori Riuniti, 1997.

O'Regan, Tom. *Australian National Cinema*. London: Routledge 1996.

Pecori, Franco. *De Sica. Il castoro cinema*. Florence: La nuova Italia, 1980.

Peranson, Mark. "The Rise and Fall of Jim Jarmusch." In *Fifty Contemporary Filmmakers*, edited by Yvonne Tasker, 177–85. London: Routledge, 2001.

Pilcher, Jeffrey M. *Cantinflas and the Chaos of Mexican Modernity*. Wilmington, DE: Scholarly Resources, 2001.

Powrie, Phil, and Keith Reader. *French Cinema: A Student's Guide*. London: Arnold 2002.

Price, Monroe Edward. *Television, the public Sphere and National Identity*. Oxford: Clarendon 1995.

Ray, Robert B. *A Certain Tendency of the Hollywood Cinema, 1930–1980*. Princeton, NJ: Princeton University Press, 1985.

Renzi, Renzo. *Il cinema dei dittatori*. Bologna: Grafis, 1992.

Ricci, Steven. "Camerini et Hollywood Questions d'identité (nationale)." In *Mario Camerini*, edited by Alberto Farassino and translated by Jacqueline Fumagalli. Locarno: Editions Yellow Now, 1992.

Ricoeur, Paul, and J. S. Bruner, "The Narrative Construction of Reality." *Critical Inquiry* 18, no. 1 (1991): 1–21.

Rieser, Martin, and Andrea Zapp. *The New Screen Media Cinema/Art/Narrative*. London: BFI, 2002.

Roberts, J. A. G. *A Concise History of China*. Cambridge, MA: Harvard University Press, 1999.

Rondolino, Gianni. *Catalogo Bolaffi del cinema italiano*. Turin, Italy: G. Bolaffi, 1979.

———. *Rossellini*. Turin, Italy: UTET, 1989.

Rosenstone, Robert A. *Visions of the Past: The Challenge of Film to Our Idea of History*. Cambridge, MA: Harvard University Press, 1995.

Rosenthal, Sandra B., and Carl R Anderson. *Classical American Pragmatism: Its Contemporary Vitality*. Urbana: University of Illinois Press, 1999.

Rossellini, Roberto. *My Method: Writings and Interviews*. Edited by Adriano Apra'. New York: Marsilio, 1995.

Ruffin, Valentina. "La lingua del fascismo nel cinema." In *Il cinema dei dittatori Mussolini, Stalin, Hitler*, edited by R. Renzi, G. L. Farinelli, and N. Mazzanti. Rome: Grafis, 1992.

Sadr, Reza Hamid. *Iranian Cinema: A Political History*. London: I. B. Tauris, 2006.

Said, Edward. *Orientalism*. New York: Vintage Books, 2003.

Sarup, Madan. *Identity, Culture and the Postmodern World*. Athens: University of Georgia Press, 1996.

Saunders, David. "What Makes a Nation a Nation?" *Ethnic Studies* 10 (1993): 101–24.

Savio, Francesco. *Cinecittà anni Trenta: Parlano 116 protagonisti del secondo cinema italiano (1930–1943)*. Edited by Tullio Kezich. Rome: Bulzoni, 1979.

Scholes, Robert. "Narration and Narrativity in Film." In *Film Theory and Criticism*, edited by Gerald Mast and M. Cohen, 390–403. Oxford: Oxford University Press, 1985.

Sesti, Mario. *Nuovo cinema italiano: gli autori, le idee*. Rome: Theoria, 1994.

Sedgwick, John, and Michael Porkony. "The Risk Environment of Film Making: Warner Bros in the Inter-War Years." *Explorations in Economic History* 35:2, (1998): 169–220.

Schultze, Hagan. *Nations and Nationalism*. Translated by William E. Yuill. New York: Blackwell, 1996.

Sitney, P. Adams. *Vital Crisis in Italian Cinema*. Austin: Texas University Press, 1995.

Sklar, Robert, and Charles Musser. *Resisting Images: Essays on Cinema and History*. Philadelphia: Temple University Press, 1990.

Smith, A. D. *The Ethnic Origins of Nations*. Oxford: Blackwell, 1986.

Snead, James, Colin McCabe, and Cornell West. *White Screen/Black Images: Hollywood from the Dark Side*. New York: Routledge, 1994.

Sommer, Doris. "Irresistible Romance: The Foundational Fictions of Latin America." In *Nation and Narration*, edited by Homi K. Bhabha, 71–98. New York: Routledge, 1990.

Sorlin, Pierre. "Il Risorgimento italiano: 1860." In *La storia al cinema ricostruzione del passato interpretatzione del presente*, edited by Gianfranco Miro Gori, 409–20. Rome: Bulzoni, 1994.

———. *Italian National Cinema 1896–1996*. New York: Routeledge, 1996.

Steinmetz, George, ed. *State/Culture: State/Formation after the Cultural Turn*. Ithaca, NY: Cornell University Press, 1999.

Stokes, Melvyn, and Richard Maltby. *Identifying Hollywood's Audiences: Cultural Identity and the Movies*. London: BFI, 1999.

Strinati, Dominic. *An Introduction to Studying Popular Culture*. London: Routledge, 2000.

Tinazzi, Giorgia. *Il nuovo cinema italiano*. Padua, Italy: Centro Universitario Cinematografico, 1963.

Tomasulo, Frank P. "*The Bicycle Thief*: A Re-Reading." *Cinema Journal* 21, no. 2 (1982): 13.

Turner, Frederick Jackson. *The Frontier in American History*. New York: Dover Publications, 1996.

Turner, Graeme. *Film as Social Practice*. London: Routledge, 1988.

Vertrees, Alan David. *Selznick's Vision: "Gone with the Wind" and Hollywood Filmmaking*. Austin: University of Texas Press, 1997.

Vincendeau, Genette. *Pépé le Moko*. London: BFI, 1998.

Virdi, Jystika. *The Cinematic Imagination: Indian Popular Films as Social History*. New Brunswick, NJ: Rutgers University Press, 2003.

Vitali, Valentina, and Paul Willemen, eds. *Theorizing National Cinema*. London: BFI, 2005.

von Bagh, Peter. *Drifting Shadows: A Guide to the Finnish Cinema*. Helsinki: Ottava, 1999.

Wagstaff, Christopher. "A Forkful of Westerns: Industry, Audiences and the Italian Western." In *Popular European Cinema*, edited by R. Dyer and G. Vincendeau, 245–62. New York: Routledge, 1992.

Waldman, Harry. *Paramount in Paris: 300 Films Produced at the Joinville Studios, 1930–1933, with Credits and Biographies.* Lanham, MD: Scarecrow Press, 1998.

———. *Hollywood and the Foreign Touch: A Dictionary of Foreign Filmmakers and Their Films from America, 1910–1995.* Lanham, MD: Scarecrow Press, 1996.

Weiss, Richard. *The American Myth of Success: From Horatio Alger to Norman Vincent Peale.* Urbana: University of Illinois Press, 1988.

Williams, Alan. *Film and Nationalism.* New Brunswick, NJ: Rutgers University Press, 2002.

Williams, Tony. *Structures of Desire: British Cinema, 1939–1955.* Albany: SUNY, 2000.

Wills, Gary. *John Wayne's America.* New York: Simon and Schuster, 1993.

Wilson, Andrew. *The Ukrainians Unexpected Nation.* New Haven, CT: Yale University Press, 2000.

Wolchik, Sharon L. *Ukraine: The Search for a National Identity.* Lanham, MD: Roman and Littlefield, 2000.

Wollen, Peter. *Paris Hollywood: Writings on Film.* New York: Verso, 2002.

———. *Signs and Meaning in the Cinema.* 4th ed. London: BFI, 1998.

Wright, Will. *Six Guns and Society: A Structural Study of the Western.* Berkeley: University of California Press, 1975.

Xavier, Ismail. "Historical Allegory." In *A Companion to Film Theory,* edited by Roby Miller and Robert Stam, 333–62. Oxford, MA: Blackwell Publishers, 1999.

Xu, Gary G. *Sinascape: Contemporary Chinese Cinema.* Lanham, MD: Rowman and Littlefield, 2007.

Index